CREATIVE DIGITAL PRINTMAKING

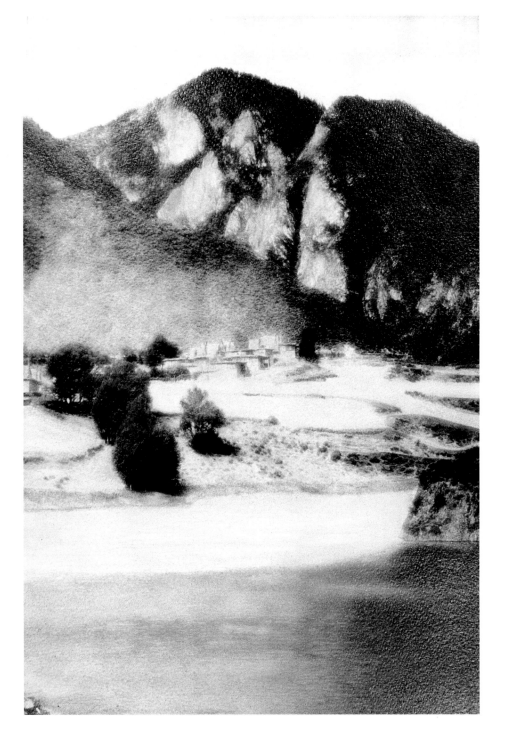

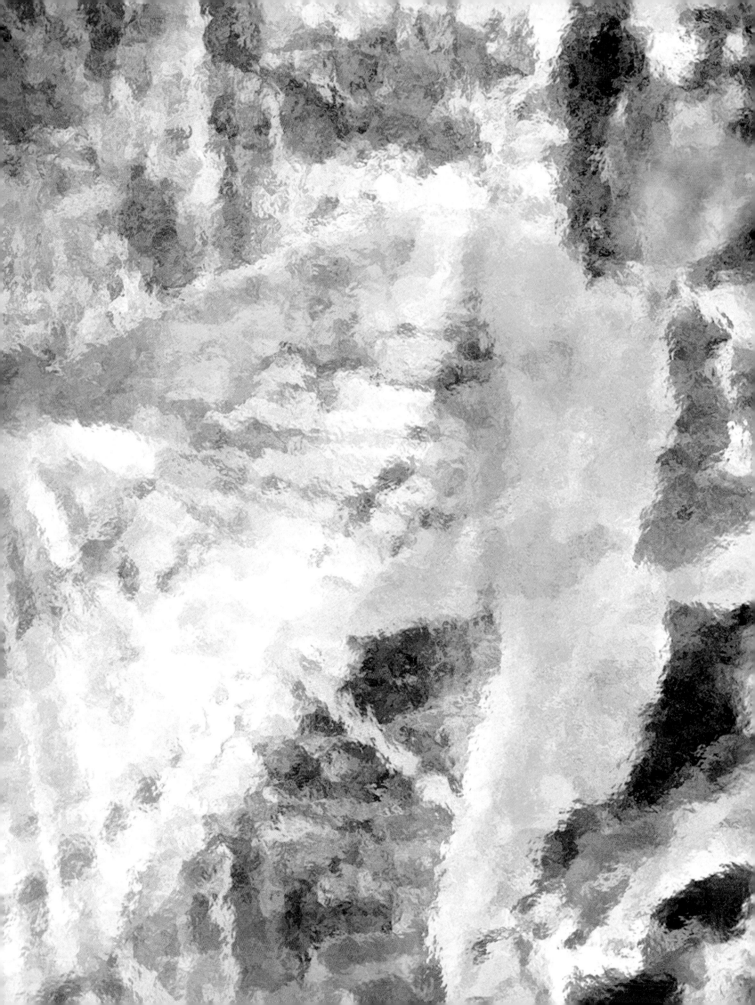

CREATIVE DIGITAL PRINTMAKING

A Photographer's Guide to Professional Desktop Printing

THERESA AIREY
with Michael J. McNamara

AMPHOTO BOOKS
An imprint of Watson-Guptill Publications/New York

This book is dedicated to
Samantha Scott and Lauren Rachel
(my granddaughters)

You both give me great joy and much love
Through your lives, my life has been enriched and my vision has grown

Half-title page: *Village by the Yangtze River*
Title page: *Girl with Umbrella*

Senior Editor: Victoria Craven
Edited by Sarah Fass
Designed by Areta Buk
Graphic production by Ellen Greene

Copyright © 2001 by Theresa Airey

First published in 2001 by Amphoto Books,
an imprint of Watson-Guptill Publications,
a division of BPI Communications, Inc.,
770 Broadway, New York, NY 10003
www.watsonguptill.com

Library of Congress Cataloging-in-Publication Data
Airey, Theresa.
 Creative digital printmaking : a photographer's guide to professional
Desktop printing / Theresa Airey.
 p. cm.
 Includes index.
 ISBN 0-8174-3726-6
 1. Photography—Digital techniques. 2. Computer printers. 3. Images,
Photographic—Data processing. 4. Photography—Processing—Data
processing. I. Title.

TR267 .A35 2001
778.3—dc21 20001022382

Manufactured in Singapore

First printing, 2001

1 2 3 4 5 6 7 8 9 / 09 08 07 06 05 04 03 02 01

ACKNOWLEDGMENTS

I wish to thank Maryalice Yakutchik for all her encouragement and moral
support and for being a great copyeditor on my original text.

A big thank you to Victoria Craven and Sarah Fass for all their help and
skill in reorganizing and editing this text, making it into a clear working guide
that will be easy to use and understand. Sarah, your eye for detail and
editing is amazing. I feel very fortunate to have had you as my editor.
Thank you.

A big cyber-hug goes out to Mike McNamara for all his input and his
technical expertise.

I want to send a heartfelt thank you to Areta Buk for her incredible
talent in book designing. I have the highest respect for you as an artist.

To all my cyber-buddies, especially Joe Meehan, Bob Shell, Randy
Morgan, Charlie Bowers, Dan Fong, and Hunter Witherill for sharing
information and confirmation on digital data, back when we were out there
searching for answers before the influx of Web sites (fabulous information
centers) began.

I would like to thank all the digital fine photographer/artists who
have contributed to the gallery section of this book. Thank you for sharing
your vision, your skills, and your art. Your gifts impact us both visually
and intellectually, and help us all to understand and accept digital imaging
as a fine art. You are truly the pioneers in this exciting and creatively
stimulating field.

CONTENTS

PREFACE

Some of you may already know me as a darkroom printer and the author of *Creative Photo Printmaking* (Amphoto, 1997). I do indeed love the darkroom—a place of magic and intrigue. Perhaps that's why it took me two years of internal debate to finally decide to enter the digital world. I was skilled in the traditional ways of photographic printmaking and it gave me great pleasure to be in my darkroom, creating and printing images. I was safe and confident in the realm of traditional photographic methods and processes; I was accepted and had a place there. So why would I bother to change?

Curiosity got the best of me. I was beginning to see digital images that were extremely complex and compelling. However, I felt that the output technology for electronic imaging was inferior to darkroom processes. But as the desktop printers got better and less expensive, new avenues opened up for different means of making prints. The software program Adobe Photoshop was being revised, and similar programs were being created. I could no longer stay away. After finishing my first book, *Creative Photo Printmaking,* I enrolled in a computer course at the Maryland Institute, College of Art, where I teach classes on creative photographic methods.

I had doubts and misgivings: perhaps I couldn't create images on a screen; perhaps I couldn't learn all this new technology. But two weeks into the course, I realized that I had made the right decision. I became very excited about all the new possibilities. It was like pulling my first print in the darkroom. My mind exploded with ideas. I knew it would take time to learn what I needed before I could use the computer to make good images, but I committed myself and learned. I am still learning and enjoying the process.

One of my instructors in the beginning of my photographic career was Todd Walker, a professional photographer/artist and author of numerous books who was instrumental in the resurgence of non-silver processes in the 1960s, and in the 1980s, pioneered the computer as a tool for his fine art printmaking. Todd believed that good photographers and artists are willing to make more mistakes than others. They learn from their mistakes. His motto was "Take risks."

If you are reading this book, you have already taken a risk—or at least you are seriously considering entering the digital world. This book is not meant to be a handbook on how to use your computer or any particular software program (such as Photoshop), although I do give specific details about how I created many of my images. My primary objective in writing *Creative Digital Printmaking* is to enlighten you about exciting new possibilities and to educate you about how to go about accomplishing them. It is designed as a sourcebook for creativity and ideas. I am here to assure you that electronic imaging can be fine art. So, let's stir up those creative digital juices together!

INTRODUCTION

In 1839, when Fox Talbot and Louis Daguerre discovered a way to permanently fix an image, they changed the entire course of photographic history. Today we are in the midst of another revolution: Digital imaging and inkjet printers are changing the worlds of both photographers and fine art printmakers.

For the printmaker, digital printmaking is a totally new field. The major changes in technology that are taking place influence our thinking in terms of digital technology. Artist-photographers now see digital media as a viable and desirable means of inexpensively outputting an image onto fine art paper as a final presentation or record of their creativity—in other words, as a final print.

Digital printing allows photographers to create different looks and moods to suit their images. It is a new means of expression, and requires a new vocabulary. For those artistic printmakers who do not have access to a darkroom or the time to spend there, as well as for those who are allergic to the chemicals used in traditional printmaking, it is a fast and easy avenue for creative expression. I believe that digital imaging is changing the world of photography, but also that the traditional processes will endure. Silver gelatin printing may in time become an "alternative" process—much as platinum and carbon printing are today—but it will always be with us.

Until very recently, the output from digital manipulation in the computer was inferior to traditionally processed prints. But today, affordable printers for personal use have become extremely sophisticated. Output from the computer is easy to produce as well as archival, and this is largely responsible for the popularity of digital imaging.

When the topic of discussion is digital prints, people tend to focus on the technical details—RAM, scanners, dpi, ppi, printers, software, etc.—and creativity is all but forgotten. Without imagination and passion, you might be able to render a technically good print but, chances are, it will also be unforgivably boring. Achieving creative output requires initial creative input from the photographer/artist. With digital printmaking, the basic foundations of photography and printmaking still must be in place: The ability to recognize and utilize light and composition are vital for creating an artistic image. The computer is just another tool, a new means by which to create images.

You don't have to be technically inclined to use the computer, just willing to spend time learning. The learning curve may be lengthy, but it is not difficult and not without excitement. So, how should you start? The most expedient way to learn how to use a computer and software (such as Photoshop) is to enroll in a computer class at a university or community college. Semester-long courses allow ample time to practice the lessons, either at home or in the school's lab. Many universities and high schools offer weekend-long crash courses that can be very helpful. By the time you have finished a course, you will know exactly what you want to buy for personal use: which computer and software, as well as which drives, printers, and scanners. It is always smart to try any equipment before investing in it so that you know from experience whether or not it fits your needs. There is one thing that you can depend on: Computers, printers, and scanners of higher quality and lower cost come along every six months—that is the nature of the industry. But don't wait to make your purchase. Find out now what you need, buy it, and work with it. If it suits your purposes, you won't be too disappointed to find out that the equipment you purchased last month is much improved this month, and $500 cheaper to boot. Be assured that you still can make the most of what you have. You have to start sometime and you have to start somewhere. Take the risk!

PART 1

The Apparition

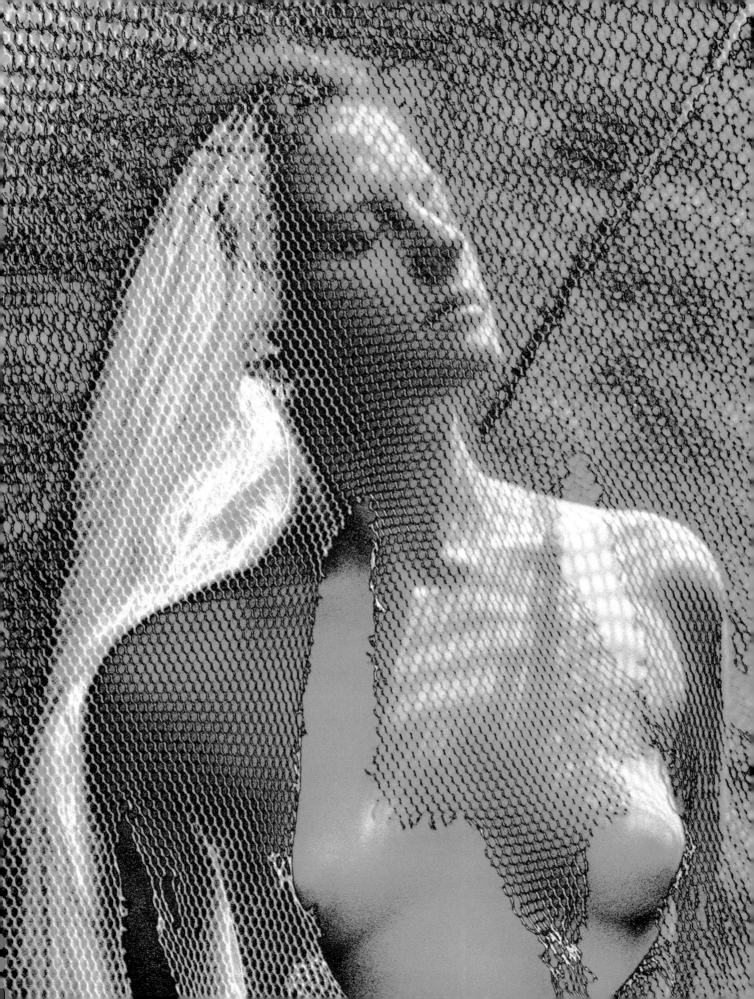

Chapter 1

DIGITAL EQUIPMENT

With so many different brands of digital equipment available, it would be silly to try to list every manufacturer for every class of equipment here. Instead, I have tried to provide you with basic information that will help you understand what each piece of equipment does and how to use it. It should also help you to determine what you need in your digital darkroom—and more importantly, what you do *not* need.

There are several ways for you to keep up-to-date on new products. Catalogs very often provide not only prices, but also fairly detailed descriptions of the newest equipment available. Many magazines and books go into even greater detail about new products and how to use them. Finally, many frequently updated Web sites—which are often either maintained by manufacturers or online versions of periodicals—list new products and discuss them fully. See the Resources section (page 187) for more information.

Julia in Net

COMPUTER PLATFORMS

For home use there are two types of computers: the Apple Macintosh ("Mac") and the IBM-compatible personal computer ("PC"). PCs are manufactured by several companies, while Macs are all made by Apple Computers.

PCs are usually preferred by people who also do a lot of office work or use business-related programs. They are usually a better value for the money, and when loaded with a Microsoft Windows operating system (Windows 95, 98, Millennium, 2000, or NT) they can run Adobe Photoshop and other image editing programs as well as Macs can. If you switch from one system to another, you'll notice that PC keyboard commands are slightly different—where the Mac has a Command key, PCs have a Control key, and where the Mac has an Option key, PCs have an Alt key—but both keyboard commands do the same thing.

As a visual artist, I prefer Macintosh computers because they are easy to use and understand, fast, and reliable. Macs also have a more advanced and better-supported color management system, making them even better platforms for professional graphic artists.

Of course, the ease of working all depends on which system you learn first. If you have been working in a PC environment, it would probably be easier for you to install a Windows version of Adobe Photoshop on a PC than learn a new system with a new set of commands.

PROCESSOR SPEED

Computers can be rated by the speed and design of their central processing units (CPUs). Generally, the faster the speed in megahertz (MHz), the faster the computer responds to commands and the faster it can make complex calculations. However, MHz ratings don't tell the whole story, as some processors are more efficient than others. For example, the G4 chips in Macs perform certain functions in Photoshop far faster than Pentium II or III chips in PCs with similar MHz ratings. When working on large files and applying filters, it is nice to have the most efficient computer you can afford, as an additional investment up front will save you plenty of waiting time over the life of the computer.

RAM

Random Access Memory (RAM) is the fastest kind of memory in terms of access. It is where data is stored temporarily before being called by the CPU and is much faster than the computer's hard drive. The more RAM memory you have, the better, as programs such as Photoshop require at least five times the megabyte storage in RAM relative to the size of the image file you have opened. For example, if you're working on a 20MB file, you should have at least 100MB of RAM available for Photoshop to operate efficiently.

HARD DRIVE

In most cases, a hard drive—also called a hard disk drive—is a non-removable disk that stores data in your computer. It is where your files are kept when they are not loaded into RAM memory or when the computer is shut down. I suggest getting a computer with at least a 4GB hard drive in order to store your images and work efficiently on them. Most computers allow you to install more than one hard drive into your system. Also, programs such as Photoshop often use a hard drive as a virtual RAM space if you don't have enough actual RAM memory. This is slower but does the trick.

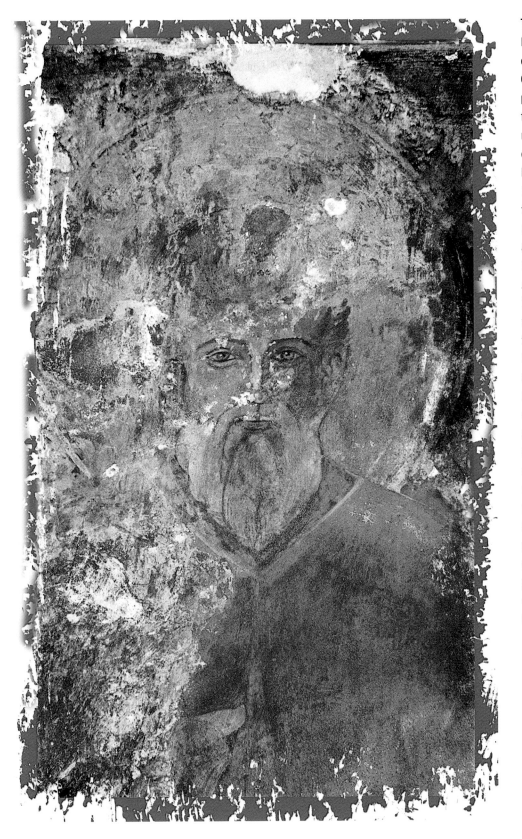

The Apostle

I found this fresco in the oldest church in Rhodes, Greece. There was very poor lighting inside and flash photography was not allowed, so the slide came out flat, with very little contrast or color. I was able to improve the image in Photoshop using several tools, such as Color Balance and Levels. I also used AutoEye software to give it the snap and clarity I wanted, then finished the image off with a broken-edge effect I achieved using Auto FX Photo/Graphic Edges software. The final file size was 10×16 inches and required 28.4MB for storage. A file this large requires at least 145MB of RAM assigned to Photoshop for the program to work efficiently and quickly; otherwise you will be waiting for virtual memory access from the hard drive.

KEYBOARD

Keyboards vary; some are quiet and have action keys that run a script, while others are noisy, with spacing that may not be compatible with the size of your hands. Try out any keyboard before you buy it, and make sure it is of good quality. Since you will spend a lot of time working at your keyboard, you should make sure that it feels right to you.

MONITORS

Purchase the largest monitor you can afford. If you intend to work with photographs and manipulate images, you will need the space to have your palettes (Layers, History, Brushes, etc.) opened on the screen along with your image. More importantly, select a screen that is easy on your eyes, since you will be staring at it for long periods of time. When I bought my equipment, I could not afford the 21-inch monitor I liked, so I purchased a very good 17-inch monitor that was flicker-free, sharp, and had outstanding visual performance. If you have the budget, get two monitors (both are supported on the Mac and on some PCs) and use one to hold all of your tool palettes.

ACCESSORIES

Graphics Tablet

Graphics tablets are used either alone or in conjunction with a mouse. They allow you to use special pressure-sensitive pens for writing, drawing smooth curves, and creating super-fine lines. Using these pens is similar to using a real brush or stylus, because they provide the same type of control. Pressure-sensitive graphics tablets are essential for quality retouching and are heavily supported by Adobe Photoshop. Many types are available, but the ones used most widely by graphic artists are made by Wacom (see the Resources section—page 187—for more information). Be aware, though, that while graphics tablets are very useful, they cannot take the place of a mouse for general use.

Modem

A modem connects your computer to a telephone line so that you can access the Internet. You also need an Internet browser utility such as Netscape or Microsoft Internet Explorer, as well as an Internet Service Provider.

The screen can get very cluttered when you are working with layers and have a few palettes open. The more complex your image is, the worse this problem becomes. One thing you can do when you must work on a smaller screen is click on the "collapse box" located in the top right corner of each palette. This will reduce the palette's size so that all that can be seen is the title bar. Clicking on the same box again will "unroll" the palette.

STORAGE

There are several viable options when it comes to storing digital files for future use:

IOMEGA ZIP DRIVE

If your computer doesn't have an internal Zip drive, you can purchase an external one. Zip disks hold either 200MB or 250MB of information as compared to floppy disks, which hold only 800K to 1.4K. The 250MB Zip drives will read both the old 200MB disks and the new 250MB ones, but the old 200MB Zip drives will not read the new 250MB disks. Zip disks are reasonably priced (about $8 each for 200MB, $20 for 250MB).

IOMEGA JAZ DRIVE

Once you begin making and storing lots of images, you will quickly outgrow your Zip disks. An alternative is to obtain an Iomega Jaz drive, which is available in either 1GB (1024MB) or 2GB sizes. These are an excellent means of temporarily storing large amounts of information. Jaz disks are more expensive than Zip disks (approximately $75 each for 1GB, $120 for 2GB).

Another removable disk option is the Castlewood Orb drive, which stores 2.2GB on each disk (at about $30 per disk).

CD-RW DRIVE

You can now purchase a CD-RW (CD-Rewritable) drive and burn your own CDs. The prices have become very affordable (below $200) and each CD holds up to 700MB of information. Using CDs is perhaps the most archival way of saving digital files at this time, and the higher quality gold and platinum disks should last more than 100 years. You can send them to most service bureaus or professional labs for reproduction, and you can dub music as well as record your images onto CDs. There are two kind of CDs: the "write-once" CD-R and the "rewritable" CD-RW. CD-Rs cost about 60 cents and last the longest, but once you burn information onto them it can't be altered or deleted. CD-RWs cost about $6 each and will only hold data for a dozen years or so, but they can be used in much the same manner as a removable hard drive or Zip disk. You can erase them and reuse them thousands of times. CD-RW drives can read CD-Rs, CD-RWs, and music CDs. They can also write onto CD-R as well as CD-RW media. This means that you can take advantage of the inexpensive CD-Rs for archiving your images or sending them out to a client.

When shopping for a CD-RW drive, check the drive's specifications carefully, as all units are not the same in terms of speed and reliability. On the box, you'll usually see three numbers—for example, 12x/10x/32x. These figures translate as follows: the first number (12x) is the write speed to a CD-R. The second number (10x) is the rewrite speed to a CD-RW (where it must first erase information before writing it). The third number (32x) is the unit's read speed from either a CD-R, CD-RW, or music CD. A CD writer with a write speed of 4x will take about 17 minutes to write 650MB of information. A CD writer with a speed of 8x will take around eight minutes to burn, and a 12x will take between four and six minutes to burn 650MB onto a CD-R. The higher these numbers—that is, the faster the CD-RW drive—the more expensive the equipment will be.

DVD-RAM DRIVE

DVD (Digital Versatile Disk or Digital Video Disk) drives are fairly new to the storage arena and several formats are battling it out to see which will be the most favored to replace the lower capacity CD-R. DVDs can store huge amounts of data—either 2.6GB for single-sided or 5.2GB for double-sided disks. They will also read all CDs, CD-ROMs, CD-Rs, and CD-RWs. Unfortunately, DVD-RAM drives use RW-type disks that don't have the longevity of DVD-Rs. DVD-RAMs can only be read by DVD-RAM drives and cost $30–$40 each. The drives themselves cost $350–$500.

OUTPUT

After you have finished working with your image in the computer, you will want to see it in print form or have it recorded onto film. Service bureaus can make slides or negatives from digital files. They can also make prints from digital files, however, this can be quite expensive and there are often color balance discrepancies between what you want and what they print. It is much more expedient to use your own printer and run proof prints for color and/or final prints in your own studio.

DESKTOP INKJET PRINTERS

There are many affordable desktop printers now available for the digital artist. The most popular models use inkjet printing technology, and there is a wide variety of choices depending on your quality, size, and speed needs.

In a typical four-color inkjet printer, CMYK inks are sprayed out of four nozzles, one for each color (cyan, magenta, yellow, and black). The nozzles spray a dot pattern to produce a print, and the number of distinct dots that a printer can produce in an image determines its *dpi* (dots per inch) rating. The higher the *ppi* (resolution of the scan) and the higher the dpi (resolution of the output or printer), the more dots are sprayed and the sharper the image appears. Epson, Canon, HP, Lexmark, Compaq, and Kodak all offer high resolution, photo-realistic printers for under $300. The only drawback that I have found with most of the smaller, inexpensive inkjet printers such as the Epson Color Stylus 600 and 800 are the ink cartridges. These are relatively small and combine cyan, yellow, and magenta into a single "color" cartridge. This means that if one color runs out, you have to replace the entire cartridge. More expensive printers such as the Canon BJC-8200 use individual ink cartridges for each of their six colors, making them less expensive to use in the long run.

Print size is another issue on the lower end. The largest print you can make with most printers in the sub-$200 category is approximately 8 × 10 inches on a sheet of 8.5 × 11-inch paper. For double that investment, printers such as the Epson Stylus Photo 1270 will deliver 13 × 44-inch prints, and for $1,000 you can choose from several printers that deliver 16.5 × 44-inch prints. For even more money, you can get large-format printers such as the 24-inch Epson 7000 ($4,000) that will print images with an area of up to 23.76 inches at a resolution of 1440 × 720. Epson Stylus Color 777, 780, 880, 890, 980, and 1280 printers all have a resolution of 2800 × 720 dpi. The new PRO 5500, which uses pigmented inks, has a resolution of 2800 × 720 and will print images of up to about 11 × 14 inches.

The top printers feature large, separate ink cartridges, which should last a very long time. They can also handle rather thick coated and uncoated papers and card stock. I have run a large variety of papers through my Epson Color Stylus 3000, from delicate Oriental papers to 140 lb. watercolor paper. In some cases, when the media is very thick, the printer's back loader must be used so that the paper doesn't bend.

To find out the latest details (including cost) on various printers, you should take a look at some of the

many magazines and Web sites that discuss them (see the Resources section—page 187—for more information). I prefer Epson printers because they allow me to print on artist papers with excellent results. In my opinion, their models also feature the best overall color, life span, and versatility. For example, they allow me to use third-party archival inksets in place of the Epson OEM (Original Equipment Manufacturer) inks[1] and obtain a more lightfast reproduction. In addition, the new Epson Stylus Photo 2000P uses extremely lightfast pigmented inks that last up to 200 years.

DYE SUBLIMATION PRINTERS

Inkjets are not the only affordable desktop printers available. Dye sublimation printers (sometimes—more accurately—referred to as thermal dye transfer printers), use a different means of getting the image onto paper. They use a special head containing microscopic elements, each capable of heating the dye on a ribbon that is sandwiched between the head and paper. The dye turns to gas (sublimates) and is absorbed by a special paper made to attract it. Because the dye clouds spread out a bit and sink below the paper surface, these printers produce continuous-tone photo-quality printed images with only 250–600 dpi resolution. The prints look just like traditional photographs on matte or glossy stock. The drawback to this type of printer, however, is that they cost more and have higher contrasts than inkjet printers, plus compatible media is fairly limited in size and surface textures.

A related printer technology is used by the Alps MD-1300 and 5000 printers. These feature micro-dry ink ribbons that are waterproof and fade-resistant and can also be used on a wide variety of papers and media. These printers are also capable of producing dye sublimation prints when loaded with the right ribbons and special media.

1 Seiko Epson Corporation does not recommend using any inks besides their own. If a cartridge made by any company other than Epson should break inside an Epson printer and cause damage, Seiko Epson Corporation will not stand by their warranty.

IRIS PRINTERS

At the high end of the desktop printer scale you'll find the CreoScitex Iris Inkjet Printers. These print with four nozzles containing four inks (cyan, yellow, magenta, and black) which are sprayed using an electron pulse. Dot sizes can be varied when sprayed, depending on the image. (Basically, the printer places small dots in areas with a lot of detail, and larger dots in solid color areas with less detail.) The paper is mounted onto a drum, which spins at a high speed. The print heads then pass across the surface in a linear fashion, finely spraying the inks. These printers are capable of producing extremely fine-grain large prints on various types of artist's papers, and most Iris printers now accept archival inks.

DRYJET PRINTERS

A modified version of the Polaroid DryJet II is now available through One Piece at a Time (OPAATE) of Hopkinton, Massachusetts. The DryJet II 2820 can produce prints that are up to 20×28 inches in size on watercolor paper, rice paper, foil, canvas, and film. The prints are waterproof and the printer itself is three times faster than the Iris printer. One Piece calls the new prints "cerographic" or encaustic giclées.

The printer uses an eight-color system that applies wax-like pigmented inks that look and feel like paint. The system uses dual piezo-electric drop-on-demand heads that print at 600 dpi. It offers a wide color gamut and prints have a display longevity of 26–28 years on Somerset Velvet papers. These are very expensive printers for home use.

FILM RECORDERS

Film recorders allow you to record your digital files onto color negative or slide film. However, they are relatively expensive and outside the means of most digital studios or digital imaging aficionados. Fortunately, most service bureaus have a film recorder, so you can take your digital files to them.

A GOOD BASIC SETUP FOR DIGITAL PHOTOGRAPHERS

This is a good starter setup that should satisfy your needs as you are learning. As you become more proficient at working digitally, you will probably want to augment the equipment on this list by adding more RAM or getting a bigger monitor.

1. COMPUTER: Get a Mac or PC with at least a 266MHz CPU, 128MB of RAM, and 4GB of hard disk space. A fast graphics card is also helpful. You will also need a CD-ROM drive (preferably internal), as well as a Jaz drive to store your images on Jaz disks. If you intend to buy a CD-RW drive, you will not need the Jaz drive.

2. IMAGE EDITING SOFTWARE: While I recommend Adobe Photoshop to manipulate and work on your images, there are many other programs available—such as Adobe Photoshop Elements or PhotoDeluxe—that might not offer as many features but are much more affordable.

3. MONITOR: Get one that is good quality, easy on your eyes, and not too small—at least 15 inches. You will be looking at that screen for many long hours.

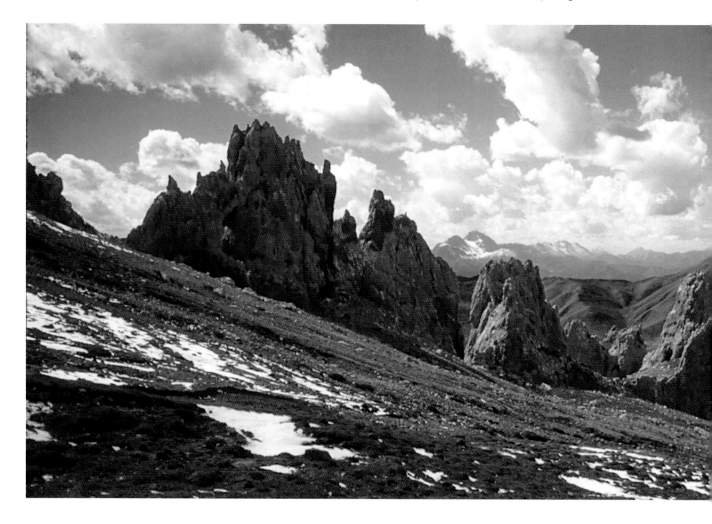

4. **SCANNER** (flatbed or transparency): If you do a lot of restoration of old photos or like to collage or scan reproduction work, a flatbed will do. You can also get a flatbed with a transparency adapter.

If you have a lot of slides or negatives and want first-generation, high-quality scans, a transparency scanner is the answer.

If you really could use both and can't afford two scanners as this time, the U-Max 1200 Powerlook III flatbed scanner is a great choice. It will produce quality scans of reflective art and you can get very good results scanning slides or negatives with the transparency adapter.

5. **PRINTER**: You can now purchase great inexpensive printers, such as the Epson Stylus 770 (print size 8.5 × 11 inches) which costs as little as $100 or the Stylus Photo 1270, which costs about $450. The Stylus 1270 will produce up to 13 × 44-inch prints that will last longer than most other inkjet prints (if you use the recommended Epson papers) and give you great color reproduction.

Mountains in Eastern Tibet
This image was taken with my Hasselblad X-Pan— a true 35mm panoramic camera. I mounted the slide in a panoramic slide holder and laid that down on my U-Max flatbed scanner with the transparency lid attached. As you can see, the result was very good.

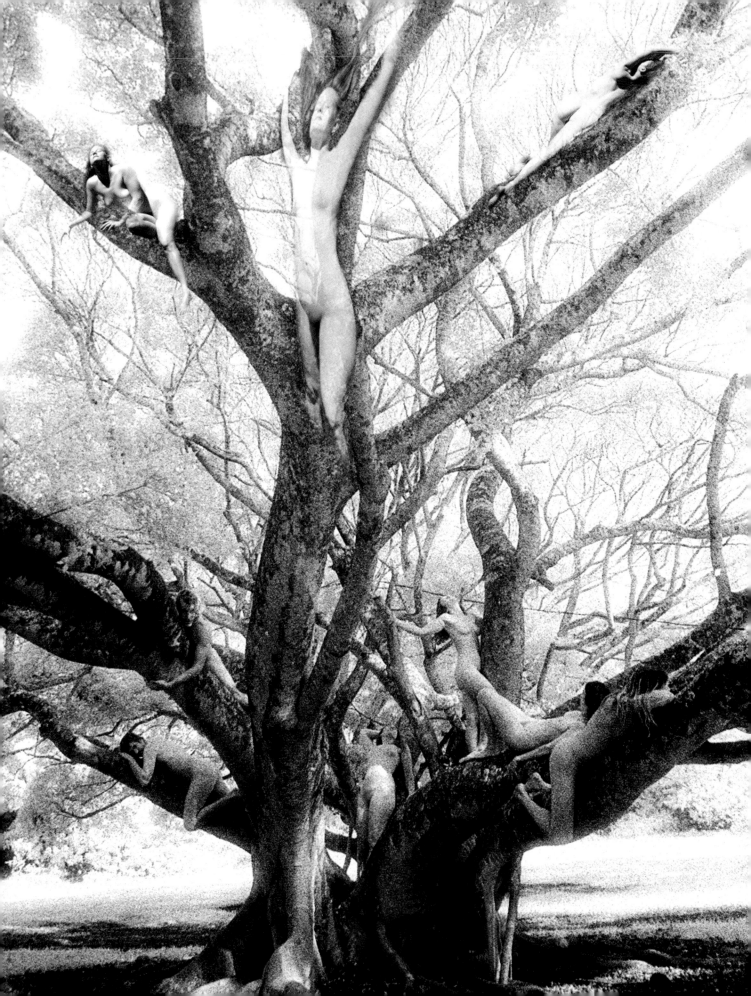

ACQUIRING IMAGES: QUALITY IN = QUALITY OUT

The quality of a print depends on the quality of the scan, and scan quality, in turn, depends on the quality of the original source material, whether it is a printed photograph, a piece of reflective art in another medium, a negative, or a slide.

Starting out with quality slides, negatives, or reflective art and using high-end scanners and printers gives you your best shot at a high-quality reproduction or final print. However, most of us can't always buy the best of everything, so we learn to make compromises . . . and deal with them. In the computer world, there is always more than one way to skin a cat.

The Living Tree

USING SCANNERS TO ACQUIRE IMAGES

- **Reflective Art:** Paintings, photographs, etc.—anything that reflects light
- **Films:** Transparencies (including slides) or negatives
- **Objects:** Anything that is thin and flat enough to fit on the flatbed
- **Collage:** A group of objects and/or pictures assembled on the flatbed

There are three types of scanners: **Flatbed scanners** allow you to scan photographs and flat (reflective) art, and some have built-in transparency adapters for scanning film (transmissive art). **Film scanners** can only be used to scan negative or positive film (transmissive art), while **drum scanners** can be used to scan reflective or transmissive media (usually at higher quality and resolution than other the other types of scanners). Each scanner comes with its own software driver and many come with scanning utilities that allow you to adjust color, contrast, and other image-quality factors.

Key features to compare include the following:

1. OPTICAL RESOLUTION

The amount of detail found in an image varies depending on its resolution, whether the image is viewed on the monitor or in print form. *Image resolution* refers to the horizontal and vertical dimensions of a file plus the number of pixels per inch (ppi). The more pixels per inch, the higher the resolution and the sharper the image. Resolution is only one of the factors that determines how sharp an image will appear or how large it can be printed. You must also know the physical dimensions of the image file. For example, a 200-ppi image scan of a 5 × 7-inch print can produce a 10 × 14-inch print at 100 dpi, but 100 dpi isn't good enough to produce good photo quality.

While flatbed scanners don't have the resolution that dedicated film scanners have, they are able to produce much larger files. That's because flatbed scanners work on larger areas, so that a 300-dpi scan of an 8 × 10-inch image can produce a huge

file, while even a 1000-dpi scan of a 35mm slide on a film scanner will produce a smaller file.

Many manufacturers advertise scanning resolution in dpi. The terms ppi and dpi are often used interchangeably, which causes confusion. Whether you refer to dpi or ppi, input resolution is simply a way of determining how much detail a scanner can capture. The more it sees, the finer the detail in the scan.

2. OPTICAL DENSITY (D-MAX)

A scanner's dynamic range is a measurement of the tonal range that it can capture, from pure white to pure black. Think of it as how deep the scanner can go to gather information from your slide, negative, or hard copy. D-Max ranges from 0.0 D to 4.0 D. A scanner with a high D-Max (3.6) can see a greater amount of tones than a scanner with a D-Max of 3.0 (which is about average), especially in the shadow areas of a slide and the highlight areas of a color negative. The higher the optical density, the better the scanner is able to capture details in shadowed areas. If the manufacturer does not list the optical density, it is probably low. I would not use a scanner with an optical density of below 3.4.

INTERPOLATION

There is a tool in Photoshop that allows you to add false resolution to an image by multiplying pixels. Many scanners also offer this feature. Interpolation doesn't increase actual detail but reduces the effects of pixelization. Let's say you want to take a relatively small file from an 8 × 10-inch photograph scanned at 72 ppi and turn it into a large 11 × 14-inch print. There won't be enough pixels to make it this large without significant stair-stepping (a term that refers to the jagged appearance of the pixels under magnification) on diagonal detail and fuzzy image quality. So you can increase the file size and pixel count in Photoshop and many other programs by using the controls found under Image > Image Size. Even if you boost the new resolution to 300 ppi and sharpen it, the interpolated image will never be as good or as sharp as the original 8 × 10-inch photograph.

Optical resolution and interpolated resolution are another factor to consider. Optical refers to the raw resolution that is produced by the hardware, while the interpolated resolution is a software process that adds pixels to create a higher resolution, but doesn't improve actual detail.

3. BIT DEPTH

Bit depth measures the amount of color information stored in a single pixel. The greater the depth, the wider the range of available colors. For example: A pixel with a bit depth of 1 has two possible values—black or white. If the pixel has a bit depth of 8, it has 256 possible values of gray. Now, when we get to color, we combine three color planes (red, green, and blue) to make a full color image. If each of these color planes (in itself a monochrome file) has up to 256 shades of gray (8 bits), then they combine to form a 24-bit image ($3 \times 8 = 24$); a pixel with a bit depth of 24 can contain one of over 16.7 million color values.

4. BED SIZE

The surface upon which you will scan hard copy and other objects is called the "bed." You should determine how large a scanning surface you will need before purchasing a scanner.

5. SPEED

It used to be that transparency scanners were faster than flatbeds (less area to scan), but that isn't the case any longer. Some of the low-end flatbed scanner can actually scan an 8×10-inch print in under two minutes, while some high-end flatbeds and film scanners take much longer to scan (more detail and color means more processing time). Look for a scanner that only takes a few minutes, at most, to make a high res scan, or you will regret your purchase later.

6. ADAPTERS

Many flatbed scanners offer transparency film adapters for negatives and slide films. Several film scanners accept adapters for APS film or autofeeders for 35mm.

FLATBED SCANNERS

Flatbed scanners scan flat artwork or text. Low-end flatbeds (under $100) deliver from 300–600 dpi resolution and are not capable of recognizing a great range of colors (only 24 bits, or 16 million colors), shades of gray, or significant highlight and shadow detail. Usually, they are only able to scan a small area (up to 8.5×11 inches). Mid-range flatbeds ($200–700) feature 800- to1600-dpi resolution and are able to recognize a larger range of colors (36-bit color, or billions of colors) plus increased shadow and highlight detail. Professional-level flatbeds cost much more but allow you to scan at much higher resolutions (2000 dpi or more) at color depths of 42–48 bits, with much greater sensitivity to details in shadows and highlights. They also have the capability of scanning a larger area—up to 11.7×14 inches. As a bonus, many of the more expensive scanners in the mid-range and pro classes, such as the U-Max 1300 or the Powerlook 1200, have built-in transparency adapters. Adapters generally cost an additional $200–$300 and allow you to scan transparencies and negatives as well as flat artwork and photographs. They don't give you the highest quality resolution for the negatives and transparencies, but choosing a model with a transparency adapter is a good choice if you need both types of scanners and can afford only one.

TRANSPARENCY SCANNERS

Transparency scanners only scan negatives and slides. The high-end models cost more but recognize more information in both the shadows and the highlights, plus they feature higher resolution, better image adjustment controls, and a variety of other tools including some that remove dust and scratches automatically. The real advantage of a film scanner is that the end product is a generation closer to the original. So film scanners are capable of giving the best quality scan with the highest resolutions.

Many of the newer film scanners have adapters for APS film and multiple slides, and some can handle medium format film. Among these are Canon's CanoScan FS2710 (for 35mm as well as APS); Konica's RX-II (for 35mm as well as APS); the Olympus ES-10 (for 35mm as well as APS); Minolta's Dimâge Scan Dual (35mm and APS with an adaptor); Fuji's AS-1

Filmscan-it (APS only); and Nikon's Coolscan III and Super Coolscan LS-2000 (both Nikons scan 35mm films and have APS adapters, which are optional). All of these transparency scanners cost anywhere from $400 to around $1,500, while a few medium format scanners are available for between $2,000 and $3,000.

Scanning APS film is easy. With the Nikon LS-2000, for instance, you simply drop the film cartridge into the scanner and it is automatically loaded; a preview of the images appears on the monitor. With a roll of APS film and an APS adapter, you can scan single negatives that you have selected as well as the entire roll (in what is called a "batch scan").

Canon's CanoScan FS2710 has a "film viewer" into which an APS film cartridge is dropped and hand-wound to the desired frame for scanning. The film viewer is then inserted into the scanner, and the selected frame scanned.

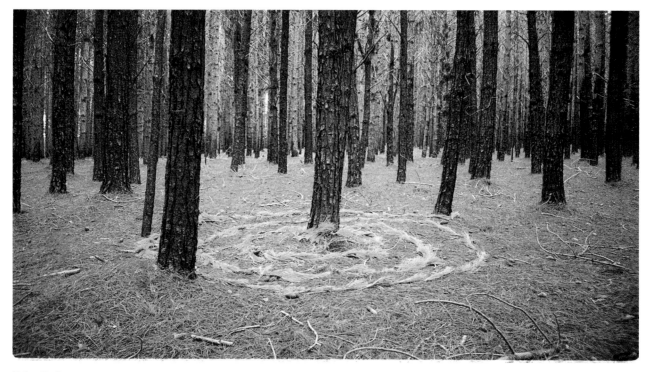

Fairy Circle
This image was taken with a Canon Elph camera on Molokai, Hawaii.

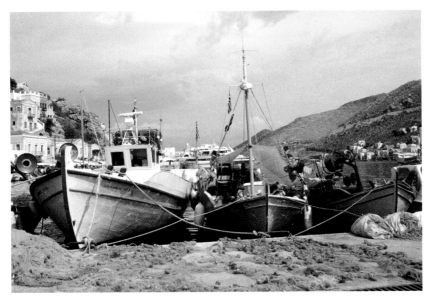

Boats in Symi Harbor, Greece

LEFT: This scan was made with a Nikon Coolscan LS-2000 transparency scanner. I took the original shot with Kodak Ektachrome E100S slide film.

BELOW: This is a digital print of an image transfer I made using a Daylab II slide printer. The texture in this image came from the texture of the paper on which the image transfer was made (Fabriano Artistico Hot Press watercolor paper). The U-Max Powerlook II flatbed scanner actually picked up the texture of the hot-pressed artist's paper!

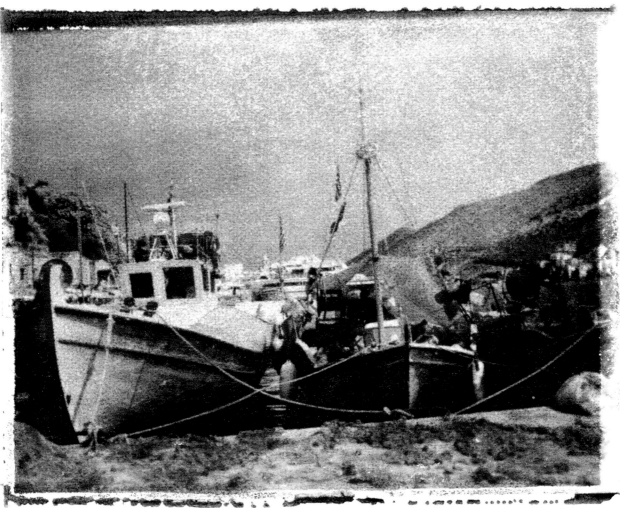

DRUM SCANNERS

Drum scanners are at the high end of all scanners and are usually used by professional color separators or in publishing houses. They usually stand alone with a built-in computer system. Prices range from thousands to hundreds of thousands of dollars. The artwork is attached to a transparent cylinder or drum, which spins very fast and moves the image under the sensor, which is usually a photomultiplier tube (PMT) or laser. Drum scanners were developed mainly for transparencies; you can't scan thick objects such as books or pieces of art that cannot be wrapped around the drum. Most service bureaus offer drum scanning, but prices are relatively high, starting at $50 or more per scan.

CHOOSING YOUR PRINT'S RESOLUTION

The final image size and resolution of a scan are very important. You should decide before scanning what size you will want the final print to be. You can make a large image smaller, but you should avoid scaling images up in size, as this causes fragmentation and a loss of information (pixels), resulting in a fuzzy print.

In order to scale a small image to a larger size while keeping the same ppi, you should check Resample Image in the Image Size dialog box. If this is checked, Photoshop will interpolate the information it needs. If Resample Image is not checked, the image's resolution will drop as Photoshop creates the larger version of it. Keep in mind that the interpolated image will not be as sharp as the original version.

For example, suppose you have a 7 × 10-inch image with a resolution of 200 pixels and a file size of 7.98MB and you decide to change the size to 11 × 16 inches. If the Resample Image box is checked, the resolution will stay at 200 ppi and the file size will change (to 20.5MB) along with the physical size as the software interpolates the needed pixels. The image will also lose sharpness and clarity because of so much interpolation.

If, however, the image size of 7 × 10 inches with a file size of 7.98MB is changed to 11 × 16 inches with the Resample Image box unchecked, the pixel dimension will drop to 125 ppi and the file size will remain

unchanged. This would be a low-resolution file and the image would not be sharp. This is because the original scan of 200 ppi was low-res to begin with. For excellent quality reproduction, an 8 × 10-inch file should be at least 300 ppi in resolution or between 10MB and 18MB in file size.

Another option that appears in the Image Size dialog box is Constrain Proportions. Selecting this option links the width and height of the image together, so that when you change one, the other is automatically changed in proportion. This prevents your image from getting distorted.

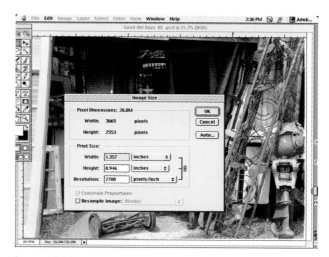

I scanned a 35mm color slide at 2700 ppi using a high-end transparency scanner. After cleaning up the scan, naming the image, and saving it on a Zip disk, I opened the Image Size dialog box and chose the size that I wanted the final image to be by adjusting the resolution. At the bottom of the dialog box, note the two options: Constrain Proportions and Resample Image.

Standing Stones

Using a flatbed scanner, the U-Max Powerlook II, I scanned an 8.7 × 5.8-inch black-and-white photograph at 125 percent using a ppi of 300. The result is an image size of 11.033 inches × 7.64 inches and a file size of 7.07MB. Then I reduced the image size to 10 × 7.64 inches (to fit on a 8.5 × 11-inch piece of paper) with Resample Image unchecked. My image got physically smaller but my file size stayed the same (7.07MB). The pixel resolution increased to 331 ppi.

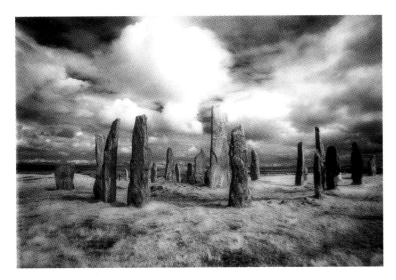

I scanned the same photo (8.7 × 5.8 inches) again, this time at a resolution of 72 ppi. My file size on this rather low-res image was 776K. Then I enlarged the 72-ppi scan to 14 × 9.37 inches with Resample Image selected. Photoshop interpolated the needed pixels to create the larger image and my file size increased from 776K to 1.95MB. This is a very low-res file, but is better than the print at 44.9 ppi without interpolation shown below.

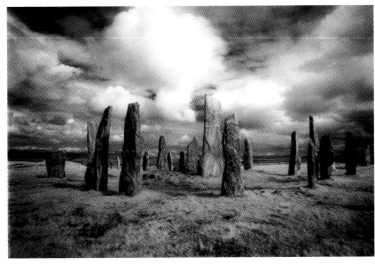

Going back to the original 72-ppi file (with the image size of 8.7 × 5.8 inches), I enlarged the image to 14 × 9.37 inches again—this time without selecting Resample Image. Since Photoshop did not interpolate any information, the resolution dropped to 44.9 ppi. At left is a detail of that enlargement. The image looks very bad because of the poor resolution.

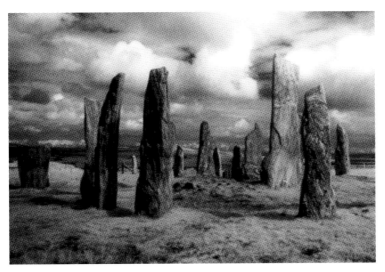

PLUG-IN SCANNING UTILITIES

Although most scanners come with scanner drivers and some form of image adjustment controls, many of these are difficult to learn. However, there are some very good plug-ins that will help you to obtain an excellent print from your digital scan automatically. One of these is the AutoEye plug-in program made by Auto FX. This software enhances your scan and immediately improves the color and detail quality of your image. It is easy to install and to use, and works with all Photoshop plug-in compatible programs.

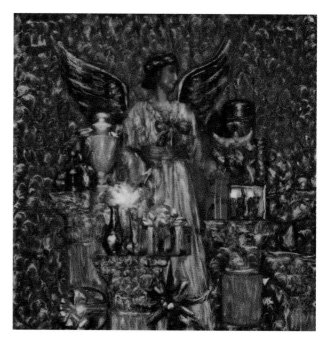

Angel in Cooper's Window

TOP RIGHT: This is a scan of a manipulated Polaroid. Because the image was made on Time-Zero film, it was extremely glossy, making scanning on a flatbed difficult. The light in the scanner causes reflections off of glossy objects lying on the glass and can also cause moire patterns—a circular wave-like pattern that appears when two surfaces (in this case the glass on the scanner bed and the glossy plastic on the Time-Zero-image) misalign or reflect on each other.

RIGHT: The AutoEye software automatically opened the file, balanced the color, and gave the image snap. Later I further adjusted the image in Photoshop.

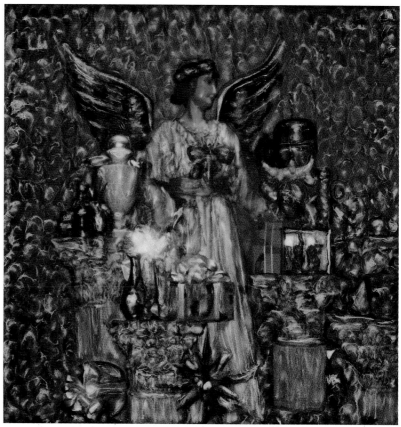

ACQUIRING IMAGES WITHOUT SCANNING

Even if you do not own a scanner at this time, you can still create great images. One option is to have images scanned at a photo store or service bureau and placed on photo CDs or picture CDs. Photo CDs can provide you with much higher-resolution scans (up to 70MB files for Pro Photo CDs at only $8–$10 per scan). Picture CDs only offer low-resolution scans (4.5MB), but these scans can be used to supply the elements for a work in progress. Almost all new computers have CD-ROM drives built in, and CDs last a long time.

Another way to acquire images without a scanner is to shoot with a digital camera. One advantage of working this way is that you can immediately download images into your computer, thus bypassing film

costs and scanner expenses altogether. However, even fairly expensive digital cameras have poor resolution compared to film, and the best 3.3–4 megapixel cameras are very expensive ($1,000 to $5,000).

If you do not need to make large, sharp prints and do intend to handcolor, a sub-$500 digital camera might suit your purposes. Otherwise, there are ways to scale up images shot with a good digital camera so that they appear sharper than they are. One way is to use Photoshop's interpolation tool. Another is to save the image as a compressed fractal file using Altamira's Genuine Fractals plug-in. You can then use the software to scale the image to a larger size without significant distortion.

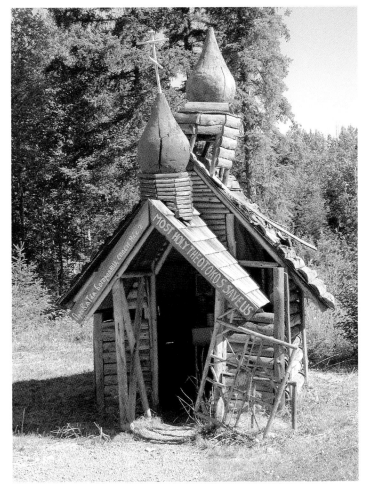

Little Alaskan Church
This image was captured using a Nikon Coolpix 990.
Courtesy of Charles Bowers.

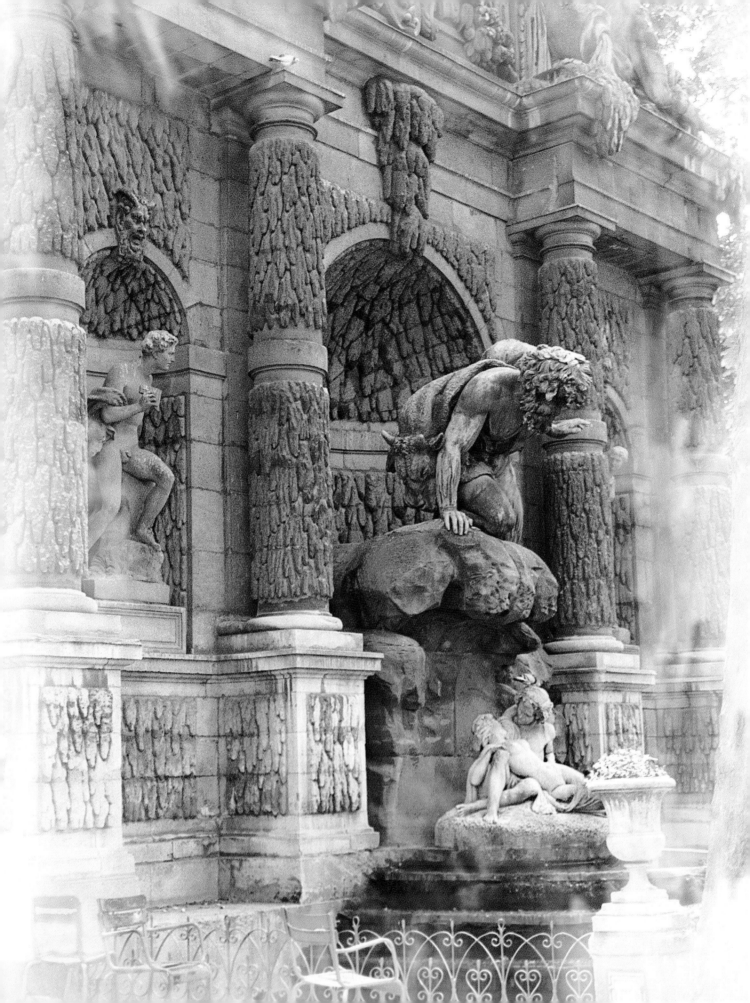

COLOR MANAGEMENT

The art of color has become the science of color in the digital world, and it is just as important to understand how color works on the computer as it is to understand how it works in photography. Digital technology has opened up the door to many new types of print media and countless ways for photographers and graphic artists to express themselves. There are now dozens of digital printers, hundreds of combinations of papers and inks, and a wide variety of other digital tools that can be used to make unique and beautiful prints for display, artists' portfolios, or four-color reproductions. Digital imaging software has made it easy for just about anyone to manipulate photographs beyond the limits of master darkroom technicians and printers. As a result, we live in a world that has been flooded by "push-button" art and photo collages. But real artists stand out from this crowd because they take time to master the new digital tools and use them to express their inner vision.

The Lovers, Luxembourg Gardens, France

If you're one of these artists, or hope to be, you'll soon learn that one of the most difficult areas to master is color—how it is produced, balanced, mixed, and used to enhance the artist's vision. In the digital world, color can easily be manipulated without making a mess in the darkroom or on a canvas, but there's still an art involved when it comes to producing prints with accurate colors, contrast, and overall tonality. It's rarely as simple as pushing the print button and having your print come out the way it appeared on your monitor. Even for Photoshop gurus, getting good color out of a digital printer usually involves a trial and error process that is time-consuming and costly. And every time we change papers or inks we have to go through the routine again. In some geographic areas, a shift in humidity can noticeably affect color balance as well.

Why, in this digital world that makes so many other processes easier, is it so hard to get accurate colors out of our printers? There are a number of reasons, so let's take a look at some of the variables that we have to deal with when working with digital color, and then at some of the solutions that should make it easier to get a great first print (or even artist's proof) from your system.

In a typical digital workflow, there are several devices that capture, translate, and eventually output color. First, there are the input devices such as digital cameras and scanners. These usually capture the details and colors in a scene (or print) using a CCD (charge-coupled device) sensor, and that analog information is converted to digital data by a device called an analog-to-digital converter (A/D converter). However, the color sensitivity of CCDs vary, and there are even some visible colors that CCD sensors ignore. The digital data is then processed mathematically into RGB (Red, Green, and Blue) channel data by a microprocessor in the camera or processing software in the computer. A/D converters also have different ways of translating color, with some being more accurate than others. Digital cameras vary in their ability to judge proper white balance, and flatbed and film scanners also judge an image prior to scanning. Left on automatic, all of

these devices will probably add a bit of cyan to a scene with a model in a red dress standing against a red barn. As a rule, every input device "sees" color differently, and that also applies to every output device as well—including color monitors, printers, and film recorders.

Fortunately, we can map out the ways a digital device captures or reproduces color if we have the proper tools such as a colorimeter or spectrophotometer. These tools can be used to determine the color gamut of a device (often referred to as a device's color space, but this term is less accurate) and to generate color profiles. A color gamut refers to the entire range of colors that an image-capture or output device is capable of recognizing or reproducing. A color profile of a device can be attached to an image file and used to help keep colors accurate throughout a color-managed workflow. Because the devices mentioned above are very expensive and require expertise to operate, we usually rely on someone else to generate color gamut maps and profiles for us. These are often included in the software that ships with scanners and printers. Monitor profiles are a bit easier to generate, and we'll cover that process later.

As mentioned, input and output devices have individual color gamuts, and therefore, different color profiles. Higher-end scanners have a wider gamut than low-end scanners, which means they can recognize more colors, especially in highlight and shadow areas. The same generally holds true for higher-priced digital cameras, six-color inkjet printers, and expensive monitors. However, the color gamut of even the best monitor is usually smaller than the color gamut of a scanner, digital camera, or printer. In addition, an individual monitor's color gamut can vary based on room lighting, the age of the monitor, whether it is warmed up or not, and the conversion algorithms used by various imaging programs.

Let's imagine that your computer monitor has been optimized so that it reproduces the colors from your scanner as closely as possible, with only a few colors falling outside its gamut. Now it's time to manipulate

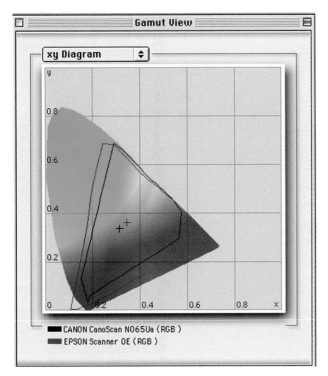

Color gamut maps of two flatbed scanners.

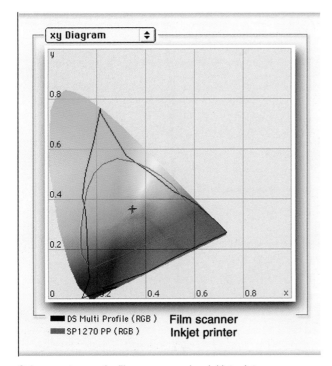

Color gamut map of a film scanner and an inkjet printer.

your images, make your collages, adjust contrast, color, saturation, and sharpness. Once the image creation and manipulation phase is completed, then your artwork is ready for the next great challenge—sending it to the printer, film recorder, or even a digital projector.

I call it a challenge because if you've gotten to this point before, you know that it's usually a hit-or-miss proposition as to whether your print output will match what you see on your monitor. That's because the printing process introduces a whole new set of variables that affect and alter color from one print to the next. Among these are the paper and inks used, the resolution of the printer, and the adjustments you make to the color and contrast-slider controls in the printer driver. Printer driver software converts the RGB data sent to it from the imaging software into CMYK data that is used by the printer engine to generate spots of ink on the paper. Again, problems arise when some of the colors being sent to the printer are outside of its color gamut, or they are interpreted differently than those appearing on the monitor.

Even if we bypassed the monitor altogether and sent the image file directly from the scanner to the printer (possible with many scanners these days), we run into the next problem. To date, there hasn't been a printer manufactured that has a color gamut as wide as the gamut of a decent scanner, so a print made from a scan will always appear slightly different from the original. We can learn to work around these limitations by either using trial and error to fine-tune our print output, or color managing our entire workflow. The trial and error method may work if you're patient, know a good deal about color, and are able to compensate for color casts in a print. But otherwise it is expensive and time-consuming to run off multiple prints in order to determine the correct settings, which wind up changing each time you use a new paper and ink combination, or even if humidity levels vary.

A color-managed system, on the other hand, can enable an artist to produce an extremely accurate match between a monitor and digital print on the very first try. But how do you get a color-managed system,

especially if you don't have the time or the desire to become a color scientist? It used to be that color management was far too complex a procedure for anyone but professional printers and service bureaus to implement. But that is no longer the case, thanks to industry standards adopted by the International Color Consortium (ICC) in 1993 and a variety of low-cost solutions based on those standards. Under these standards, the color gamut of every device that captures, displays, or outputs color can be mapped into an ICC profile. These profiles can be attached to a file at capture, or assigned to a file when displayed or printed. Within the Macintosh or PC-Windows (98 or higher) operating system, there is a color

management system (CMS) that keeps track of these profiles as they move between programs. On the Mac, the CMS is called ColorSync; on the PC it is called ICM. (Since ICM 2.0 in Windows 98 Second Edition, the color engine within the Windows environment has been based on the same engine found on the Mac, helping to ensure color accuracy across platforms).

If you use Adobe Photoshop 5.5 or 6.0, you've already been introduced to some of the aspects of color management. This program is one of the few that is fully compatible with ICC profiles. But you need to know a few things about how to use the color management tools within the program in order to get the best results.

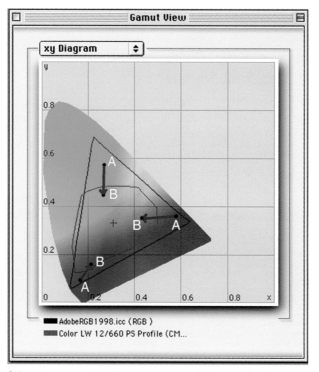

Color gamut map of a film scanner and an inkjet printer with arrows showing how color management converts the colors of one to the other.

SETTING UP YOUR SYSTEM

A full tutorial on color management is included with Photoshop, and further information can be found at the Web sites listed at the end of this chapter. But if you don't have the time to read these, follow these instructions on how to set up your system so that you get consistent results using the profiles and color management tools that you already have.

1. CALIBRATE YOUR MONITOR

One of the easiest steps in the color management process is a visual calibration of your monitor that can be used to generate an ICC profile. Adobe Photoshop ships with a control panel "wizard" that works well on both Mac and PC computers, and all you have to do is follow the basic step-by-step procedure in order to visually calibrate the monitor. Once you have saved a monitor profile, you open the ColorSync control panel (on the Mac) or the Display control panel (on a Windows-based PC), and select the new profile as the monitor profile (on the PC, choose Display/settings/advanced/color management). Now, any program that uses color management will automatically use this monitor profile to convert colors for viewing. A visual calibration tool such as this will work for most artists, however, you can improve the accuracy of the profile by using a colorimeter to measure the actual color phosphors on your monitor. These devices, with appropriate calibration software, can be purchased for as low as $500 from several manufacturers.

2. SETTING UP COLOR PREFERENCES IN PHOTOSHOP 6.0

The variety of color-setting choices within Photoshop 6.0 is quite overwhelming, even for an expert. But the following settings work well if your output is being sent to an inkjet or dye sublimation printer. If your artwork is being sent out for print reproduction (magazines, books, or posters) you should try to get a printer profile from your color separator as well as advice on optimized CMYK settings.

In Photoshop, open the Color Settings dialog box (Edit > Color Settings) and select Adobe RGB

(1998) as the working RGB color space. This color space delivers better results when output is being sent to an inkjet printer that has color management capability, such as all of the Epson printers, most Canon printers, and a variety of others. (If your

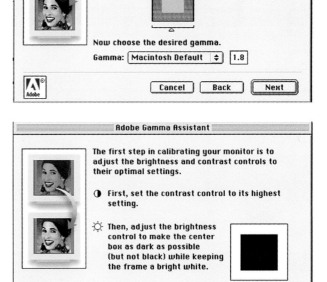

Adobe Gamma control windows showing visual calibration procedures.

inkjet printer doesn't ship with color profiles, you might be better off at this stage selecting the monitor profile you generated in step 1 as your working color space.) If your artwork is destined for display only on the Internet, choose the sRGB color space. But don't use sRGB for color print work, since it is a narrower gamut space that clips many colors, especially deep purple and blue.

All of the other choices in this first part of the Color Settings dialog box can be left at the default settings for now, including the gray space setting. In most cases, you won't be printing grayscale images even if your printer is loaded with quad-black inks that require you to work in RGB color mode.

Under Color Management Policies, choose Convert to Working RGB, and under Conversion Options, check the Black Point Compensation and Use Dither settings. If you don't select Convert to Working RGB, your monitor colors won't match your print output if you open a file that has already been tagged with a profile from another program or from a scanner. Now, if a file has no profile attached to it when you open it, a Missing Profile window will pop up. Choose the Assign Working RGB option if you don't have specific profile for the image (most images from digital cameras don't include a profile). If you know what the profile should be (you may have a scanner profile, for example, or have been given an accurate camera profile) choose Assign Profile and check Convert to Working RGB. All other settings should match those in the illustration.

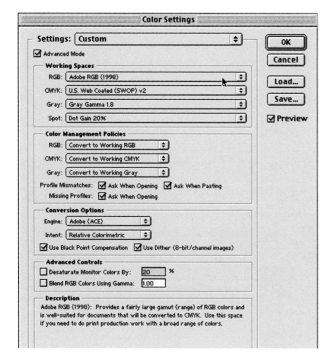

ABOVE: Color Settings dialog box in Photoshop 6.0.
RIGHT: Epson Print dialog box.

3. PRINTER SETTINGS

Now that we have Photoshop squared away as far as color settings are concerned, it's time for the final challenge—the printer! Here's where it gets really tricky, especially if you work on both Mac and PC platforms. The optimum settings on one platform aren't the same on the other, even though the color management engines (ColorSync on the Mac and ICM on the PC) used by the operating systems are very similar. I'll concentrate on the Mac side and point out some of the PC differences along the way. I'll also assume that most of you are using an Epson desktop printer since these currently have sophisticated controls for color management, along with excellent print quality and longer print-display life spans. I'm sure that by the time you read this, most other printer brands will ship with similar driver controls.

When you're ready to send your artwork to the printer, choose File > Print (Command-P) and make these choices in the Print dialog box. First select the paper you are using, then choose Custom/Advanced in the mode window. This will take you to a second window where you can choose your printer resolution and dithering settings (which vary depending on the paper used and content of your image).

The next steps are perhaps the most important of all. In the Color Management window, click on the first setting Color Adjustment and then choose No Color Adjustment in the mode setting. Do not choose the ColorSync option unless you are using a version of Photoshop that is older than 6.0! On a PC, you've got to go through several steps to get to the Color Management dialog box (try Print > Setup > Properties > Custom > Advanced). Once you're there, select the ICM setting instead of the Color Adjustment setting (I told you they behaved differently, didn't I?). Now click OK and go back to the first printer dialog box on both Mac and PC platforms. Under Source Space choose Document: Adobe RGB (1998) (unless you want your printer to mimic the output from a CMYK proofing device). Next, under Print Space, choose the profile for the paper you are using, and then select either Perceptual or Relative Colormetric under Intent. Adobe suggests using the Relative Colormetric intent for photos, but I prefer the Perceptual setting because it produces more accurate shades of blue.

You may be wondering why I suggested turning off the ColorSync option when using Photoshop 6.0 on the Mac. That's because the Mac version 6.0 actually

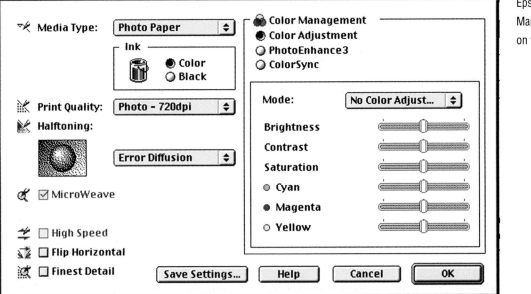

Epson printer Color Management window on the Mac.

performs a color conversion before sending the color data to the printer driver. If the ColorSync option is still on, the printer driver will take that data and convert it again with disastrous results (I call it double-sync-jeopardy).

Another major concern, especially for fine art printers, is what to do if you use a fine art paper or ink set made by another manufacturer. Generally, these don't ship with profiles (and the paper profiles provided by Epson and other printer manufacturers assume you are using their inks). Your best bet is to experiment with some of the profiles that are listed in hopes of finding one that delivers decent results with your paper-and-ink combination. If you can't find one, check with the paper or ink manufacturer to see if they have any profiles for your combination. If all else fails, check the service bureaus in your area to see if they can generate a color profile for you (for a fee, of course). If they can, they will supply you with a test file and directions for printing it with your paper-and-ink combination. You bring them the output, and they analyze it and give you an ICC profile to use with Photoshop. Finally, you could spend about $10,000 on your own spectrophotometer and software that will allow you to generate your own profiles for any combination. (GretagMacbeth's SpectroScan table with its ProfileMaker software is a fast and accurate choice if you have the money).

The above settings and procedures should allow you to get a first print that looks darn close to what you see on your monitor. However, generic profiles provided by the printer manufacturer don't take into account the individual variations that occur from printer to printer, and from one batch of ink (or paper) to another. So you may have to do some fine tweaking after you see what the first print looks like (or check with the manufacturer to see if they have updated profiles). For fine tweaking, hold the print up next to the image on the monitor and open the Curves dialog box (or even the Variations dialog box).

Adjust the Curves (or Variations) to make the image on the monitor match the print as closely as possible. When you've done so, open the Curves dialog box once more. Now, adjust the Curves so that the image on the screen looks like you wanted it to in the first place, and save these curve adjustments (as an .acv file) in the Photoshop folder. Now, go back two steps in the History palette to the image you last sent to the printer (and probably the last one you saved). Open the Curves dialog box and load the correction curves you made. Then print again and you should hit the target. Don't save the file with these curve adjustments even if the print is perfect. By loading the curves just prior to printing, you don't have to save the image with the correction curves that are specific to your temporary paper/ink combination. Instead, you save an image the way you want it to appear, and then create and load curve adjustments based on new paper stock or inks just prior to printing. That way, if there's a change in paper and inks that affects the output, you can generate a new curve and apply it to the saved image.

For further information on color management, read the online tutorial that ships with Photoshop, and then check out some of these sites and publications:

- **www.agfa.com:** Agfa sells several publications that describe color management and ICC profiles, such as *The Secrets of Color Management, An Introduction to Digital Color Prepress,* and *Color Proofing Guide.*
- **www.apple.com:** Check this site for publications on color management and using ColorSync.
- **www.adobe.com:** Check this site for publications on using the color management tools in Photoshop. Even if you don't use Photoshop, this information is very helpful.
- **www.kodak.com:** Kodak has an online digital school that has several lessons on color management.
- **www.popphoto.com:** *Popular Photography's* site offers free ICC profiles for digital cameras and a variety of fine art papers and inks.

Here is an image printed without color adjustment and with ColorSync off. Intent was set to Relative Colorimetric.

This is the same image with ColorSync on.

Chapter 4

PAPERS

Inkjet printers are causing enormous changes in the worlds of both photographic and digital printmakers. For years, photographers have searched for different photographic paper surfaces to change the look and feel of their images. Until very recently, only a few manufacturers made photographic papers with interesting textured surfaces for the creative photographic printmaker or for the photographer who wished to hand-color. As the popularity of digital printmaking grows, artists are scrambling to find papers that are durable and archival, and on which the inks will not have an adverse effect.

Both the inks and the papers used are contributing factors to a print's degree of quality and permanence. Just about any artist's paper can physically pass through the newer desktop inkjet printers. However, just because the printers accept these papers and print images on their surfaces doesn't mean that the prints will be lightfast and render good color and detail. Even when pH-balanced acid-free papers are used, there are potential problems. Will the paper's properties be compatible with the inks used? Will the interaction between the inks and the paper fibers, pulp, sizing, or pH balance lead to the deterioration of the paper and the image?

These questions are being asked throughout the industry, and in many cases don't have simple answers.

Rice Paddies in Sichuan, China
This image was printed on Arches Cold Press paper on an Epson 3000 printer. I thought the texture of the cold-pressed paper gave a nice tactile quality to the surface of the print and added to the rough structure of the rice paddies. Later, I handcolored it using Conté pastel pencils.

ARTIST'S PAPERS

Painters and artists have always explored the vast world of paper options, but until recently, photographers have been limited to a few types of papers and surfaces. Even platinum printers are limited to just a few paper surfaces on which to coat their light-sensitive platinum and palladium chemistries. As a result, most photographers have little knowledge of, or interest in, artist's papers. However, with the advent of Polaroid transfers, coating with liquid emulsions, photo transfers, and inkjet printmaking, this is changing rapidly. The limitations of the silver gelatin photographic paper surfaces no longer need limit a photographer's creativity. Photographers are discovering that they can transfer or print images onto a multitude of surfaces and textured papers, selecting from many different colors and weights. They can even create or enhance moods and feelings through their choice of paper.

Artist's papers are made for printmaking, drawing, watercolor, and pastels. Many are decorative. Oriental papers are used for collage, chine collé, Japanese sumi painting, block and intaglio printing, and book making.

Watercolor paper comes in three surface textures: hot-pressed, cold-pressed, and rough. The color and thickness (or weight) varies, as does the sizing—which can be heavy, medium, light, or nonexistent (this is called *waterleaf*). They are made for innumerable purposes but until recently have mostly been used by non-digital printmakers.

Many variables can affect the quality of a final print. Some papers tend to change the color of the digital image when the inks react with the paper fibers or the sizing. Other factors include how deep the inks are absorbed into the paper and how heavily the inks are sprayed onto the surface. Very often, the colors in the image as they appear on a computer monitor do not translate to the printed page with perfect accuracy. Some paper surfaces absorb too much of the ink and tend to make the print look flat and muted in color, resulting in blocked-up shadows and washed-out highlights. Some paper surfaces are too heavily sized and the ink cannot penetrate the surface; it sits on top of

TIP

To run tissue-thin paper through a printer, attach it to a heavier substrate with removable tape or removable glue and run them through together. Make sure the corners of the pieces of paper that are entering the printer first are perfectly attached and flat to avoid lifting and jamming. Also, be sure to peel the print away from the heavier substrate as soon as it is finished.

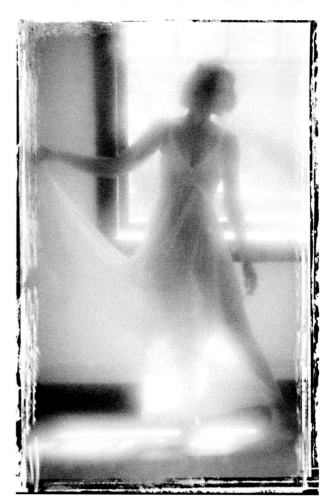

Linda Dancing
This was printed on Bienfang hot-pressed charcoal paper on an Epson 3000 printer and later slightly enhanced with Conté pastel pencils. I chose a smooth-surfaced paper in order to emphasize the fluidity of the dance movement.

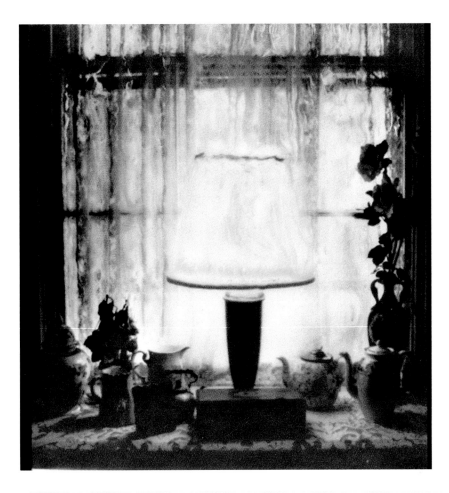

Light in the Window

This image was printed on lightweight Daphne paper (handmade in Nepal). I used this translucent, warm-toned paper to present the feeling of warmth and light. Lightweight is tricky to use because it is so thin. The paper also comes in medium and heavyweight but they are not as translucent as the lightweight.

TIP

There can be a great deal of trial and error on the way to finding a paper-and-ink combination that suits your style. To save paper and ink, use the marquee tool to select a small piece of the image that you plan to print. Then cut out 4 × 4-inch test patches of an assortment of papers and match up the selection to the same dimensions. When printing, make sure that the selection area is checked in your printer's dialog box so that the entire image doesn't get sent to print. Next, also in the printer's dialog box, select the media choice and color space (see chapter 3 for more information) that work best for your printer as well as for your paper- and-ink combination. Now you can use the test patches to print out samples of different color and resolution settings until you find the one that looks the best. Turn off the selection area on your print driver and you're ready to go.

I usually work in Photoshop 6.0 and print to an Epson Stylus Color 3000 printer loaded with either Lyson inks or Lumijet's Platinum ink set. When using artist's paper (as opposed to coated inkjet papers), I used to select "plain paper" in the printer's dialog box, but this placed too much ink on the paper. Eventually, I tried the "Photo Quality Ink Jet Paper" setting. With this setting, I obtained far better color and better distribution of the inks. It was easy to experiment with the settings because I was only printing 4 × 4-inch patches.

Remember, printers, like cameras, can't think; they do what you tell them. Select a few papers that you wish to print on and run tests with various settings.

Masked Nude
I printed this image on Bienfang Rough Watercolor paper on an Epson 3000. The rough texture of the paper accentuates the image's texture.

the printed page, takes too long to dry, and smears easily. Some papers do not allow the inks to be absorbed or dry fast enough; when the printer ink nozzles are rapidly pulsating the inks upon the paper surface, there is blending and smearing from line to line. Other paper surfaces are too soft and inks spread out (this phenomenon is often called *wicking*), softening the details too much and causing *dot gain,* which gives a grainy, speckled look to the image. On some printers, thick papers cannot make the necessary U-turn on the rollers without getting stuck (these

papers can therefore only be used on printers with straight-through paper paths).

Even though some printers can make an image on just about any paper, the fine-tuning of the image—much like the fine printmaking techniques that are executed in the darkroom—requires you to have knowledge about paper in order to perfect and understand the process and materials. With this knowledge comes the ability to produce a colorful, archival print on a textured surface—a real leap forward for photography.

PAPER TERMS

Two excellent resources for further information about paper are the Daniel Smith catalog and Inkjetart.com (see Resources section, page 187).

ACID-FREE: A term applied to papers and materials containing no acid or having their acid content neutralized to a pH of 6.5–7.

ACIDITY: A measure of how acidic a material is. A neutral or acid-free paper (desired in most cases) can become acidic from poor storage methods and environmental conditions, as well by interaction with chemicals found in paints, glues, and inks.

ARCHIVAL: A term referring to a material's ability to maintain its physical properties and appearance (i.e., color, shape, detail) over an extended period of time; its resistance to aging or deteriorating.

CELLULOSE: The chief constituent of the cell walls of plants; a main ingredient of paper.

GRAMS PER SQUARE METER (G/M^2): Metric measure of paper, which indicates the weight of 1 square meter (39.37 inches) of paper, regardless of the sheet size. Metric weighing is not popular in the United States, but it does standardize the weight of one square meter of paper. Many European papers list their weight in g/m^2 instead of lbs.

LIGHTFASTNESS: Ability of a material to resist fading from exposure to the light.

LIGNIN: An ingredient of paper that comes from the cell walls of plants. If left in the pulp it can contribute to chemical degradation of the paper.

PAPER WEIGHT: A ream (500 sheets) of paper is weighed to determine the paper's basis weight. This works well with types of paper that have a standard size, such as Text, Bond, or Cover. However, printmaking and watercolor papers come in various sheet sizes, making it hard to determine their basis weight.

For example, let's say a ream of 22 × 30-inch Arches watercolor paper weighs 140 pounds. A ream of paper of the exact same thickness that measures 25.75 × 40 inches will weigh more because of its larger size, although each sheet will feel and look the same "weight." Therefore the metric approach (grams per square meter or g/m^2) is a more exact way to calculate the weight of watercolor or printmaking papers because it weighs the paper by the square meter. *See* Grams per square meter.

pH: A value that measures the acidity of a chemical solution on a scale of 0 (more acidic) to 14 (more alkaline); 7 is neutral. Papers with a pH of 6.5 to 7.5 are generally considered to be neutral.

PLY: This term denotes a single web of paper. Machine-made paper can be used by itself, as in 1-ply paper, or laminated onto one or more additional webs as it is run through the machine. One-ply paper then becomes 2-ply paper (2 webs), 4-ply paper (4 webs), etc. The higher the ply number, the thicker and stronger the paper.

PULP: A wet mixture of cellulose and plant fibers (such as cotton, linen, and wood) that is used to make paper.

SIZING: A material such as glue, rosin, gelatin, or starch that is added to paper to make it more resistant to liquid. This can be accomplished in three ways:
- *Internal:* The sizing is added to the paper pulp in a vat during a beating and mixing stage.
- *Surface:* The sizing is applied to the formed sheet of paper. This can be done by painting or brushing the sizing onto the surface of the sheet.
- *Tub:* The dry, formed sheet of paper is passed through a vat or a tub of sizing, then re-dried. Tub sizing creates more deeply sized paper. Most watercolor papers are tub-sized, and this allows artists to work and rework the paper surface without damaging the fibers.

DETERMINING THE "FRONT" SIDE

Some artist's papers, such as watercolor papers, have a "front" side, especially if they have been surface-sized. Generally the front is the smoother, harder side of the paper. When you take out a large sheet of artist paper to cut down to size, hold it up to the light and find the logo or watermark. If you can read it normally (left to right), that is the front side.

Some tub-sized papers do not have a front side, but there is generally a softer side and a harder side as a result of running through the press. In this case, you can print on whichever side you choose. However, if the logo or the watermark is visible on the sheet of paper being used, it is more professional to have a legible watermark on the print. Many print collectors are discriminating enough to look for the watermark on the paper; this assures them that the print is on good-quality paper and increases the value of the print.

TIP
I make a habit of marking the back side of the paper by drawing an X with a pencil in at least the four quarters. This way, when I cut the paper to size for the printer, the X or a part of it will be visible and I know that is the back of the paper. This can be handy when working with certain papers.

CHARACTERISTICS OF ARTIST'S PAPERS

Artist's papers must have certain qualities in order to accept the ink from an inkjet printer and render good results (ie., good color and sharp details in the print). Here are the characteristics and features to consider:

Absorbency
- The pulp must have just the right amount of sizing, neither too much nor too little.
- The paper's surface should be able to accept the ink that is quickly pulsed through the inkjet nozzles. The ink should neither go too deeply into the paper nor sit on top of it.
- The inks must dry instantly so that the next line of sprayed ink going across the paper's surface does not

smear the one created before it. With thermal inkjet technologies used in Canon, HP, Lexmark, and a variety of other printers, the ink is heated to a boiling point and then shot through the printer nozzle. This means that the ink is in liquid form when it hits the paper surface and can be absorbed by it. Other printers, such as the Epsons, use Micro-Piezo technology that forcibly ejects inks out the nozzles without having to heat them. These inks dry faster, usually by the time the paper is ejected from the printer.

Compatibility
- The pulp must be made so that the inks and paper do not have an adverse chemical reaction and create acids or other harmful by-products that will promote deterioration or discoloration.

Neutral pH Balance
- The paper should be pH-balanced and acid-free. However, even if it is, it may react adversely with some inks. This is why tests are constantly under-way at places like Wilhelm Imaging Research.

Weight
- In order for the paper to go through the rollers and make the "U-turn" without jamming, its weight (or thickness) should be rated somewhere between 20 lbs. and 140 lbs. Anything thicker requires extra steps in the loading procedure. For some printers, the use of thick paper is not possible at all, while others can handle up to 300-lb. papers.

Color
- The color of the paper should be as close to pure white as possible so as not to change the colors of the whites in the image you are printing, and also to enhance the color range of the inks. Colored papers can be used, but will result in prints with colors that are different from what you see on your monitor, since monitors expect a white background. For example, a black ink printed over a yellow paper will sometimes cast a green color in the printed image.

Surface Texture

- *Hot-Pressed Papers:* The smoother the paper, the more photographic details (including defects) will be perceived.
- *Cold-Pressed Papers:* The slight texture they add varies according to the paper manufacturer. Sometimes this texture can be a plus, while at other times, it is a drawback. For example, a textured surface can camouflage a file that is slightly out of focus, but if used on an image of a nude, can give skin the appearance of cellulite.
- *Rough Papers:* The surface of these papers has a great deal of texture and will sometimes break up the details in the image. This paper can be useful for printing architectural images, allowing you to add extra texture to a stucco facade and thereby give your print an extra dimension that was perhaps missing in the original shot.

Permanence

- Many factors affect the image permanence of inkjet prints. Among these are ink chemistries, paper pH,

and display conditions. Most inkjet printers are sold with non-archival dye-based inks. The prints they produce are boldly colored, but will fade or deteriorate in a few years depending on the stock on which they are printed. For designers and graphic artists who are simply concerned with producing great color and sharp detail in order to sell an image for an ad or magazine article, this is not a problem. Their print is not the final image—it will be reproduced. However, for the artist or photographer whose final work is destined for display, this is a major issue.

Dye-based inks are generally relatively unstable and will fade when exposed to bright lights. However, several archival dye-based inksets are available (see chapter 5). Pigment-based inks are made from organic solids and other materials that resist fading. The drawback is that they have a smaller color gamut and a slightly washed-out appearance.

Another problem is the pH balance in the papers. Although a higher pH is good for paper, it can have an adverse reaction with the inks. For this reason,

PAPER SURFACES AND TEXTURES

Cold-Pressed: A slightly textured paper surface that has been produced by running the sheets through cold cylinders or rollers.

Hot-Pressed: A smooth paper surface that has been produced by running the sheets through hot cylinders or rollers.

Rough: A heavily textured paper surface produced by running the sheets through textured cylinders. Sometimes the paper is wet and pressed with a textured surface.

Vellum: A kind of paper with a very finely textured surface. Vellum can also be used to describe a translucent drawing paper or certain heavyweight papers.

Laid Paper: Paper that has a grid pattern of ribbed lines in the surface. The lines come from the wire screens on which the wet pulp dries. The ones running the length of the paper are called laid lines, while the lines running perpendicularly to them (across the width of the paper) are called chain lines.

Wove Paper: Paper that does not show any laid lines.

Rag Paper: Paper made from cotton or linen rag fiber. Rag papers contain between 25 percent and 100 percent cotton fiber pulp, which is indicated as a percentage of the total fiber content, for example, 25 percent rag. The higher the rag content, the stronger the paper.

Rice Paper: This is actually a misnomer, since paper cannot be made from rice alone; however, some Oriental papers are sized with rice starch. The term is more commonly used to describe several types of lightweight Oriental paper.

Handmade Paper: Any sheet of paper that is made by hand, using a mould.

Machine-made Paper: Any sheet of paper made by a very fast-moving machine that forms, dries, sizes, and smoothes the sheet. This type of paper has a uniform surface within the hot press, cold press, or rough categories.

many of the paper companies are now producing papers with slightly lower pH values. They are also are making the paper as white as possible, since white paper is better able to produce the full gamut of colors that are available in the ink sets. Even acid-free, pH-balanced, expensive, properly sized papers can react adversely with the inks in your printer and cause the paper structure—and therefore, the print—to deteriorate. In fact, many of the coatings used on inkjet papers have actually been proven to be harmful to image stability. This is the reason why manufacturers often choose to have their papers tested by Wilhelm Imaging Research.[1]

What is the definition of "archival"? That is a complex question that even experts have a tough time answering. There are so many environmental variables, such as where the print will be stored (in a dark drawer or a lighted room); the conditions in which it is stored (in a room with or without temperature control); and whether the print will be stored with other materials that could chemically react with the paper's properties.

The laboratory at Wilhelm Imaging Research (known for its image fading research) does not rate papers and inks on an archival scale. Rather, it refers to "Years of Print Display before Noticeable Fading Occurs" as a means of measuring the lightfastness of materials.

Most digital printmakers would be satisfied with 35 years of print life and really happy with 75 years. But few inks and papers can deliver these results. Of course, extensive research is ongoing. Currently, the technology exists for making archival prints (on an $899 Epson Stylus Photo 2000P) with a print life of up to 200 years, but the paper surfaces are very limited and you must use Epson pigmented inks and their Heavyweight Matte paper. In addition, there are several papers claiming a print life of 100 to 150 years—such as Lumijet Charcoal R and Tapestry X; Concorde Rag; and Waterford DI—but these must be matched carefully with the correct inks.

1 Wilhelm Imaging Research, Inc., is devoted to research, consulting, and publications on the permanence and lightfastness of photographic and digital materials. To get the latest update on materials visit their Web site: www.wilhelm-research.com.

RECOMMENDED PAPERS

Listed below are some of the artist's papers that I have tried and really like to use for my digital prints:

Arches HP 90 lbs.

This is a smooth watercolor paper with a light cream color. The soft cream tone of the paper causes a slight muting of the colors, but it is not a major problem for most images. If necessary, it can be adjusted or compensated for in the printer's dialog box by increasing the Saturation setting before printing. Wilhelm Imaging Research has given this paper a longevity of 32–36 years when used with archival inks.

Arches CP 140 lbs.

This is a very good paper for inkjet printing. It features a soft white color and accepts the Lysonic Archival and Lumijet Platinum and Silver inks very well. It has a nice heavy feel and imparts an added dimension of texture to the image.

Arches Bright White CP, HP, and Rough

This paper, which is available in several surfaces, boasts a brighter, whiter surface than the standard Arches CP. This improves the color gamut and allows the paper to deliver more saturated colors.

Bienfang

- *Aquademic* is a heavily textured watercolor paper that comes in 90-lb. or 140-lb. weight. It is pH-neutral and acid-free, but is considered a student-grade paper. You will find that the inks will "wick" (go into the paper's fiber and spread out, rendering muted colors) on this surface, but if you are using the digital image as a sketch for a pastel rendering, that doesn't matter. I use this paper to teach hand-coloring and also recommend it as a learning paper because it is inexpensive and has a wonderful texture—it is a joy to color with pastel pencils and soft pastels. To date this paper has not been tested by Wilhelm Imaging Research labs.
- *Inca* charcoal paper is a very lightweight (70-lb.) acid-free paper with a subtle laid surface that

Statue of Daphne

This image was taken with Polaroid Time-Zero film. It was manipulated with a stylus in the first 12 hours of development, then scanned. The final image was printed onto Arches CP watercolor paper and then handcolored with Conté pastel pencils.

receives pastels and pencil coloring beautifully. The surface is whiter than Bienfang watercolor paper and renders brighter colors and greater detail. Inca is also considered a student-grade paper and is very economical. It has not yet been tested by the Wilhelm Imaging Research labs.

Lenox

Lenox is 100-percent cotton printmaking paper that has a slightly warm color. It has four trimmed edges. I prefer to use the front side of this paper, as it is more textured, while the back is smoother and harder and gives the image a slight banning look. ("Banning" refers to slight horizontal lines that appear throughout an image when the paper's surface is very smooth and

slick and the inks do not lay properly.) This paper has not been tested by Wilhelm Imaging Research.

Somerset Velvet

This paper has a very soft surface that sometimes alters the image's colors because some of the ink is absorbed too deeply into the paper fibers. Somerset Velvet accepts Epson, Lysonic, and Lumijet Platinum inks very well. It is a nice surface to handcolor, especially with Conté pastel pencils. Somerset comes in three surfaces: Satin, Textured White, and Vellum. The Satin finish gives sharper detail and it will also take pastel coloring very well. According to Wilhelm, Somerset Velvet has an image permanence of 60–75 years when used with Lysonic archival inks.

ARTIST'S PAPERS

RIGHT: **Nude in the Garden**
This image was taken with Fuji Astia slide film and then scanned using a Nikon CoolScan LS-2000 film scanner. It was manipulated in Photoshop using the Find Edges filter (Filter > Stylize > Find Edges) and then printed out onto Lenox watercolor paper.

BELOW: **Moonlight in Logan, Utah**
This image was shot with Tri-X black-and-white film. The negative was scanned and adjusted (dodged and burned) in Photoshop. The image was printed out onto Somerset Velvet paper. The softness of the paper's surface enhanced the texture of the snow and imparted a rich, deep black to the print surface, all of which augmented the "magic" of the moonlight.

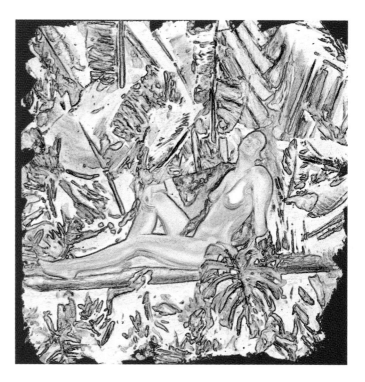

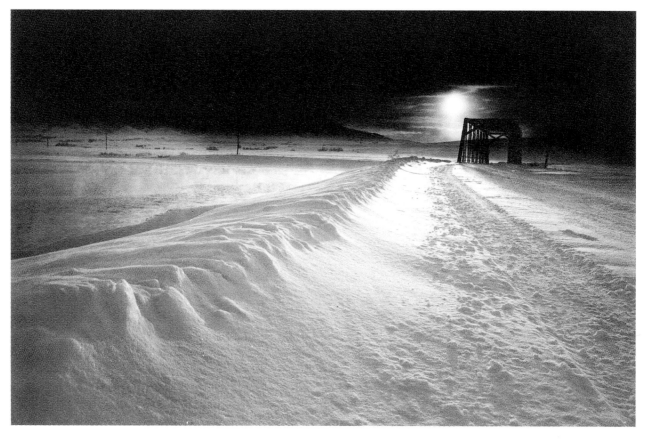

COATED INKJET PAPERS

Many fine artist's papers have been coated in order to allow them to receive ink from inkjet printers more easily. These coatings maximize the color gamut of the paper and ink combination used, while minimizing dot gain. Most inkjet manufacturers offer their own premium photo-inkjet papers with a variety of surfaces and textures, as well as coated canvas and watercolor paper. In many cases, these papers will produce outstanding image quality as they have been fine-tuned to the brand of printer. However, the choices available from printer companies are rather limited, opening the door to companies that specialize in coating fine art papers for inkjet printing. You may have to do a bit of experimentation with these papers before you are completely satisfied with the results, but the effort will be worth it.

DETERMINING THE "FRONT" SIDE

On most coated inkjet papers, it is possible to distinguish the front side—the side meant for printing—from the back based on color: the back of the paper is usually off-white or yellowish, while the front side is closer to pure white. However, in a low-light situation or under tungsten lights, it is often hard to see the difference. One way to tell is by gently folding the paper onto itself so that you can compare the colors directly. If both sides seem to be the same color, feel each side carefully—usually the coated side has a harder feel to it. Finally, if you still cannot tell which is the coated side, place the corner of the paper in between your slightly moistened lips. Whichever side sticks to your lip is the coated side.

COATED FINE ART PAPERS

Lumijet Print Media

Lumijet was one of the first companies to combine a paper and ink together to assure an archival print. Today there are many other coated papers and inks that can be combined to make archival prints. Any of the papers listed in this chapter, when combined with Lumijet Platinum or Silver inks, Lysonic inks, MIS inks, or Generations Micro-Bright Pigmented inks,

will render a print that has a longevity of between 35 and 150 years (depending on the paper and the ink chosen). See the Wilhelm Imaging Research Web site (www.wilhelm-research.com) to find out the latest test results.

Lumijet has two series of coated inkjet papers:

PRESERVATION SERIES

This series of print media was developed for the fine art printmaker desiring the highest quality paper with archival qualities and lightfastness. The papers are acid-free and fiber-based; their base materials will not adversely affect inks.

Platinum inks matched with the five "Fine Art" papers in the Preservation Series have a display longevity rating of up to 75 years. The other two papers in the series—the "Premium" papers—Tapestry X and Charcoal R, should last for 120+ years when used with Platinum inks.

The big bonus with the five surfaces in the Fine Art Preservation series is that the color of your image never changes from one surface to the next. These papers are not cheap, but they more than pay for themselves by saving you time, energy, and paper, not to mention your sanity.

Here are the seven paper surfaces:

- *Gallery Gloss* resembles glossy photographic paper and gives images an excellent photographic look. Most inks dry very quickly on this paper and exhibit excellent color saturation.
- *Soft Suede* is a white, smooth, soft matte surface. It renders extremely sharp images in a very photographic style. This paper receives handcoloring very well, but the surface coating can be easily rubbed or scratched off while coloring with dry pastel pencils. Try using waxy pencils such as Prismacolors or oil-based pencils such as Marshall's Photo Pencils. These mediums glide on much more smoothly and are unlikely to damage the surface. However, it is very hard to blend or erase color once laid down on this paper. *Do not* use a kneaded eraser on it, as it will stick to the surface.

- *Classic Velour*, a 100-percent rag paper, has a soft white color and the look and feel of cold-pressed watercolor paper. Images printed on it show superb detail but also have a relatively soft overall look. Classic Velour receives handcoloring with watercolor pencils (such as Faber-Castells); wax-based pencils like Marshall's Photo Pencils or Prismacolors; or pastel pencils applied gently, but the surface is softer than typical watercolor paper, so the coating is more easily scratched or rubbed off, making it difficult to reduce or blend colors.

- *Flaxen Weave* has a textured surface that resembles a more textured cold-pressed watercolor paper. It has a soft, off-white color; the images printed on this surface are extremely sharp and beautiful. The paper's coating is tougher than that of Classic Velour and it can be colored with pastels or pastel pencils. However, care should be taken when coloring as the surface as it still can be damaged. Watercolor pencils can also be used with just enough water to get a flow of color.

- *Museum Parchment* has a pure white base and also resembles a cold-pressed artist paper with a parchment-like finish. This paper is the thickest in the Preservation series and may not pass through printers that lack a straight paper path. It can be handcolored with pastel pencils, Marshall's Photo Pencils, or watercolor pencils (dry or wet).

- *Tapestry X* is a pure white textured paper (similar to Luminos Tapestry photographic paper) with a pure white inkjet coating. It gives images a heavily textured look—as though they had been printed on canvas. This coating is so dense that oil paint can be used to handcolor images printed on it. However, it is also extremely water-soluble. Tapestry X is extremely archival—Wilhelm Imaging Research has given it a rating of at least 120 years lightfastness.

 If you intend to use an Epson 3000—or any other printer with a "pizza wheel"—to print on this paper, you should be aware that the surface, which is not fast-drying, is subject to picking up pizza wheel tracks. The wheel actually punctures the surface, leaving tiny holes in the coating, so if you handcolor using oil paints, the acids in the oils will seep through and cause the paper fibers to deteriorate. A good way to avoid this problem is to remove the pizza wheel from the printer (see page 70).

- *Charcoal R* has a very smooth surface, which brings out details in the image. It has the same base as Luminos Charcoal R photographic paper, but with a pure white inkjet coating that is identical to the one on Tapestry X. This means that Charcoal R is also subject to pizza-wheel tracks, and its smooth surface makes the tracks even more apparent. The same precautions about using oils to hand-color mentioned in the description of Tapestry X apply to Charcoal R. Since it has the same coating as Tapestry X, it should also have a display life of 120 years.

LUMIJET STANDARD PRINT MEDIA
These papers come in a variety of surfaces, including Glossy, Pearl, and Matte as well as Paper Canvas, Cloth Canvas, Belgian Linen, Silver, White Opaque, and Clear Film. They are made with high-quality materials and if used with Lumijet Platinum inks will produce prints that last at least 30 years on display. The estimated display time decreases somewhat when this media is used with the Lumijet Silver inks, and even more when used with their Standard ink set. When used with the quad-black ink set, they should last 36+ years.

Somerset Photo Enhanced
This paper is the second generation of Somerset Velvet Radiant White. It is a coated paper featuring an expanded color gamut and less dot gain. Tests done by Wilhelm Imaging Research in June 2000 show that images printed on Somerset Photo Enhanced with dye-based inks will begin fading within three to four years. It seems to do better with the pigmented inks, such as MIS Archival, Generations, the Epson Archival inks, or with monochrome ink sets. However, this is not a good choice for long-term storage of an image.

LEFT: Mountains, Tibet

This is a close-up of an image I printed onto Lumijet Tapestry X paper. The rough canvas-like surface enhanced the rugged appearance of the mountains.

BELOW: Ox in Rong Ba Cha, Tibet

This image was printed on Lumijet Charcoal R paper and handcolored with Conté pastel pencils. I added edges and texture with Auto FX Photo/Graphic Edges.

COATED INKJET PAPERS

Concorde Rag

This 100-percent-cotton paper is acid and lignin free. It weighs 250 g/m² and has a warm white color and a lovely soft feel. This is a great paper, producing excellent shadow density with a wide color range. Its soft surface does not interfere with the sharpness of the image. Current test results from Wilhelm Imaging Research indicate an image stability of over 150 years when the paper is used with pigmented inks for the Roland Hi-Fi Jet Printer.

Lyson Media

These papers are specially formulated to provide maximum color quality from Lysonic inks. According to Wilhelm Imaging Research, they all should last about 65 years on display when used with archival inks. In addition to the four surfaces listed at right (which I recommend), there are four newer papers that are currently being tested by Wilhelm Imaging Research—100% Cotton Rag, Professional Photo Gloss, Professional Photo Satin, and Fast Dry Photo Gloss.

- *Standard Fine Art* is a soft white paper with a very classic look. It produces good details and great color.
- *Soft Fine Art* has a beautiful, slightly textured parchment-like finish and produces great color and details.
- *Rough Fine Art* has a very textured finish, which makes it easy to color with pastels. However, it renders an extremely sharply detailed print with a great color gamut.
- *Photo Matte* is a smooth white paper that renders a photographic-type image. It renders great details and good color.

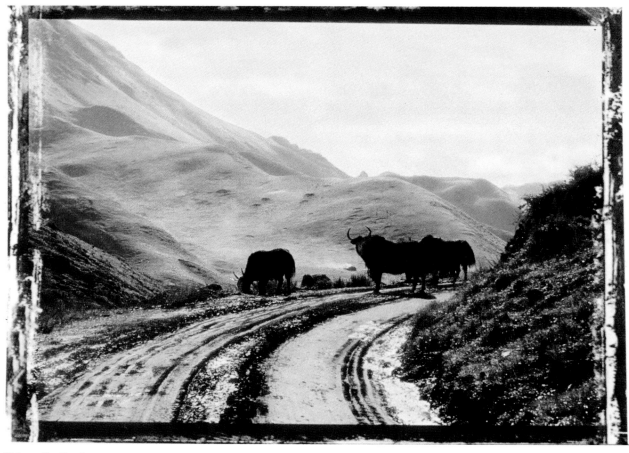

Yaks on the Road
This image was printed on Lysonic Rough Fine Art paper and handcolored with Conté pastel pencils.

BullDog Products

- *Tarajet Canvas* is a canvas made for desktop inkjet printers. It has a coating that delivers a wide color gamut, and a smooth finish that receives the inks very well. Tarajet Canvas is made by the same people who produce Fredrix canvas for painters. It was tested by Wilhelm Imaging Research and is expected to have a display life of 22–27 years.
- *BullDog UG Canvas* is a very heavy coated canvas that is made primarily for use in Iris, ColorSpan, and Encad printers. According to Wilhelm Imaging Research, it should last twice as long (up to 75 years) as the Tarajet Canvas.
- *BullDog UG Canvas Matte* has a very good color gamut. If used with pigmented inks it is expected to last over 50 years.

Hahnemühle

These are German-made papers. Tests conducted by Atlantic Papers (one of their distributors) indicate that all of the papers that are listed here have a display longevity of 35–65 years depending on the inks used. They are currently being tested by Wilhelm Imaging Research.

- *William Turner* has a soft finish and a slightly textured surface, but renders great details and good color. It is a beautiful paper for the final image. The surface is hard enough to take coloring if desired or needed. The paper's weight is 300 g/m^2, which is comparable to 140 lbs. in this case.
- *Arkona* is a very thick paper (335 g/m^2, or about 155 lbs.) resembling a rough watercolor paper. It has a great texture and produces beautiful images with

great details and a wide color gamut. When used with archival inks, it also takes handcoloring very well. Because the surface is very tough and textured, it takes wet watercoloring without damaging the surface or smearing the inks. It is also a good paper on which to use pastels and pastel pencils because the pigments are captured in the little wells that form the texture of the paper. Arkona is a wonderful paper to use for pastel renderings or watercolor paintings using the digital image as a light sketch from which to work.

- *Japan* is a lovely Oriental-type paper which resembles Kinwashi Oriental paper made from manila fibers. Japan, like Kinwashi, is translucent with lovely white straw-like vegetable fibers throughout, but is also lightly coated to receive inkjet inks. Matched with the proper image, this is a dynamite combination—one of my favorites.
- *Allegretto* resembles a rough watercolor paper. Its soft gold color does not interfere with the overall color of images on the paper. This paper renders great contrast and very good detail. Its weight is 160 g/m^2 or about 75 lbs.
- *Albrecht Dürer* is a rough textured paper weighing 210 g/m^2, warm white in tone but yielding a print with great contrast and overall color. It is sold through Luminos as Lumijet Flaxen Weave and through Lyson as Rough Fine Art paper. This is my very favorite paper for handcoloring. The surface is tough enough to withstand rubbing and blending with color pencils and if using archival inks, such as Lumijet's Platinum ink set, you can also use watercolor or gouache (such as Chroma's or Jo Sonja's) paints on them.
- *Structure* features a softly rippled, textured surface. It has a nice white finish and a wide color gamut, yet imparts a slightly soft look to the image. It is an excellent choice for almost any image. It weighs 150 g/m^2 or about 70 lbs.
- *Linen* is a 70-lb. paper that should go through any printer. It has a nice white surface with a linen-like weave surface (almost canvas-like) that can camouflage a host of imperfections. It renders rich colors and—in spite of the rough surface—sharp details.

- *Bugra* resembles laid-surface pastel paper. It is quite thin (140 g/m² or 65 lbs.) and comes in four colors: Aquamarine, Mint, Natural White, and German Antique. All of these papers are coated and will take the inkjet inks nicely. The proper image matched with the first three colors can be quite striking. German Antique is light yellow with tiny light and dark flecks (which look like eyelashes) running through it, and gives images printed on it an old, vintage look.

- *Torchon* is sold through Luminos as Lumijet Museum Parchment and through Lyson as Soft Fine Art paper. It is another favorite paper of mine for handcoloring. This too will take more abuse than most papers when you blend colors from color pencils such as Marshall's Photo Pencils. Torchon will take watercolor and gouache paints if used with archival inks (such as Lumijet's Platinum ink set or their quadtone inks). It will also take watercolor paints extremely well if you are using pigmented inks, such as the MIS Archival ink set or the Jon Cone ink sets.

- *German Etching* is also sold through Luminos as Lumijet Classic Velour and through Lyson as Standard Fine Art watercolor paper. This paper will not take watercoloring and is more delicate than Torchon or Albrecht Dürer, but used with the quadtone or monochromatic archival ink sets it produces a beautiful range of tones, extremely deep, rich blacks, saturated colors, and sharp details in the print.

- *Photo Matte* is sold through Luminos as Lumijet Soft Suede and through Lyson as Photo Matte. I use this paper to achieve a photographic look, but not for handcoloring.

Epson

- *Archival Matte* is a heavyweight paper (192 g/m² or 45 lbs.) that is especially resistant to ozone and atmospheric contaminants. It gives 24–26 years of lightfastness, and costs about $16 for 50 sheets of 8.5 × 11-inch paper. It can be used with the Epson Stylus Photo 870, 875DC, 1270, and 2000P.

- *Premium Semi-Gloss Photo Paper* weighs 251 g/m² and gives 9–10 years of lightfastness, and costs about $15 for a box of 20 8.5 × 11-inch sheets.

- *Premium Luster Photo Paper* weighs 250 g/m² and gives only 6–7 years of lightfastness, and costs about $35 for 50 sheets of 8.5 × 11-inch paper.

- *Watercolor* weighs 190 g/m² and can only be used with the Stylus Pro 7500 and 9500 and the Stylus Photo 2000P. A box of 20 sheets of 13 × 19-inch paper (the only size available) costs about $25.

New Papers for Inkjet Printing

There are more and more papers coming out all the time for inkjet printing. Some are specially coated (for inkjet printers) and some are uncoated watercolor papers. Below are a number of new uncoated papers being introduced to the market. Some of these have not been tested for print longevity (or test results have not yet been published).

- *Red Tail* is a bright white paper made by Hawk Mountain Art Papers. It contains no added optical brighteners and is internally sized. It is has a soft matte finish and is acid- and lignin-free. At 120 lbs. (250 g/m²), it is rather thick. My experience has taught me that images printed on Red Tail do not have the snap or depth that can be obtained from coated inkjet papers.

- *Lanaquarelle*, a French mouldmade watercolor paper, is not new—it's been around since 1590! However, it is new to the digital artist, as it is now being advertised as an "inkjet print paper." Many artist papers are now being advertised as inkjet print papers, meaning simply that they can go through an inkjet printer and receive an image on their surfaces. However, as we discussed, how well the image looks on this paper (color range and dot gain) and more importantly how long it will last are other questions to be addressed.

 Lanaquarelle's sizing is mainly internal, but there is also a light coat on the surface. The paper, which is a warm white in color, comes in hot-pressed, cold-pressed, and rough surfaces. The cold-pressed version is smoother than Arches cold-pressed paper,

while the hot-pressed version renders greater detail in the print. Two weights are available: 300 lbs. and 140 lbs. The 140-lb. paper passes through the Epson 3000 very easily, however, some printers are not able to print on 140-lb. papers. None of the versions of this paper have been tested by Wilhelm at this time.

- *Guardian Inkjet Optimized Watercolor* paper is a new product from Weber-Valentine. It has an optimized coating for inkjet printing and a natural white base. No longevity test results are available at this time.
- *Waterford DI* is an enhanced "digital inkjet" version of the standard Waterford watercolor paper. It has a bright white cold-pressed finish and comes from the same mill as Somerset paper. This paper is given an extra sizing for inkjet printing and works best with pigmented inks. Its longevity is still being tested.

NON-ARCHIVAL INKJET PAPERS

These inkjet papers give great color reproduction, but they are not intended for archival use—fading will occur in one to four years. They are excellent papers for temporary use, and I recommend them for graphic designers and publishers. I use them to proof color, look at composition, send to printers for color comparison, and present work to gallery curators.

Epson Photo Quality Inkjet Paper (matte finish)

For a relatively low cost (about $13 for 100 sheets), this paper delivers good resolution, rendering clear, sharp images that are easy to handcolor. I recommend it for proofing and for short-term presentation of images.

Konica Quality Photo Glossy

This paper is water-resistant and dries quickly. The pure white surface produces a saturated, wide color range and nice finish at a reasonable cost (about $35 for 50 8.5 × 11-inch sheets—several other sizes are available).

Konica Quality Photo Silky

This paper has the same features as the glossy version, but the lightly textured surface camouflages imperfections. A box of 15 8.5 × 11-inch sheets costs about $13.

PRINT SPRAYS

Inkjet prints, like photographs and other artworks, are susceptible to damage from the pollutants in the air, such as cigarette smoke and UV rays. Inkjet prints made with dye-based inks are also susceptible to ozone and water damage; just sneezing on a print made with dye-based inks can lift the inks and ruin the image. I have always been hesitant about spraying my prints for fear that the surface would yellow or crack later on, but recently a few sprays have been manufactured specifically for inkjet print protection that will not crack or yellow with age. All sprays should be used with care and with proper ventilation.

Lumijet Image Shield

This is non-yellowing, has a UV inhibitor built in, makes the print "wet fast," and does not change the color of the inks. This is the spray I use and I have been pleased with the results.

Iris Print Seal

This aerosol spray overcoat varnish has been formulated to prevent Iris prints from fading and smudging. The invisible spray protects the print with a moisture-resistant finish and has a built-in UV inhibitor. It is distributed by Improved Technologies.

Lyson Print Guard

This spray improves wetfastness, has a UV inhibitor built in, and will improve the inks' fade resistance. It has a polymeric base and is non-yellowing. Print Guard can be found on Inkjetart.com and the Lyson Web site.

BullDog Ultra Coating

This vinyl-based laminate is made especially for inkjet prints made on canvas or glossy inkjet papers. It has a UV inhibitor, makes the prints waterproof, and is non-cracking and non-yellowing. The vinyl base makes the coating flexible, so that the canvas does not crack. It is applied with a foam roller. The laminate has a strong odor and should be used with proper ventilation. It can be found on Inkjetart.com and the BullDog Products Web site.

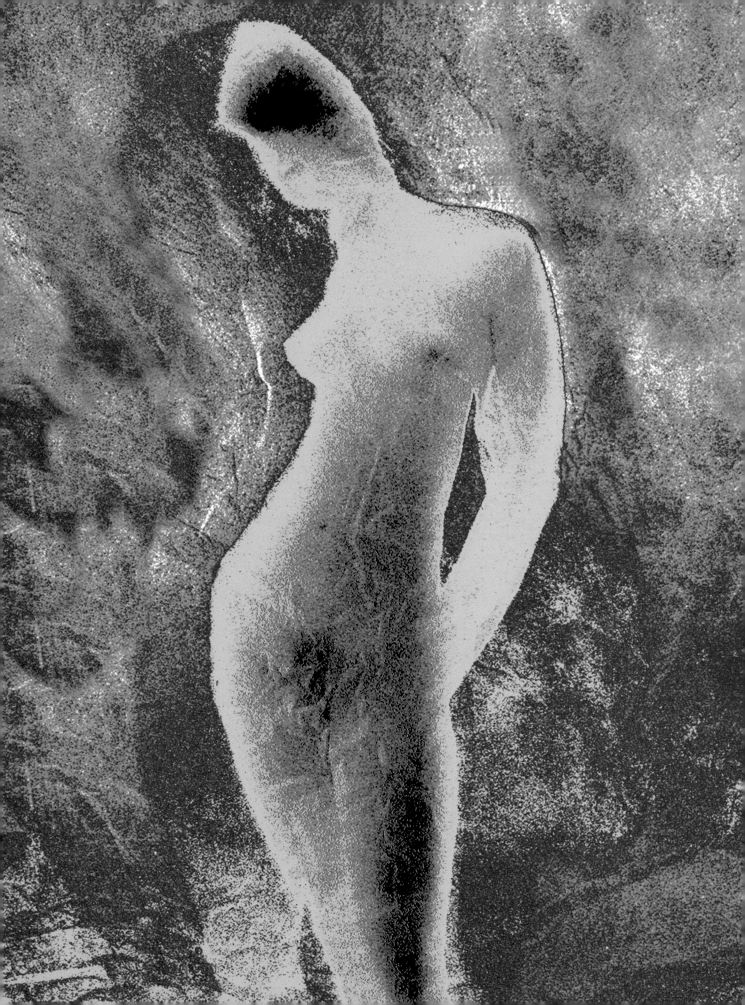

Chapter 5

INKS

Two types of inks are commonly used in inkjet printers. The first is *pigment-based* ink. This type of ink contains finely ground, insoluble particles—often made out of natural, long-lasting materials—that are suspended in a uniform liquid matrix that is either water- or oil-based. If you spray pigmented ink onto a paper surface, the individual particles will remain on the surface after the surrounding liquid (be it water or oil) has dried. Pigmented inks tend to withstand light and humidity quite well, and prints made with these inks can last anywhere from 15 to 200 years on display.

The standard ink sets that come with most printers are generally *dye-based*. These inks are made from organic ingredients that are completely water-soluble. They produce brilliant and accurate colors and are compatible with a wide variety of paper surfaces and textures. However, prints made with most of these OEM dye-based inks don't last very long when displayed or even stored in the dark. There are several dye-based ink sets that are archival, such as Lumijet Platinum and Silver inks and the Lyson Archival set.

Shy Nude

Due to their transparency, dye-based inks have a wider color gamut than pigment-based inks and are more compatible with the inkjet engines found on most desktop printers. An inkjet printer requires a nozzle with an extremely tiny opening; the inks are sprayed out in size ranging from 3 to 50 picoliters. (A picoliter is about the size of a blood cell.) Since dye-based inks aren't composed of the kind of particles used in pigment-based inks, they don't clog the fine print heads as easily. However, new pigment formulations from Epson contain particles that are smaller than a micron and don't clog the heads.

Most printer manufacturers make a dye-based ink set that has a wide range of colors but is not lightfast or archival (i.e., standard OEM inks). However, several manufacturers now make lightfast dye-based inks for use with inkjet printers. These inks, like their pigmented cousins, have a narrower range of colors than the standard (OEM) dye-based inks (colors in the magenta/yellow range tend to be less vibrant than the reds and yellows in the OEM ink sets). However, making color adjustments in the printer driver software can help to improve colors before printing.

LUMIJET INKS

These dye-based inks are compatible with a variety of printers including the most popular models from Epson. Lumijet has matched their inks with their archival coated inkjet papers for varying degrees of permanence according to a printmaker's needs.

- *Preservation Series Platinum Inks* are translucent inks with bright, beautiful color that are designed for archival printmaking with the highest lightfastness. When matched with Lumijet Preservation Series papers, prints made with these inks will last 65–120 years. They can also be used with other inkjet coated papers and with uncoated papers such as Somerset Velvet and Arches CP or HP watercolor paper.
- *Preservation Series Silver Inks* closely match OEM inks, but will bring the display life of a print up to 30–35 years when matched with the proper paper. They don't last as long as Platinum inks (which

provide a display life of up to 65 years), but they will give you a wider color gamut.

- *Preservation Series Monochrome Inks* offers a permanence of 70+ years of indoor life when printed on Lumijet's Preservation Series papers. These four shades of neutral black inks replace the four color cartridges in the printer and produce a beautiful fully toned black-and-white image.
- *Standard Inks* are comparable to normal OEM inkjet printer inks and have a very wide color gamut. They should resist fading for one to three years.

LYSONIC INKS

Lysonic Archival Inks are dye-based inks made in England. They have an estimated display life of 65–75 years when images are printed on pure cotton paper and kept in average lighting. The color range is very good, but as with most archival dye-based inks, the reds and yellows need plumping up (added saturation) before printing.

Lyson also offers several sets of monochromatic inks, which will be discussed later.

EPSON INKS

Epson has recently introduced a new set of archival pigment-based inks for their Stylus Photo 2000P that will deliver an archival lifespan of more than 100 years. They also have modified their dye-based inks for the Stylus Photo 1270, 870, and 875 DC printers. The new versions deliver 20–25-year lifespans depending on the paper used.

TIP

If you are using an Epson 3000 printer, when printing with any quad set of monochromatic inks, remember to send the print over to the printer in RGB mode and print in the color space (not black). Because of the manner in which the printer is set up, it will then use all four shades of ink instead of just the black channel.

Green Steps and Blue Shutters, Bermuda
This vibrant image was printed with the Lumijet Preservation Series Flaxen Weave paper and the Platinum ink set.

Epson's ink cartridges for these printers contain a unique microchip that makes it difficult for third-party manufacturers to offer alternative inks. Since they are dye-based, the new inks are compatible with a greater variety of other media than the pigment-based inks. Unlike other inks, they require no tweaking of ICC profiles to obtain great color results. The new inks, which cost about the same as the standard inks, also deliver similar color, but they are much more lightfast.

When these inks are used with Epson papers (and sealed in a frame in an area with low amounts of ozone), you can expect the following display lifespans:
- Photo Paper: 6–7 years
- Premium Glossy: 9–10 years
- Archival Matte: 24–26 years

Of course, the combination of the paper, the paper's coating, and the inks all contribute to the longevity of a print, so printing with the new Epson inks on a non-coated watercolor paper such as Arches CP or Somerset Velvet will yield different and potentially shorter display lifespans. I have made some prints on the Epson Stylus Photo 1270 using Lumijet Preservation Series Parchment paper, and the images looked spectacular. Unfortunately, when I cut a print in half and placed one piece in a normally lit interior room and the other in a dark drawer, the results were horrible. The print kept in the light almost faded away in just six weeks. To date, the best lifespan prediction on record is for Epson's Archival Matte paper (see information at left).

Epson has recently introduced four new printers for the professional graphic printer. The 24-inch-wide-format Stylus Pro 7000 and Stylus Pro 7500, as well as the Epson Stylus Pro 9000 and the Stylus Pro 9500, both of which will produce a print of up to 44 inches wide, come with the new Micro Piezo DX3 print head technology which enables the printer to place precise microscopic drops of ink on a vast variety of media for ultrasharp resolution and high print-to-print consistency. They use a six-color, high capacity, six-cartridge linking system to produce digital prints of extremely high quality, using a new archival pigment-based ink that will last more than 200 years.

The Stylus Pro 7000 and Stylus Pro 9000 use a dye-based ink which is *not* archival. They are less expensive (although still not exactly affordable for the average digital printmaker)—costing about $4000—than the 7500 and the 9500, which cost about $5,000 and $11,000, respectively and use archival inks.

The Epson Stylus Photo 2000P also uses Micro Piezo Technology and new pigment-based inks to produce continuous-tone, photographic-quality prints as large as 13 × 44 inches. When used in combination with the Epson Archival inks and the new Epson papers, it can produce prints with a display lifespan of up to 200 years. This is an amazing desktop printer. Although its prints have a slightly narrower range of colors than ones made on printers that use dye-based inks, they look great. The price is around $900.

IRIS EQUIPOISE INKS

CreoScitex makes these inks for Iris printers. Matched with Arches Cold Press paper, they produce prints that will last from 32 to 35 years; with Somerset Velvet, the display longevity has tested at 20–24 years.

ENHANCED GENERATIONS MICRO-BRIGHT PIGMENTED INKS, VERSION 4.0

MediaStreet.com has developed an enhanced set of pigment-based inks that can be used in the Epson Stylus Color 3000. According to the manufacturer, these inks will not clog printer nozzles. The colors are very good, but are still not as bright as those produced by dye-based inks; the reds tend to be a little flat and on the bluish side. The cartridges hold a large volume of ink—I didn't think I was ever going to run out!

MIS ARCHIVAL INKS

Formulated for Epson printers, these inks are a hybrid dye-based/pigmented ink. They are highly UV-resistant and, when used with coated paper, also have a high level of water resistance. However, when used with some uncoated artist's papers, the inks will spread out a little. My experience with these inks has been very good; the color is great—comparable to other archival ink sets. The longevity of these inks was tested by the Rochester Institute of Technology's Image Permanence Institute in 1999. At that time, results indicated a display life of 49 years when printed on Somerset Velvet paper. Since then, however, the yellow ink's formula has been slightly altered. According to MIS Associates, the new version has a permanence that is five times greater than that of the old version. Official testing by RIT has not yet been completed.

OBTAINING GOOD COLOR FROM ARCHIVAL INKS

As I mentioned earlier, the one problem with archival inks is that they have a narrower color gamut than the standard OEM inks, especially in the yellow/red range. I choose to use these archival inks and papers regardless of this shortcoming in order to extend the display life of my prints. Below is a breakdown of how I improve the reds and oranges in prints that use archival inks and papers. This process is based on the printer driver that comes with the Epson Stylus Color 3000 inkjet printer and one of two sets of ink: Lumijet Platinum or Lysonic Archival Ink. It works extremely well for my system, and it may help you figure out a process that works for you and your system.

1. The first step toward making any kind of color or tone adjustment is to make sure that your monitor is color calibrated (see chapter 3).

2. Then, after you have finished working with your image in the computer and you want to print the image with the colors, contrast, and image cropping seen on your monitor, choose Image > Adjust > Hue/Saturation (or Command-U). Slide the Saturation bar to about +12. (This is selected according to the needs of the print, but generally

I choose between 12 and 14. If you increase the saturation much beyond this, the colors will block up in certain areas.) At this point, the image seen on the monitor may appear too red or orange, or a bit garish in general, but it will print correctly if the remaining steps are followed. Note: Do not save this temporary setting.

3. Open your printer driver dialog box. In the Epson Stylus Color 3000 control box and other Epson drivers, you'll find the following options:

- **MEDIA TYPE**: I generally select Photo Quality Ink Jet paper to print my images, even when they are to be printed onto uncoated artist's papers. If I am using a glossy stock I will select Photo Quality Glossy Paper. However, if I am printing onto a very contrasty inkjet coated paper such as Lumijet Flaxen Weave, I may "lie" to my printer and tell it that I am printing on glossy stock. Because the printer will not lay as much ink down on glossy stock, I will prevent bronzing from occurring. Bronzing looks like solarization in the dark areas; it is a result of too much ink being laid on the paper.

- INK: Make sure that your file matches your printer's color space. If it is a black-and-white file, you should select Black. However, if you have changed your file to a color mode to tone it, you will want to choose Color. For example, if your file is in the RGB mode, click on Color.
- PRINT SPACE:

 Profile: I get better reds and yellows (using archival inks) with Apple RGB.

 Intent: I prefer to use Perceptual instead of Relative Colorimetric as the blues reproduce better.
- MODE: If using archival or pigment inks, I choose Advanced and then click on More Settings. This brings up a second dialog box.

 In the second dialog box, you will have the following options:

 Print Quality: I choose 720 dpi if I am printing on textured papers such as Lumijet Flaxen Weave or Arches Cold Press. If I am printing on a paper with a smooth surface, such as Lumijet Soft Suede or Glossy, I choose 1440 dpi. The 1440 setting (the highest resolution on the Epson Stylus Color 3000 printer) will give you more saturated color and less color banding in strong, solid color areas. If I am printing very large and intend to use the large print as a sketch from which to make a painting, I also use the 720 dpi setting.

Halftoning: Select Error Diffusion for the best ink pattern when you are printing photographic images.

Color: Click on Color Adjustment and select the Automatic mode. There are other selections, but this one works best for me. In the slider controls under Mode, you can add or subtract color. It is here that I add saturation (usually between 12 and 20) and magenta (usually between 3 and 20, depending on how much red is in the image) if I need to plump up the reds and yellows in the archival ink sets.

Using the adjustments listed above, I have been able to produce a very good saturated red and orange color range in my prints using the archival inks and papers mentioned. However, if you follow this same correction routine with standard dye-based inks and inkjet papers, you probably won't like the resulting prints.

If trying to correct the shortcomings of certain inks sounds like too much trouble but you want long-life prints, you have two other alternatives. Purchase a new Epson Stylus Photo 1270, 870, or 875 DC and you'll get a display life of more than 20 years. Or you could load your printer with Lumijet Silver inks. These inks give better color but will only last 35 years (printed with the proper papers) instead of 75 years.

MAKING BLACK-AND-WHITE PRINTS USING ARCHIVAL INKS

You can use either color or quad-black archival inks to make high-quality black-and-white prints. When using four- or six-color ink sets, you can either use a single color (black) to make your prints (provided you print them while in the grayscale mode) or you can mix all of the colors to make a neutrally balanced black-and-white print while in RGB color mode. Because it only uses a single ink, the first method doesn't produce prints with as much detail or as many shades of gray as using all four colors to make a black-and-white print. Prints made using a single black ink will be blocked up

and have a color cast—usually blue, as the black ink in most color sets tends to be bluish.

If you print a grayscale file in the color space (in your printer driver dialog box), the resulting print will likely have a greenish hue. To counteract this color cast and obtain a cool black image, you should first convert your grayscale file to an RGB file (Mode > RGB). The file will not change color or tone, but the title bar will read RGB instead of Grayscale and you will be able to adjust color more accurately. Now you can successfully print the file in the color space.

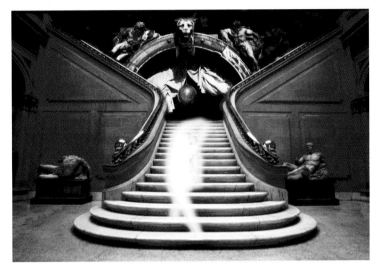

Nude on the Staircase
This is a black-and-white image in grayscale mode that was printed using the grayscale (black) color space in the printer driver dialog box. The result is a bluish print because the black in the RGB color ink set is actually a bluish tone.

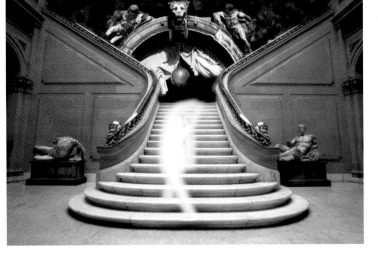

This greenish cast was caused by printing a black-and-white file in the color space in the printer driver dialog box.

To warm up or neutralize a cool-toned black-and-white print while still in Photoshop, select Mode > RGB, then choose Image > Adjust > Color Balance and add about 9 magenta. Then in the printer dialog box, go to Advanced and double-click on More Settings. This will take you into the advanced printing section. Under Color Adjustment Mode, scroll down to Auto. Then, in the boxes below, adjust the color settings. You should add about 16 magenta. But be careful . . . if too much magenta is added, the print will be magenta-toned.

To render a nice, warm sepia-toned print, first make sure your black-and-white image is in the RGB mode. Then, add a bit of magenta and a little yellow to the image to tone it. Another option is to keep the image in grayscale and choose the Duotone Options dialog box (Image > Mode > Duotone). Choose the color cast or toning effect that you want, then print it using the color inks.

QUADTONE INK SETS

The second method that you can use to make quality black-and-white prints requires you to load a quadtone ink set. As previously described, this is a set of cartridges in four shades of black that replaces the CMYK cartridges in your printer. There are a few good ones on the market.

Cool-toned black-and-white print. This result was achieved by adding magenta to the black-and-white file as instructed above and printing the file in the color (not black) space.

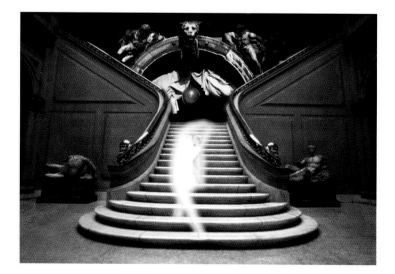

I created this sepia-toned print by adding magenta and yellow to the black-and-white image while it was in the RGB color mode, then printing the black-and-white image in the color (not black) space.

If you are using an Epson 3000 printer, when printing with any quad set of monochromatic inks, remember to send the file to the printer in RGB mode and print in the color (not black) space. Because of the manner in which the printer is set up, it will then use all four shades of black instead of just one black channel.

Lysonic Quad Black Inks

Lyson offers three monochromatic ink sets: Quad Black Cool Tone, Quad Black Neutral Tone, and Quad Black Warm Tone. Here are the latest test results from Wilhelm Imaging Research (an Epson 3000 was used):

Quad Black Neutral Tone
- with Lyson Standard Fine Art paper: 100 years
- with Somerset Velvet Radiant White: 100 years
- with Epson Photo paper: 80–90 years

The Cool Tone set has not yet been tested but is expected to surpass the Neutral Tone set.

Quad Black Warm Tone
- with Lyson Standard Fine Art paper: 80–90 years
- with Somerset Velvet Radiant White: 55–60 years
- with Epson Photo paper: 15–20 years

ConeTech Piezography BW

This is a neutral quad-black ink set made for the Epson Stylus Color 3000 printer. The set comes with its own software, which is easy to install and has it own built-in paper profiles. The inks are slightly warm in tone and give great, consistent results. A beautiful paper choice for this ink is Somerset enhanced papers. These give good separations in the dark tones and beautiful highlights with an extraordinary amount of information. Cone has designed a quadtone RIP which connects the computer with the printer and instantly turns the printer from a 720 dpi to a 2160 dpi, making the image continuous-toned, with no dots in the highlights. For the fine art black-and-white printer, this is a super combination for gallery-quality prints; the black-and-white prints made with this combination are drop-dead gorgeous!

You can find out more about this system by going to www.inkjetmall.com or www.cone-editions.com.

Lumijet Preservation Series Monochrome Ink

Lumijet's quad-black Monochrome ink set consists of two neutral blacks, a selenium (cold black), and a sepia (warm black). These inks give a very wide and beautiful tonal range in a monochrome print. Presently, the inks are available in separate cartridges for the Epson Stylus Color 740, 760, 800, 850, 1160, 1520, and 3000 printers.

When these inks are used on the Preservation Series papers, prints display dense blacks and delicate off-whites with an extended continuous tonal range compared to black-and-white photographic prints. According to Wilhelm Imaging Research, prints made with this paper-and-ink combination will last at least 100 years in normal lighting conditions, and longer if stored in boxes with only occasional indoor display.

Lumijet now also produces a Sepia Quad ink set, which produces a beautiful warm-toned black-and-white print.

MIS Quadtone Inks

These inks will give you a far better black-and-white image than printing a black-and-white image with color inks. The only problem that I have found with these hybrid dye/pigment inks is that when used with certain coated inkjet papers, such as Lumijet's Charcoal R and Tapestry X, they will puddle.

To get started printing with quadtone inks, select your paper and cut it into small pieces (about 4 × 6 inches) for test prints. Print a section of a black-and-white image on these pieces before making a large print. (Your file should be in the RGB mode because most printer drivers require an RGB file to print with quadtone inks. If you have scanned the image in grayscale, convert it.) After the test prints dry, make any necessary color changes either in Photoshop or via the printer driver. Eventually, you will arrive at the perfect balance without wasting large sheets of paper in the process.

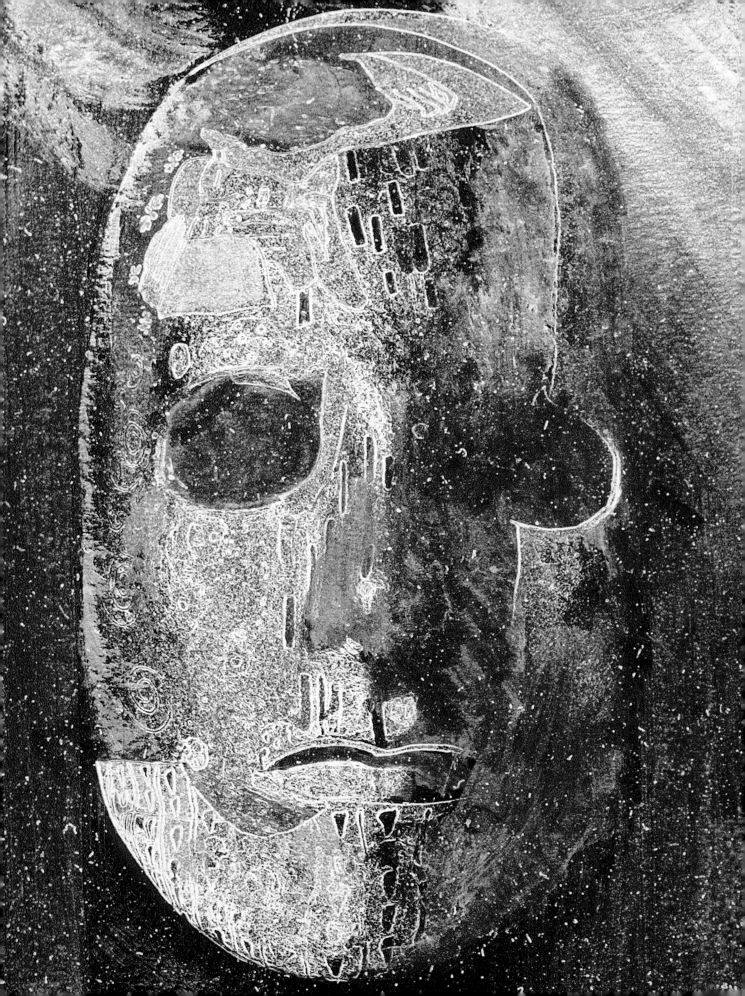

HANDCOLORING THE DIGITAL PRINT

When there are colors in an image that are just not bright or rich enough, I often enhance them with pencils. This saves a lot of time, ink, and paper. In some cases, however, I wish to do a handcolored version of the entire image. In these instances, I will usually print the image out at 360 dpi either in black and white or in color that has been greatly desaturated and lightened. There is no sense in wasting ink when you are going to color over everything. I use the lightly printed image as a sketch for the painting or pastel rendering. I market these images as "pastel renderings—camera generated" or "oil paintings—camera-generated."

Oil paints cannot be used on most types of paper, as the acids in the oils will deteriorate the paper fibers. Even with the coated inkjet papers, most of the coatings are not impenetrable enough to prevent the oils from being absorbed to the paper's fiber base and ultimately destroying the paper fibers. However, two of the coated inkjet papers in Lumijet's Premium Preservation Series— Tapestry X and Charcoal R—*can* now be colored with oil paints. The coating on these two papers is impervious to oil.

Venetian Mask, Year 2000

Lumijet Tapestry X and Charcoal R have the same base as the Luminos photographic papers called Tapestry X and Charcoal R. However, instead of a light-sensitive silver gelatin coating, the Lumijet papers have a pure white inkjet coating especially formulated to give great color range and sharp details and reduce dot gain in the digital print. The coating on the inkjet papers is made in Germany and is different from the other papers in the Preservation Series, whose coatings are made in England.

When I do wish to paint with oil paint, I print my image out on Tapestry X or Charcoal R or I select a canvas upon which to print my "sketch" for an oil painting. Several suitable types of canvas are now available (see Chapter 4 for more information).

I also like to use Conté pastel pencils and Marshall's Photo Pencils when coloring on Tapestry X or Charcoal R. Because both of these surfaces have a sheen, before coloring on them with pencils, it helps to give them two light coats of a final fixative, such as Krylon Crystal Clear, Marshall's Pre-Color Spray, or any other matte finish spray. This will give the surface a "tooth" that will allow the coating to receive coloring from pencils (oil and pastels) more evenly and prevents the pastel from wiping off when you are trying to blend.

These two papers are not fast-drying papers, so it is easy to over-ink the paper and thus run the risk of ending up with bronzing and "tracking marks" from your printer's "pizza" wheels on your prints. Epsons and some other printers can have this problem. The tracking marks are more visible on Charcoal R than Tapestry X because the rougher texture of Tapestry X camouflages the marks more. In general, I prefer Tapestry X because its canvas-like texture gives the image a more painterly finish yet retains the sharpness and great color of the digital file.

If you do get tracking marks on the print, Conté pastel pencils will easily fill in the white dots and blend into the other colors. When finished blending the marks out, spray the finished print with a light coat of workable fixative (such as Krylon Workable Fixatif) first. When the workable fixative is dry (this will take about five minutes), spray with a final fixative, such as Krylon Crystal Clear.

The other coated inkjet papers that I color on are from the Lumijet Fine Art Preservation Series: Flaxen Weave, Museum Parchment, Classic Velour, and Soft Suede. Because of the fragile nature of their surfaces, extra care must be taken when coloring on Soft Suede and Classic Velour. They cannot be reworked as much as the others. When removing color or reducing the color on Soft Suede, a kneaded eraser will stick to the surface and leave a black residue that cannot be removed. Classic Velour's coating is easily lifted during rubbing or blending colors; even pastel pencils tend to scratch the surface. For this reason, I use Marshall's Photo Pencils and the waxier pencils such as Prismacolors to add color or to enhance certain areas on both of these papers, and I do very little erasing or blending.

On other paper surfaces, such as Flaxen Weave and Museum Parchment, I mainly use Conté pastel pencils and Marshall's Photo Pencils to add color. The coating is tougher and the surfaces are more textured than those of the Soft Suede and Classic Velour papers, making it easy to blend and recolor without causing damage. You can also use watercolor pencils—either dry or with a touch of water—for a flow of color. Be careful not to add too much water, as the inks are water-soluble and will mix with the colors and turn muddy. (The inks will not, however, run like they do on other coated inkjet papers.) Even with these tougher coatings you can still pick the coating up if you rub too hard or use the eraser too much, so a gentle approach is recommended.

The textured surface of artist's watercolor papers, such as Arches Cold Press, is stronger than those of the coated inkjet papers. Blending and removing unwanted color is not as risky in terms of damaging the surface. However, the paper will deteriorate from the acids in the oil paint and the inks are still water-soluble, so the safest choices of coloring mediums are pastels, Conté pastel pencils, Marshall's Photo Pencils, dry Faber-Castell watercolor pencils, or Prismacolor color pencils.

REPAIRING TRACKING WHEEL MARKS WITH PASTELS: MONK CARRYING TEA KETTLES

1. This image was taken with Fujichrome MS 100/1000 slide film. It was printed on Charcoal R inkjet paper and picked up some "pizza wheel" tracks.

2. This is the same image with the tracks repaired using Conté pastel pencils.

1

2

STEPHANY BY THE VINES

1. The original image was a Kodak black-and-white infrared negative. I scanned it on the Nikon LS 2000.

2. I added a white space around the image when scanning by choosing Image > Canvas Size and adding 1 inch to the dimensions, keeping the background color white. Then I put the file in RGB mode and added a brown border. To do this I clicked on the background box and chose a brown color. Next I chose Image > Canvas Size and added 1 inch to the dimensions.

 The brown border appeared around the image. I opened up Auto FX Photo/Graphic Edges and selected a finishing edge—# 308—from Volume I, which affected the brown border.

3. I printed the image out onto 90-lb. Bienfang watercolor paper and handcolored it with Conté pastel

pencils. The Bienfang paper has a very nice texture for holding the pastels. After coloring, I sprayed the print with Krylon Workable Fixatif to set the pastel to the paper. When that had dried, I sprayed on a final fixative—Krylon Crystal Clear—to preserve the image.

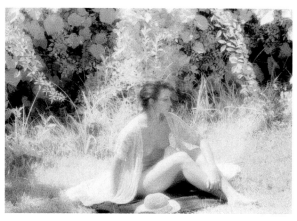

1

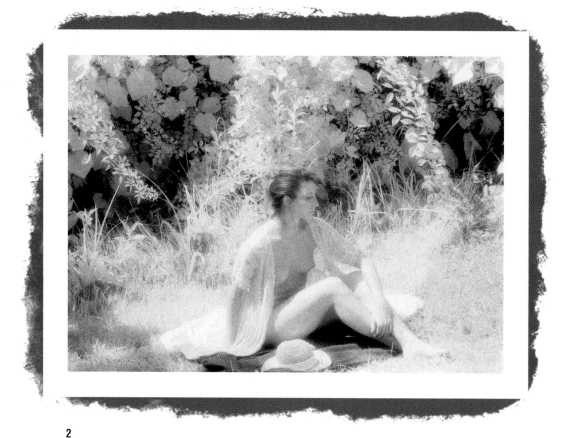

2

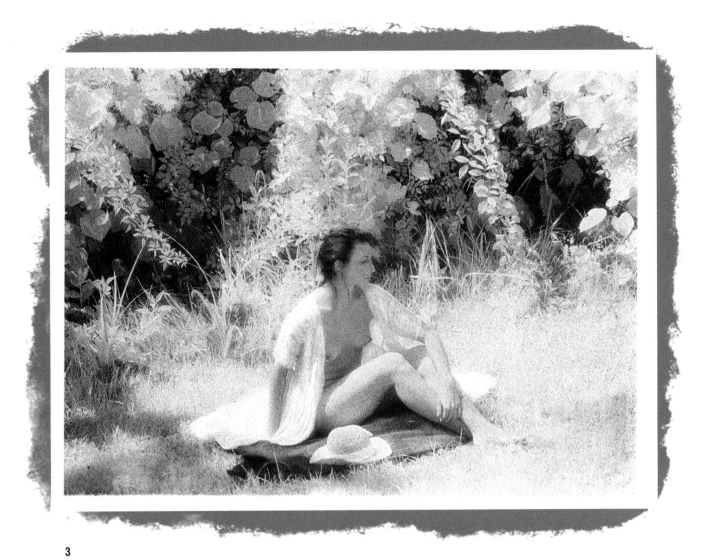

3

MOM AND ME

1. This is the original damaged print.

2. Here is the print after it was repaired in Photoshop. I used the clone tool (rubber stamp) to remove defects and scratches and to generally repair the image. Next I used Color Balance to add a bit of blue, as it was very yellow with age (blue counteracts the yellow tone). Then I went into Levels and used the eyedropper to pick up a nice white and a good black, thereby adding a bit of contrast.

3. I printed the image out on Lumijet Classic Velour paper, then used Conté pastel pencils to enhance the eye and cheek colors slightly. The slight "screen texture" was present on the original photograph.

1

2

3

YAKS ON THE ROAD

1. This is the original image, made from the scan of a poorly exposed slide. The sky is too white and the light on the yaks is not even because I was so scared when I saw these beasts that I forgot to open up a stop to compensate for the back-lit situation. I snapped the shot and ran! The yaks are silhouetted. The image was printed on Lumijet Flaxen Weave inkjet paper.

2. This is the print after I handcolored it with Conté pastel pencils.

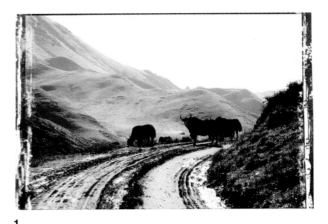

1

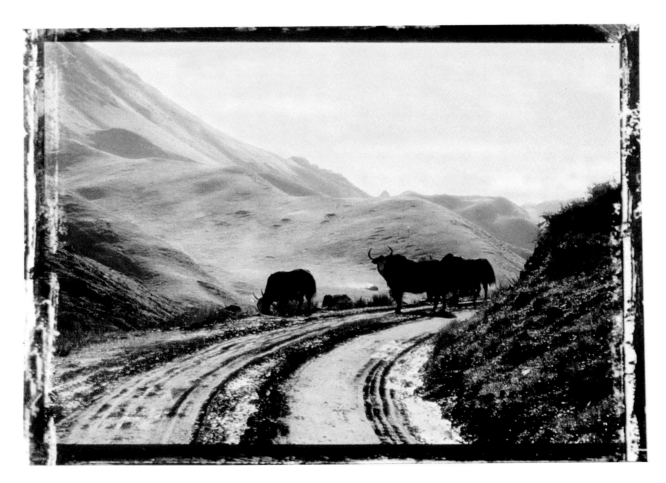

2

HANDCOLORING TECHNIQUES AND TIPS

PASTELS

Using pastel pencils is a great way to learn how to hand-color. It is easy, fast, and clean (no smelly chemicals, no staining, no mess). Pastels are also economical; a little bit goes a very long way. They can be blended with a fingertip or a cotton swab. The color can be reduced or taken off with a kneaded eraser without leaving any telltale smudges behind on the surface. If you don't like the color you have applied, remove it and lay another color down. Nothing could easier or more fun!

I especially enjoy working with Conté pastel pencils because, as in the story of Goldilocks and the Three Bears, they are neither too hard nor too soft—they are just right! Conté pencils come in a great selection of 48 beautiful colors that can be blended or overlaid to produce even more colors. The bonus when working with Conté pastel pencils is that you can use them on photographic papers and coated inkjet papers as well as artist's papers.

The big secret to working with pastels on both inkjet and artist's papers is that you must set the pastel to the paper with a workable fixative such as Krylon Workable Fixatif after you finish coloring. After the workable fixative dries (5 to 10 minutes), you can use a final fix such as Krylon Crystal Clear, or Krylon UV-Resistant Clear Gloss or Sureguard McDonald Pro-Tecta-Cote, both of which have a UV inhibitor. I like Sureguard's Matte Special spray, for a soft luster finish. This will ensure that the pastels will not smear and will protect them from atmospheric pollutants.

WORKING WITH PASTELS IS EASY IF YOU REMEMBER THESE THREE IMPORTANT TIPS:

1. Pastel colors are mixed on the image itself and not on a palette as with other mediums. You can blend colors or layer color on the image to get a different or more saturated color.

2. Work from top to bottom to avoid disturbing or smearing the color already laid down.

3. Work from dark to light. Dark colors go down first and then lighter or accent colors. The very last thing I do is to add my "sunshine" pencil (a pale golden yellow—#47 in the Conté set) to the image to highlight and bring out where the light may be gilding leaves or reflecting off of objects.

TIP

Spray on your workable fixative very lightly. Pastels are water-soluble and will dissolve under a heavy coat. It is better to give the print two separate coats rather than one heavy one. Always wait for the first coat to dry, and then apply the second, if desired. Also, *always* spray fixatives outside and do not breathe in the fumes. Fixative sprays are toxic.

COLOR

There are many books on color available at the library or in major bookstores or art supply stores, but the best way to learn about color is to study nature. Go for a walk and really look at the landscape. Pick up a leaf and see how many shades of green there are. Look closely at the bark of a tree; tree bark is sometimes brown, but most often is a subtle mix of grays, greens, and reddish browns. Watch the sunset. Really observe how the sky changes—how the clouds become pink and their undersides, a darker purple-pink. Watch a storm approach; see how the sky turns bluish-purple, how the light changes and thereby changes the colors in the landscape. In early spring, watch the colors of the foliage change from reds, yellows, and yellow-greens to deep greens.

TIP

Take photographs of the spring, fall, summer, and winter colors in a landscape and keep these as reference prints. Take pictures of cloud formations and sky color shots also. It's a good idea to take photos of the same scene in the morning, at midday, and in the late afternoon. See how the color changes from cool to warm. I have a box full of these reference shots; on a cold, dreary day, it helps to have these to refer to for your coloring.

Cat by Bird Bath
This is the handcolored version of a manipulated Polaroid Time-Zero image. After scanning the image on a flatbed scanner, I printed it out onto Arches Cold Press watercolor paper very lightly as a sketch for a pastel rendering.

HANDCOLORING TECHNIQUES AND TIPS

HOW TO HANDCOLOR

STUDY YOUR PRINT AND SELECT A COLOR PALETTE. If you are working on a landscape, decide if you are going to make it a spring, summer, fall, or winter landscape. You wouldn't want to use too many yellow-greens in a midsummer green tree (perhaps just on the tips of the leaves, where the sun may be shining through); the bulk of the tree should be a deeper, darker shade of green.

BASIC COLOR MIXING

- If you need colors that are not in your set, mix them yourself.
 Red + Yellow = Orange
 Red + Blue = Purplish-Magenta
 Red + Green = Gray
 Blue + Yellow = Green
 Blue + Orange = Gray

- A color can be muted or reduced in intensity by overlaying or mixing it with white.

- A color can be darkened in intensity by mixing with black or dark gray.

TIP

Layering color is applying one color over another color to obtain a different color effect. If I layered colors by cross-hatching blue in one direction and red in the perpendicular direction, it would give the area a purplish look. You can also layer by applying one color, spraying with a workable fixative, allowing the spray to dry, and then applying another color on top of the previous color.

On the other hand, in the spring, the colors would be lighter and would have more of the yellow-greens.

ATTACH YOUR PRINT TO A STURDY SUPPORT. I tape my print to a sketchboard or clipboard to hold it steady while I am coloring.

ADD COLOR AND BLEND IT WITH A COTTON SWAB OR A TISSUE WRAPPED AROUND YOUR FINGER. (Be sure to tuck the bulk of the tissue in your palm, so that the edges do not disturb any areas already colored.) The color will spread out nicely and easily. Use light circular movements so that you don't rub your color completely off. If you want more intense color, just pat the color down instead of rubbing it.

WORK WITH DARK COLORS FIRST, THEN LAYER LIGHTER COLORS ON TOP OF THE DARKER SHADES. If you want to layer your colors and have reached a point where the print will not take any more color, spray the print lightly with a workable fixative, wait for it to dry (about 10 minutes), then add more color. This works well with up to five different layers of color.

REMOVING COLOR

A kneaded eraser—available at any art supply or craft store—is all that is needed. These inexpensive erasers look like hard blue rectangular pieces of gum. They work by lifting the color off of the paper without disturbing the paper's fibers. Start by kneading the eraser in your hand to warm it up and make it pliable. Kneaded erasers can be shaped into a point to lift color out of a small area, such as around eyes. They can easily be torn apart so that you can work with smaller pieces, and they can be cleaned by stretching them out and rekneading them. When your eraser cannot hold any more pigment or color, discard it.

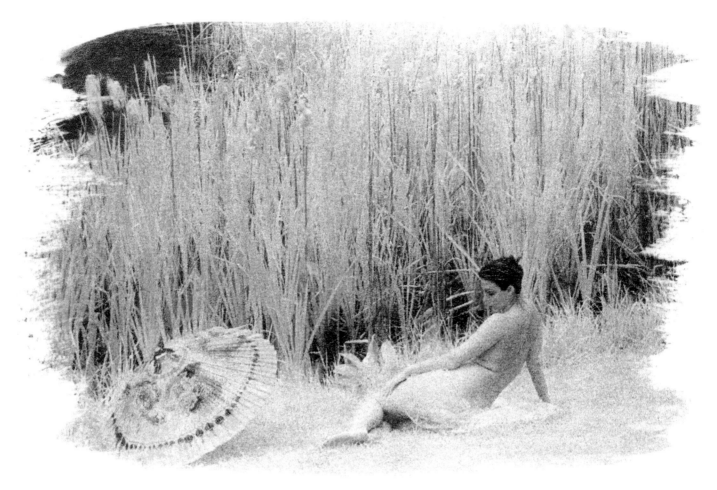

Stephany by the Pond

The original image was shot on Kodak infrared film. After adding a painterly edge (Auto FX Photo/Graphic Edges Vol. V, #245), I printed it out on Tapestry X paper and handcolored with Marshall's Photo Pencils.

PART II

Turkish Bath at Kallithea,
Rhodes, Greece

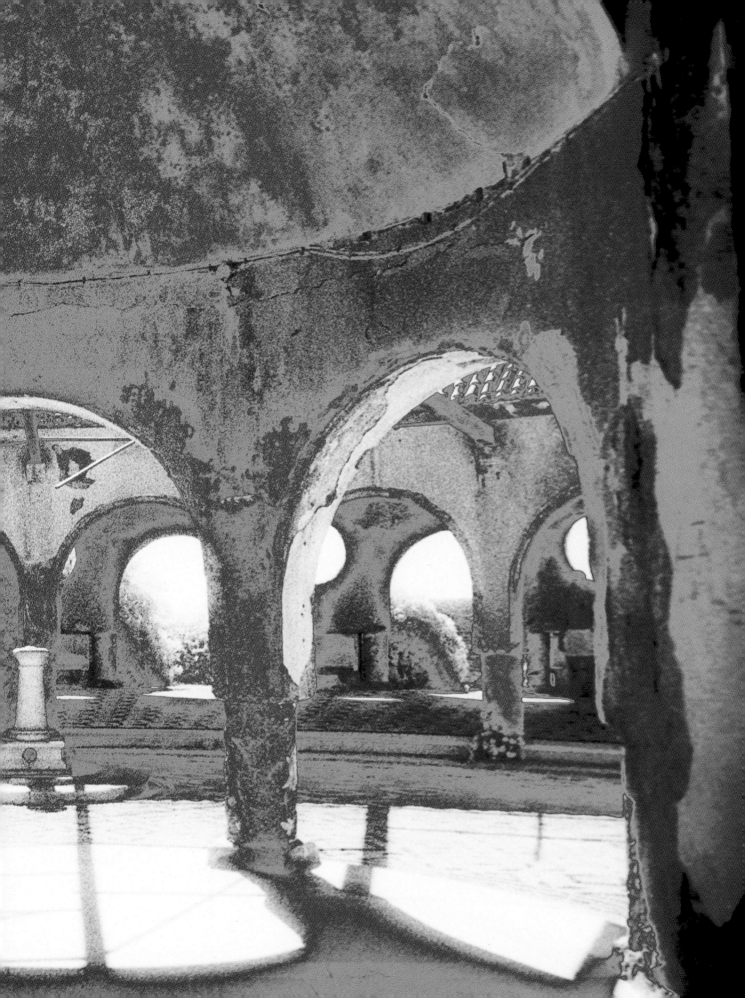

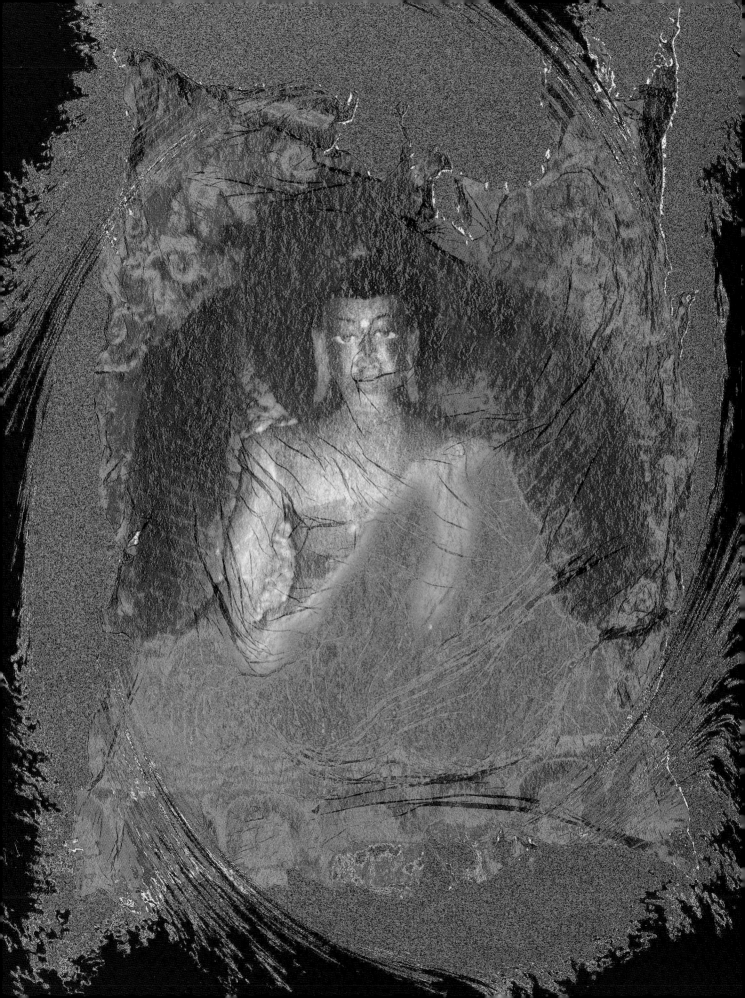

CREATING IMAGES STEP BY STEP

In this chapter, each image will be accompanied by a step-by-step explanation of how I used each tool or filter to achieve each effect. Adobe Photoshop was used to create all of the final images. With Photoshop, there are always many ways to reach the same end, but if you are a neophyte, knowing one way is usually enough. As you acquire more knowledge about this fabulous tool, you will discover the different avenues you can take to achieve the effects you want.

To use any of Photoshop's tools, you must choose it by clicking on the corresponding icon in the toolbox. The toolbox is located on the right side of the screen, but can be moved if you click on the title bar and drag the box to a new destination. Some tools have more than one version. This is indicated by a small triangle in the lower right corner of the box; clicking on it launches a pop-up menu with the names of the different tools. When a tool is selected, an option bar containing option settings will appear in the menu at the top of the screen.

Cosmic Buddha

SELECTION AND FEATHERING

To effect a change in an image, you must first define the area you wish to work on. This is done by "selecting" the area with a selection tool. There are four selection tools: marquee, lasso, magic wand, and pen. Once an area has been selected, only that area will respond to filters or commands. You also may "invert" the selection and work in the surrounding areas without affecting the selected area.

To select more than one area in an image, hold the Shift key down while making your selections. If the wand seems to be selecting too much, go to the option bar (located at the top of the screen) and reduce the tolerance value.

To give a selection smoother edges, you can soften the color transition between edge pixels and background pixels by using the antialiasing command before making the selection. Antialiasing is available for the lasso, polygonal lasso, magnetic lasso, elliptical marquee, and magic wand tools. Go to the top of the screen and click on the Antialias box. This method softens only the edges of the pixels selected, so no detail is lost.

You can also choose to feather a selection's edges by choosing Select > Feather, then entering a value for the Feather Radius and clicking OK. Feathering blurs edges by creating a transition space between the selection and the surrounding pixels. This blurring can cause some loss of detail at the edge of the selection, so pay attention to the size of your Feather Radius. Try feathering with a radius of 5, then try 25 on the same selection—the difference will be easily discerned. I generally keep the value at around 5 to 10 pixels, depending on the size of the image. By selecting a high value for the Feather Radius, you can also use this tool to create a halo effect around a selection.

> **TIP**
> Photoshop offers so many selection tools that you may not always be sure of which one to use. I choose the magic wand when the subject is an entirely different color from the background. I use the pen tool when the subject has a linear design, and I use the lasso when it is a less definite area, such as an area of leaves on a tree that I wish to select and lighten.

OLD CAR AT ANTIQUE SHOP

SELECTION TOOL: magnetic pen
ADJUSTMENT TOOLS: Hue/Saturation; Paths; Feather; Inverse

1. This image was shot at ISO 125 with Fuji NPS 160 color negative film. I used a Nikon LS 1000 transparency scanner to scan it at 100 percent at 2700 ppi.

2. I chose Image > Adjust > Hue/Saturation and desaturated the entire image, leaving it in the RGB mode. When you use this command, you get a dialog box that includes a saturation slider bar. If you move the slider to the right, you will increase saturation or color; if you move the slider to the left, it gradually removes color. This command is preferable to the Desaturate command (Image > Adjust > Desaturate or Command-Shift-U) if you wish to control the amount of color being removed. If you use the Desaturate command, all of the color is instantly removed. I didn't like the result when I desaturated this image, so I returned to the color version.

3. Using the magnetic pen tool, I selected the car. I created a path around it, then converted the path into a selection by choosing Make Selection from the pull-down menu in the Paths palette (Window > Show Paths).

4. Next I chose Select > Feather and set a Feather Radius of 4 pixels so that there would not be a sharp line dividing the selected area and the background.

5. Reversing my selection (Select > Inverse or Command-Shift-I), I kept the car in color and desaturated the background. Reversing the selection allows you to do anything you want to the background and not affect the selected area—in this case, the car.

6. I went back to my original selected area—the car—using the Inverse command (Select > Inverse) again and desaturated it (Image > Adjust > Hue/Saturation) by sliding the saturation bar over to the left (to -58). I left the background in color. Since the file was still in the RGB mode, it was possible to print the image in color (on Bienfang charcoal paper) with the car remaining black and white.

1

2

3

4

5

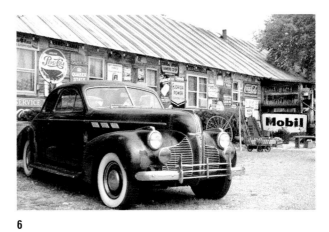

6

CONVERTING BLACK-AND-WHITE FILES TO COLOR

When working in Photoshop, I have often wished that I had more color slides or color negatives. Since I do have many black-and white-negatives, the solution I have found is to change my grayscale images to color and add "tone" to the final image. I have created some exciting effects while doing this.

The following images are examples of taking a black-and-white negative and working with it in the RGB mode. This can be a valuable creative tool that sometimes changes the entire image by adding exciting and unusual effects.

FEMININITY

ADJUSTMENT TOOLS: Color Balance; Curves; rubber stamp
PLUG-IN SOFTWARE: AutoEye; Auto FX Photo/Graphic Edges

1. I shot the original negative at an ISO of 50 on Ilford SFX 200 film in the studio. I used modeling lights and a red #29 Tiffen Filter. The image was scanned at 100 percent at 2700 ppi.

2. My first step was to change the file's color mode from grayscale to RGB (Mode > RGB). Once in RGB mode, I went to Image > Adjust > Color Balance, where I added about 64 red and 40 yellow to give the image a sepia or brown tone.

3. Next, I opened the Curves dialog box (Image > Adjust > Curves or Command-M) and played with the control bar until I liked the color and solarization.

4. Here is the image after the Curves adjustments were made and AutoEye was applied. AutoEye is plug-in software made by Auto FX that works with Photoshop. It is a great tool for sharpening and correcting color automatically. You can also use it manually if you choose.

5. I decided to finish off the print by adding a blue border and edges. To do this, I opened up Auto FX Photo/Graphic Edges and selected Volume I, #58. This software is another Photoshop-compatible plug-in. It includes 10,000 edges, which come in volumes with numbered edges grouped by type. You can use the edges to go graphic or choose something more painterly. The program also includes lighting effects and a selection of textures to add to your images.

6. I felt that the turquoise patches near the model's legs were a distraction, so I went into the toolbox and used the rubber stamp to clone them out. To use this tool, you first choose a brush size by clicking on the brush icon at the top of the screen, then choose your opacity (I chose 98 percent). Then you move your brush to the area you want to copy and click while holding down the Option key. Move to the area you wish to remove, and click to deposit a clone of the information you selected first. Once I had used the rubber stamp, the image was softer and more pleasing to the eye. I printed it on Lumijet Preservation Series Charcoal R paper.

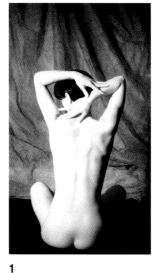 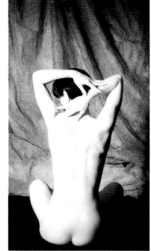

1 2

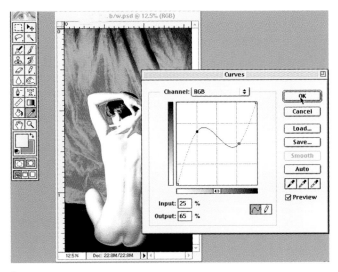

3

4

5

6

NUDE IN NET

ADJUSTMENT TOOLS: Invert; Color Balance; Curves
PLUG-IN SOFTWARE: Auto FX Photo/Graphic Edges

1. The image was shot outdoors with Kodak high-speed black-and-white film (ISO 250). I used a golf practice net as a backdrop. The negative was scanned with a Nikon LS 2000 scanner at 2700 dpi.

2. Using the plug-in software program Auto FX Photo/Graphic Edges, I added a border (Vol I., #58).

Then I inverted the image (Image > Adjust > Invert or Command-I).

3. I converted the file to RGB (Mode > RGB). Then, I chose Image > Adjust > Color Balance and added -12 yellow and +6 red to get a sepia tone.

4. Next, I inverted the image a second time.

5. Finally, I chose Image > Adjust > Curves (you can also hit Command-M) and played with the curves bar until I liked the solarization and colors.

1

2

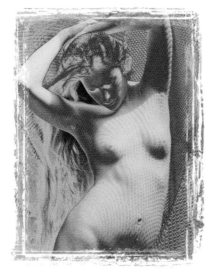

3

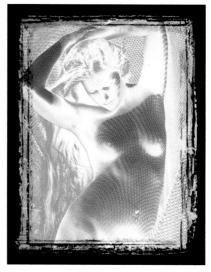

4

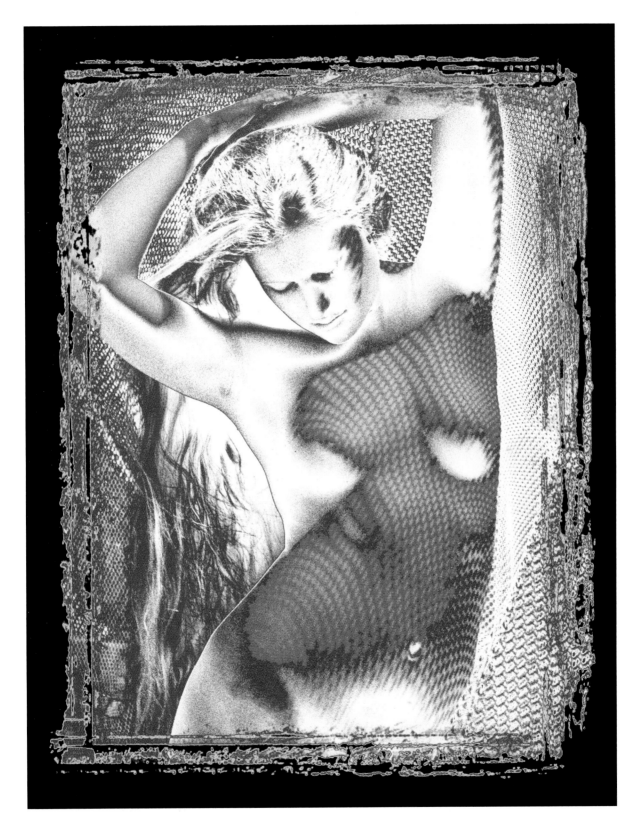

5

VENETIAN MASK, YEAR 2000

ADJUSTMENT TOOLS: Levels; Invert; Curves
FILTERS: Find Edges
PLUG-IN SOFTWARE: AutoEye; Auto FX Photo/Graphic Edges

1. *Venetian Mask* is a toned black-and-white photograph made from a Kodak T-Max 100 negative scanned on a U-Max Power Look II flatbed scanner. Because the image looked flat and did not have the correct tonal values, I used the Levels command to bring out the best tonal range for the print. To access Levels, I chose Image > Adjust > Levels (not Auto Levels). The Levels dialog box appeared, showing a histogram of the tonal range in the image. At the right of this box, there are three eyedroppers. The black eyedropper represents the dark tonal range in the image, the gray one represents the midtones, and the white one represents the highlight tones in the image. I clicked on the black eyedropper, then clicked on the darkest area of the image.

 Next, I clicked on the gray eyedropper, chose a midtone area in the image, and clicked. Finally, I clicked on the white eyedropper and clicked again on the whitest area in the image. I could see the change in the tonal values immediately. When I was satisfied with the tonal range, I replaced the 0 in the first box near Output Levels with 5 and the 255 in the second box with 245, then clicked OK. This lightened the print a bit. I have found that if this is done, when you print the image, not as much ink will be deposited on the print—you will avoid the bronzing or blocking up of the dark areas in the print. Here you can see the difference between the contrast and tonal ranges before and after using the Levels command.

2. Next, I chose Filters > Stylize > Find Edges. When you use this tool, the image gets very light and the lines are emphasized. It looked too light, so I decided to invert it.

3. I inverted the image (Image > Adjust > Invert or Command-I). This was better (I liked the edges, which were now white), but too dark.

4. I went into Curves (Image > Adjust > Curves), and used the graph line to play with the image until it solarized—the effect I wanted.

5. The image lacked snap or contrast, and it wasn't as sharp as I would have liked it to be, so I applied AutoEye (Filter > AutoEye) to it. This change was perfect. It lightened the image a bit too much, but the contrast and sharpness were there. I next went back to the Curves command and darkened the image a bit. Now it looked like what I had in mind.

6. Looking at the image, I realized that there was too much space at the bottom. I cropped the image to make it look more balanced and cloned some information at the top (there seemed to be a diagonal light line going through the top of the mask). I also added some of the rusty color to the top left corner.

7. Next I went into Auto FX Photo/Graphic Edges and selected an edge (#58 from Volume I). Then I went into the program's textures and added a dark gold tone around the edge. The edges and texture set the image off beautifully and I was very pleased with the final image.

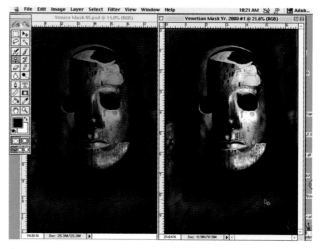

1

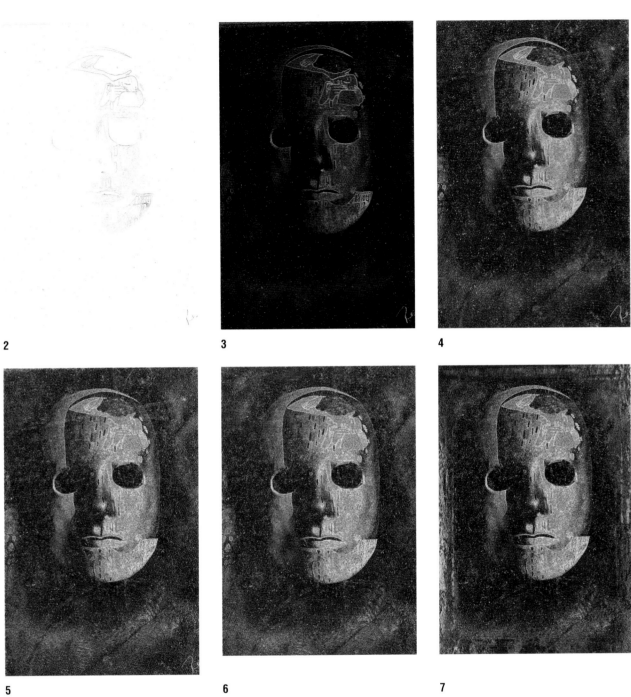

2

3

4

5

6

7

CONVERTING COLOR IMAGES TO BLACK AND WHITE

When I traveled to eastern Tibet to photograph for a month, I had to consider very carefully which films to take because of the airline's limitations on baggage weight and the number of carry-ons. This was a very hard decision. Ultimately, I decided to take mostly color slide film and APS film for my two Canon cameras—Elph and EOS-lite.

I do most of my photographing with the Canon EOS 1N, which is lightweight and easy to use. However, there are times when even the EOS 1N is too heavy or bulky and I just want to walk around with a very lightweight automatic camera and "point and shoot." In that situation, my EOS-lite is perfect. Not only is the camera smaller, but the film cartridges (APS) are smaller and allow 40 shots. Images shot with this camera and film can be blown up to 9 × 12 inches with very little visible grain.

I was very happy with my decision to take mostly color films because I can very easily change my color files into black-and-white or warm-toned files for possible handcoloring. I also have the choice of printing in either color or black and white. It makes sense and it saves time and money, plus there is the convenience of carrying only one film type.

There are several ways to convert a color file into a black-and-white file:

1. Leave the file in RGB mode and desaturate the colors, by going to Image > Adjust > Hue/Saturation. Move the slider bar under Saturation to the left. This command gives you the control to remove as much color as you want. Then you can go to Image > Color Balance and add a bit of magenta and some yellow to get the exact tone you want.

2. Change the mode by selecting Image > Mode > Grayscale. The image will immediately go into black-and-white tones. The new version of the image will not have a wide tonal range. This is my least favorite method.

3. You can take your color file (RGB) and go to Image > Mode > Lab Color. Lab Color mode will allow you to work in the Alpha 1 channels for tonal adjustments. Choose Windows > Show Channels. Go to the A and B channels and delete them by dragging them to the trash can icon in the layer's palette. This leaves you with the Alpha 1 channel, which is where you will be adjusting the image. You can now bring up the Brightness/Contrast control (Image > Adjust > Brightness/Contrast) or the Levels control (Image > Adjust > Levels) to adjust the tonal range in the image.

4. Take your open RGB file and go to Layer > New Adjustment Layer > Channel Mixer. The Channel Mixer dialog box will immediately appear. Check OK. Another dialog box will appear; in this one, check Monochrome. As soon as you check this, your image will appear in black and white. You can now go into each channel—Red, Green, and Blue—and adjust the image as you like. You can watch the image change as you move the slider bars. Now, if you bring up the Layers palette (F7), you will notice that there are two layers: your color image (background) and the channel mixer layer. When you are satisfied with your tonal range, you must flatten the image before printing or applying other filters to it.

You can also click on the second layer (RGB mode) which is now really a black-and-white image in the RGB mode, then choose Image > Adjust > Curves. Under curves you can also select the three channels (Red, Blue, and Yellow) separately and adjust the image visually. The channels will say Red, Blue, and Yellow, but the image will be black and white. Obviously, this is the most complicated of the four techniques, but it gives you far more control than the other methods and renders a beautifully toned black-and-white image.

USING THE HUE/SATURATION TOOL TO REMOVE COLOR: MELISSA WITH WHITE CLOTH

ADJUSTMENT TOOLS: Hue/Saturation; Color Balance; Curves
FILTERS: Gaussian Blur

1. The original image was taken with color slide film (Fuji Astia) and a #2 soft filter. Here is a straight print from the slide, which was scanned at 2700 ppi on a Nikon LS 2000 scanner. When I looked at this image I knew that it would have a classic look if it were in black and white. So I decided to remove most of the color and then tone the image a rich brown color.

2. First I chose Image > Adjust > Hue/Saturation and moved the saturation slider to the left. Here is the desaturated image.

3. Next, I added some color using the Color Balance command. I added about 50 magenta and 30 yellow to give the image a rich brown tone. Then I used the Curves command (Image > Adjust > Curves or Command-M) to make it darker by lowering the graph line from the center. I wanted to add a slight softness, so I then chose Filter > Blur > Gaussian Blur and brought up the dialog box. I set the radius at 0.9 pixels to just slightly blur the image.

4. Here is the final image.

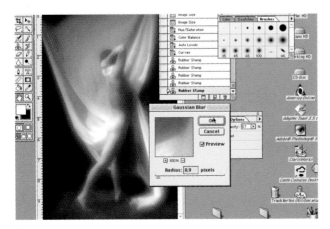

1

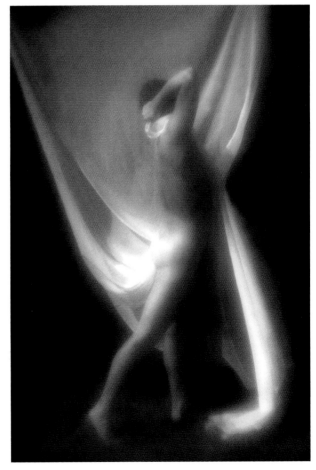

4

3

CONVERTING AN IMAGE TO THE LAB MODE: NOMAD TENT IN DEGE COUNTY

ADJUSTMENT TOOLS: Show Channels; Brightness/Contrast; Levels; Color Balance

1. This image was taken with Fuji Astia color slide film and scanned at 2700 ppi on a Nikon LS 2000 scanner. I knew when I took it that it would be a great black-and-white image.

2. I changed the color mode to Lab (Image > Mode > Lab Color). I then chose Window > Show Channels. I deleted the a and b channels, leaving only the Alpha I channel.

3. In order to adjust the image's tonal range, I opened the Brightness/Contrast dialog box (Image > Adjust > Brightness/Contrast). I also went into Levels (Image > Adjust > Levels or Command-L), where I used the eyedropper to choose a deep black and a nice white for good contrast.

4. Next I changed the color mode to grayscale (Mode > Grayscale). After the image was in the grayscale mode, I changed it to RGB (Mode > RGB). This allowed me to tone the image by choosing Image > Adjust > Color Balance. I added a little red and a bit of yellow to get a nice sepia tone.

5. Finally, I printed the image out on Lumijet Charcoal R paper and handcolored it with Conté pastel pencils. The image now looks the way I first imagined it.

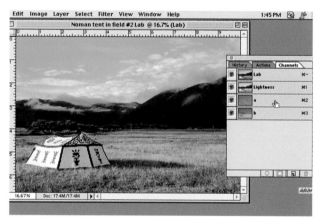

1

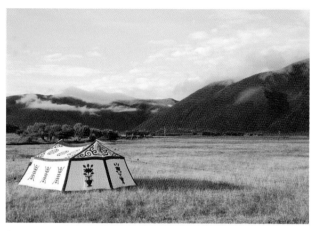

2

3

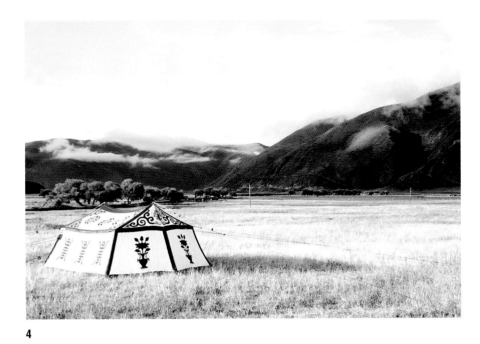

4

5

CONVERTING A COLOR FILE INTO A BLACK-AND-WHITE FILE USING THE CHANNEL MIXER: NOMAD AND YAK HERD

SELECTION TOOLS: lasso; magic wand
ADJUSTMENT TOOLS: Layers; Channel Mixer; Curves, Feather; Color Balance, Color Picker; paintbrush

1. This image is a color print taken with the Canon EOS-lite camera using Fuji Smart APS film (ISO 100). I was in a rush because the herder was moving quickly across the mountain range. I jumped out of the van, ran up the hill, and had only enough time to point and shoot.

 The APS negative was scanned at 2700 ppi, 1.059 inches wide by 0.627 inches high, giving a 13.9MB file. My first step was to change the print size to 10 × 5.923 inches, having unchecked Resample Image in order to keep the file size the same. This is the resized color image.

2. Next, I chose Layer > New Adjustment Layer to open the New Adjustment Layer dialog box. I went to Type and selected Channel Mixer. There, I chose Monochrome.

3. Once the Monochrome box was checked, the image became black and white. I opened the Layers palette (F7). The first layer was Channel Mixer; the second was the color image. I double-clicked on the Channel Mixer and the Channel Mixer dialog box when the source channels appeared. I was then able to adjust each channel—Red, Green, and Blue—as I liked.

 Another option would have been to click on the second layer (color image) in the Layers palette and then choose Image > Adjust > Curves. In Curves you can also select the three channels separately and adjust the image visually.

4. I had visually adjusted my image to create a good black-and-white image with a wide tonal range, but the area with the yaks was still a little blocked up (meaning that there was little information in the dark areas), so I selected them with the lasso tool. Under Select > Feather, I set a Feather Radius of 25 pixels. This softened the change of tones between the darker and lighter areas of the image.

5. I went back to Curves and selected the red channel, then lightened the black areas of the yaks by pulling down on the diagonal line. The yaks now looked lighter and more separated from each other in tonal values.

1

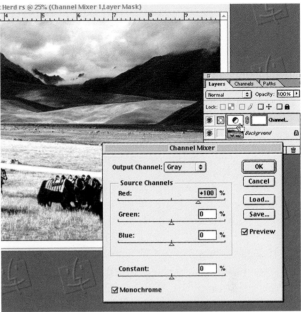

2

3

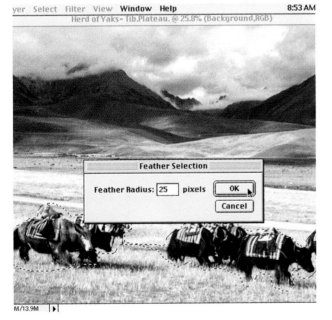

4

5

6. I went back to the Layers box and clicked on the right side arrow to flatten the image. The image was black and white, but since it was in the RGB mode, I could tone it by bringing up the Curves dialog box and selecting the channels.

7. I tweaked the red channel and added yellow by pushing up on the blue channel. I could also have chosen Image > Adjust > Color Balance and adjusted the color there.

 Here are the color print, the black-and-white print, and the sepia-toned print of the same image.

8. I decided to print the sepia-toned print. However, after printing it, I noticed that the field's tonality was a little light, so I used the magic wand to select the area around the yaks. I darkened the selected area in Curves (Image > Adjust > Curves), but it was not enough—the image still needed more tone.

9. First, I chose a foreground color in the same tonal range as the field. I did this by double-clicking on the foreground color icon found in the toolbox. When the Color Picker dialog box appeared, I used the eyedropper to sample the image and find the perfect shade. Then I clicked OK. Next I selected the field area with the lasso. I chose a large brush and set the mode to Normal, then went to the options and decided on an opacity of 46 percent and began to paint in the desired tone. If you need more color, go back and raise the opacity to a higher percentage. Or paint it again.

10. Here is my final image.

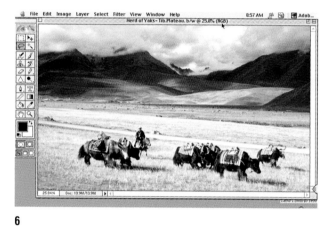

6

7

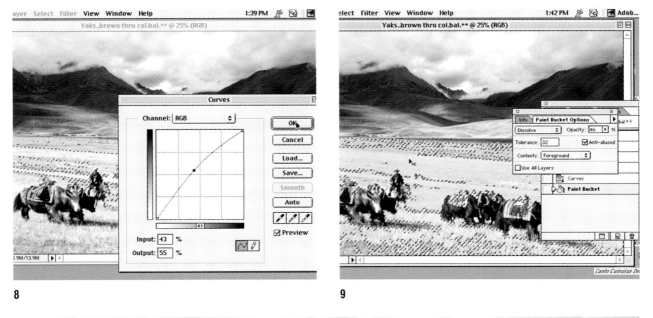

8

9

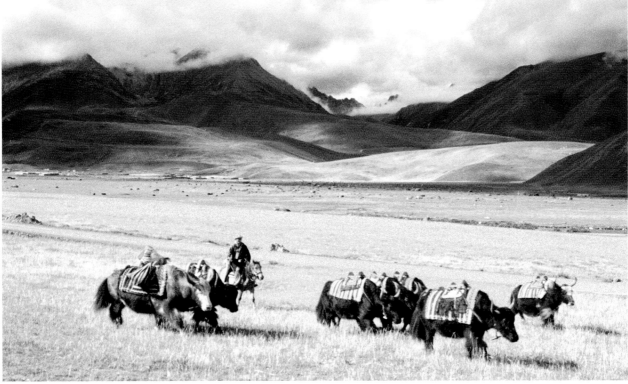

10

BORDERS AND EDGES

In traditional photography, photographs are usually presented without borders or edges; they are generally window-matted or dry-mounted on mount board and then framed with a plain, thin metal frame. Some photographers will go to the trouble of filing out the inside of the negative carrier to print a black border around the image. Others will leave a wide white border around the image.

Digital images, especially those printed onto artist paper and handcolored, are often perceived as more painterly than photographic. Auto FX Photo/Graphic Edges is a wonderful software that allows you to choose which frame best suits the image and also adds in a selection of lighting effects and textures to give the image a "finished" look. It is up to you to decide whether to stay basic and minimal or to create an elaborate border for your image. For some images, just a simple border is all that is needed. This can be done easily in Photoshop with the adjustment tool called Canvas Size.

LINDA BY THE FENCE

ADJUSTMENT TOOLS: Canvas Size; Color Picker
PLUG-IN SOFTWARE: Auto FX Photo/Graphic Edges

1. The image was created using Kodak infrared film, ISO 250 and a red #25 filter. Here is the image after I scanned it at 100 percent at 2700 ppi with a Nikon LS 1000 scanner.

2. Next, I applied an edge from Auto FX Photo/Graphic Edges (Volume I, #58).

3. I then went back to the original image and made a black border around the print. The first step was to make the background color (located in the toolbox) black. Just click on the small arrows under the foreground/background boxes and get black as your background color. You can change the color for your borders simply by clicking on the background box and selecting a color from the Color Picker dialog box that will appear. Another option is to use the

eyedropper to select a color from your image. In this case, the image is in grayscale so my color options were white, black, and gray tones.

The next step was to go to Image > Canvas Size and increase the dimensions by one inch. When I clicked OK, the image appeared surrounded by a black border.

4. Using the Auto FX Photo/Graphic Edges software again, I selected the same edge. Now the edge is applied to the black border and does not eat into the image.

5. For this version of the image, I made my background color a soft shade of gray (by clicking on the background box and selecting a shade from the Color Picker that appeared).

1

2

3

4

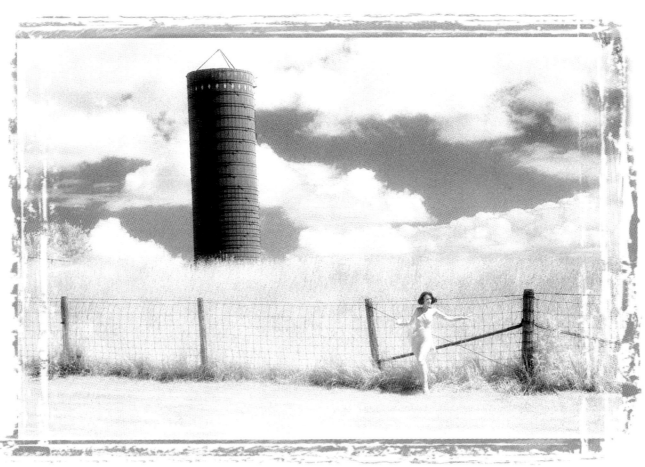

5

SOLARIZATION

Pseudo-solarization, also known as the Sabattier effect, is the total reversal of an image on paper. This effect differs from true solarization in that white bromide lines form between the light and the dark areas of the "solarized" print. True solarization occurs on film in the camera because of long overexposure. Because today's films have such an extensive exposure latitude, this rarely happens, hence the term Sabattier effect has become synonymous with solarization among photographers.

Generally speaking, pseudo-solarization of an image on paper or film is achieved in the developing stage of processing by reexposing the film or paper to light. In photography, there are so many variables involved in making a solarized print—such as the wattage of your light bulb, the point at which you interrupt the developing stage with the second exposure, the paper choice, the chemistry, etc.—that making solarized prints is difficult and very time-consuming. However, using Photoshop's Curves command makes solarization a very simple and quick procedure, giving you far more control and instant verification. There are so many possibilities with this easy command that it can become overwhelming.

BARN IN WOODBINE, ILLINOIS

SELECTION TOOLS: lasso
ADJUSTMENT TOOLS: Feather; Curves; Color Balance

1. The original photograph was taken with Kodak's high-speed black-and-white infrared film. I scanned it at 100 percent at 2700 ppi. It needed a lot of work to make it look snappy because the negative was a bit flat. It was an overcast day and not much infrared was recorded.

2. The first thing that I did was to select certain areas with the lasso tool. Next, I feathered (softened) the edges (Select > Feather) so that there was no telltale sharp edge between the areas lightened or darkened and the adjacent areas. Just as you do in the dark-room when burning or dodging, when you feather, you must keep the tool or your hand moving so that you don't leave obvious indicators of your doctoring.

3. Next, I went to Image > Adjust > Curves and darkened the print overall. Here is the image with all the "dodging and burning" finished.

4. Going back to the Curves command again, I made a nice "S" curve and solarized the image.

5. I converted the image to the RGB mode (Mode > RGB). This way, I was able to add color by going to Image > Adjust > Color Balance. I added red +12 and yellow -10, giving the image a nice dark brown tone. I printed the final image on Lumijet Preservation Series Soft Suede paper to enhance the dramatic black-and-white look. The smooth matte surface of this paper renders great sharpness and detail, giving images printed on it a photographic quality. The whole process was done with no odors and no mess—environmentally safe!

1

2

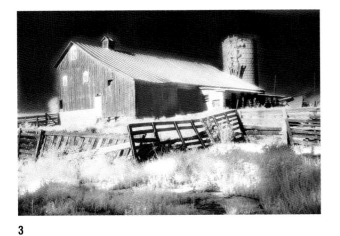

3

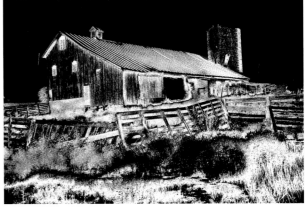

4

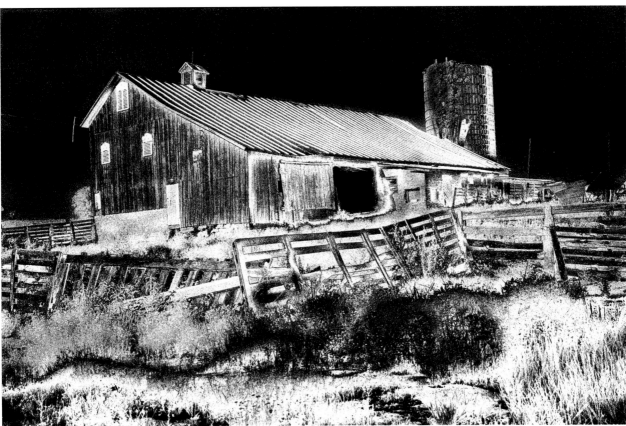

5

INVERTING AN IMAGE TO MAKE A NEGATIVE PRINT

Over the years, there have been many times when I have made negative prints that I liked better than the positive versions of the same images. Inverting can make a daytime scene into a nighttime scene, and it can also sometimes impart a mysterious, supernatural, or metaphysical mood to the image. Many times the negative print was more a reflection of how I felt about the subject than an accurate representation of how it looked when I took the shot. Like solarization, inverting is a time-consuming task in the darkroom, but a very easy command in Photoshop. And, of course, when you're working digitally, if you don't like your results, you can simply undo the command.

THE TOPIARY BUDDHA

ADJUSTMENT TOOLS: Invert; dodge tool; Curves
FILTERS: Plastic Wrap

1. This image was taken during the summer with Kodak high-speed black and white infrared film in the Ladew Topiary Gardens in Monkton, Maryland. My goal was to make it appear as if it had been taken in the winter after a snowfall. The first step was to scan the negative at 100 percent at 2700 ppi on a Nikon LS 1000 scanner.

2. Next, I applied the Plastic Wrap filter (Filter > Artistic > Plastic Wrap), setting the Highlight Strength at 15, Detail at 9, and Smoothness at 7.

3. I then used Command-I to invert the image. By creating a negative print, I made the subject look as if it were surrounded by snow.

4. Using the dodge tool—it looks like a dark circle on a stick—I lightened the foliage in the tree and on the right side of the evergreens. Now the image looks like a snowy nighttime scene.

5. I inverted the image again (Command-I).

6. Next, I converted the grayscale file into a color file (Mode > RGB). After the mode was changed, I went back to the Color Balance dialog box and added about -12 yellow and +20 red.

7. Then I went to the Curves dialog box (Command-M or Image > Adjust > Curves) and played with the curves until I liked the look of the image.

8. This is image #4 printed out on Hahnemühle Arkona paper and handcolored with Conté pastel pencils. Now the image—taken in the middle of the summer—looks like a daytime snow image.

1

2

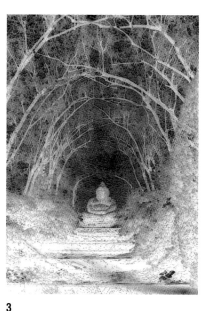

3

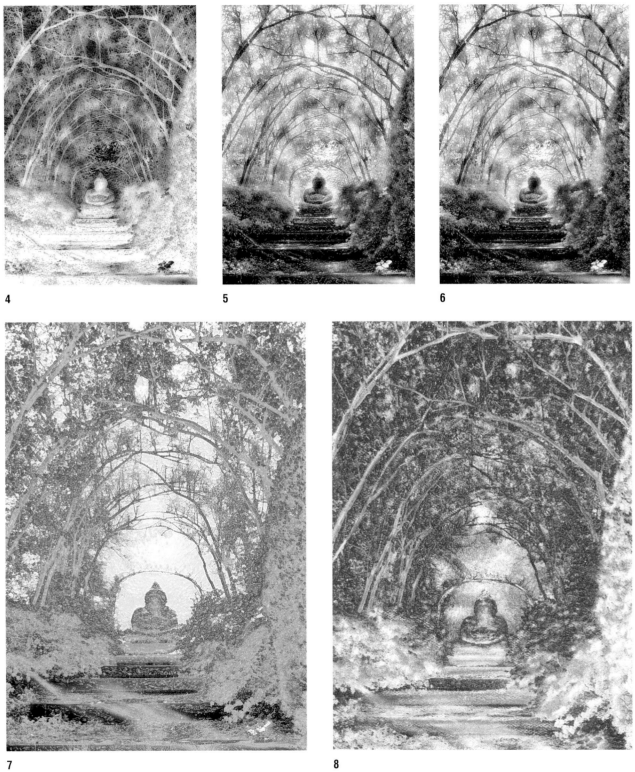

4

5

6

7

8

DUOTONES

Printing duotones allows you to increase or extend the tonal range of a black-and-white image. A grayscale image can show about 256 different shades of gray, but a printing press can only reproduce 50 shades of gray. So, if a grayscale image is printed using just black ink, it cannot display the range of tonal values that the same grayscale image printed in two (duotone), three (tritone), or four (quadtone) color inks—each reproducing about 50 shades of gray—can.

Converting your file is done very quickly and easily in Photoshop; just choose Image > Mode > Duotone. In the Duotone Options dialog box, there is a pop-up menu under Type that gives you three options: Duotone (two colors of ink), Tritone (three colors of ink), and Quadtone (four colors of ink). You can select your colors by clicking on one of the blank boxes and bringing up the Custom Colors dialog box. Selecting the best color combination of inks is easy because the screen image immediately changes as you pick the various colors. When you click on the color book in the Custom Colors dialog box, a list of colors formulated by Pantone and other companies will appear. Click on the shade you like and the image will instantly use it. When you like what you see, click OK.

Clicking on the graph square (the one with the diagonal line through it) pulls up the Curve Options palette. This palette controls the amount of ink used to print at the different brightness levels of the grayscale image. You can change the shape of the curve to set the different levels of ink in the highlights, midtones, and shadows. The curve allows you to tweak the color in the image by controlling the tones in the print; by pulling the diagonal line up or down you can make the tone lighter or darker.

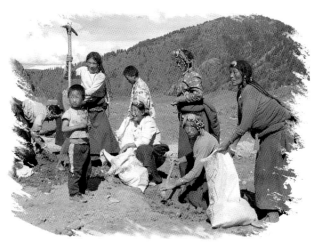

Tibetan Woman Working with Children
This image was taken with color slide film and converted to grayscale in Photoshop. I then put it in the duotone mode and selected an ink color for the highlights. Even though my screen image was very brown and white, it printed out in black and white here because I printed it with the ink set to black in the Printer Options dialog box.

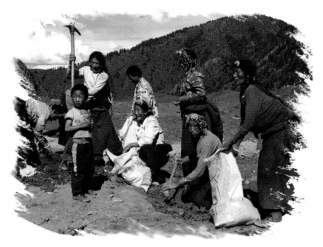

Here is the same duotone image printed with color inks.

TIP
There are also a number of duotone presets located in the Photoshop Goodies folder. To use these presets, click on Load in the Duotone Options dialog box. A Load dialog box will appear with preset color combinations. Select one and click on Load. The color combination will instantly be applied to your image. I suggest playing around with these presets when you have some free time and making note of the colors you like. This will save time when you are working on an image and do not want to spend time checking all of the presets out.

NUDE IN THE POOL

ADJUSTMENT TOOL: rubber stamp
PLUG-IN SOFTWARE: Auto FX Photo/Graphic Edges

1. This image was taken with Kodak black-and-white infrared film, ISO 320, with a Hoya red filter #25 and Nikon Soft Focus filter #2. The soft filter catches the light reflections in the water and expands them into starbursts. I scanned the infrared negative with a Nikon LS 1000 at a resolution of 2700 ppi.

2. After lightening up the whites and using the rubber stamp tool to clone in some extra sparkles on the right hand and arm, I added edge #370 from Auto FX Photo/Graphic Edges, Vol. 3. This edge added that water-like effect.

3. I didn't like the straight edges on the top and bottom so I cloned them out using the rubber stamp tool. Next, I opened the Duotone Options dialog box (Image > Mode > Duotone) and selected orange and black as my two colors. Then I printed the image on Lumijet Preservation Series Soft Suede paper.

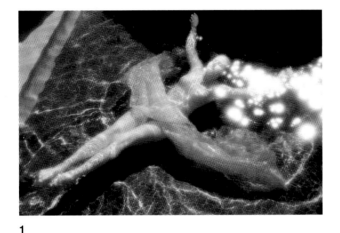

1

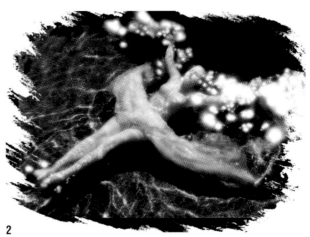

2

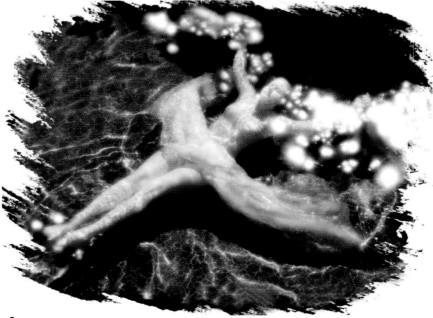

3

SCANNED POLAROID IMAGE AND EMULSION TRANSFERS

I love to make transfers from my slides and negatives. It is a very creative and satisfying process, one that allows me to add another dimension to the image. Image and emulsion transfers are accomplished by prematurely peeling apart a Polacolor negative from the substrate and transferring it onto a non-photographic surface such as artist paper, wood, glass, or metal. When the image dries it becomes integral with the substrate's surface. A rough watercolor paper can add texture and/or color to the finished image.

When these transfers are scanned, the scanner picks up the texture of the substrate in addition to the image itself and reproduces it in the printed image. Once in a while, this added structure will detract from the final image, but in most cases, it will add another interesting visual aspect to the final image. Another advantage to scanning your Polaroid transfers is that you can enlarge them to any size you wish.

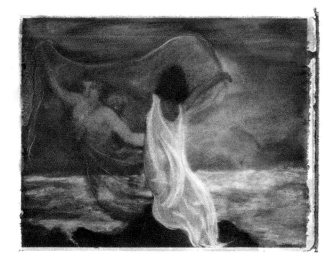

1

SAM'S DREAMS

ADJUSTMENT TOOLS: Invert

FILTERS: Find Edges; Add Noise

1. This is a scanned 8 × 10-inch Polaroid transfer. It was scanned on my U-Max Power Look 1200. The original transfer was made from an Agfa 1000 slide using a Daylab II slide printer.

2. I chose Filter > Stylize > Find Edges, then inverted the image (Command-I)

3. Finally, I chose Filter > Noise > Add Noise, set the amount at 86, and selected Uniform Distribution (which distributes the noise evenly and smoothly) and Monochromatic (which makes the noise all one color).

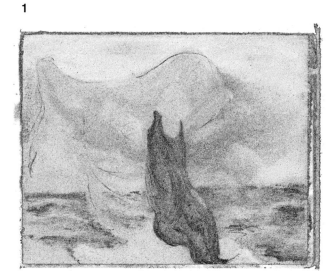

2

3

CREATING A MEZZOTINT EFFECT

Mezzotint is an intaglio printmaking technique. The surface of a metal plate is worked with a tool called a mezzotint rocker, which gives the dark areas a rough dot pattern. A mezzotint screen is a tonal screen for half-tone photography, employing a random pattern of dots.

Photoshop has a mezzotint filter (Filter > Pixelate > Mezzotint). This filter is usually too rough and dark for my taste, so I use the Add Noise filter and create a softer dot pattern, which I feel does not overpower the image.

The mezzotint look gives the image an Old World feel, which I find very appealing. It is reminiscent of images printed from the old Agfa 1000 transparency film.

1

SILHOUETTE NUDE

ADJUSTMENT TOOLS: Color Balance; Curves
FILTER: Add Noise

1. This image was made with Fuji Astia 100 film. The model was standing outdoors behind a sheer cloth on a summer afternoon. The slide was scanned at 100 percent and 2700 ppi on a Nikon LS 2000.

2. I chose Filter > Noise > Add Noise and set it at 96. I selected Uniform distribution and Monochromatic. This is the image with the Noise added.

3. I then chose Image > Adjust > Color Balance and added +24 red and -14 yellow. Finally, I darkened the image by going to the Curves dialog box (Image > Adjust > Curves or Command-M) and pulling the graph line down from the middle. I printed this image on Lumijet Flaxen Weave paper, which emphasized the grainy look of the image. The mezzotint effect gives the manipulated image a vintage look that the original lacked.

2

3

BOATS IN SYMI HARBOR, GREECE

ADJUSTMENT TOOLS: Hue/Saturation; Color Balance; Color
Picker; Canvas Size
FILTER: Add Noise
PLUG-IN SOFTWARE: Auto FX Photo/Graphic Edges

1. This is a scanned image from a color slide taken
 with Fuji Astia. I used a Nikon LS 2000 to scan it
 at 100 percent at a resolution of 2700 ppi.

2. I chose Image > Adjust > Hue/Saturation and moved
 the saturation slider bar to -67.

3. Next, I went to the Color Balance palette (Image >
 Adjust > Color Balance) and changed the settings to
 +30 red and -30 yellow. This gave the print an old-
 fashioned look.

4. I used the Add Noise filter (Filters > Noise > Add
 Noise) to add 96 percent noise, selecting Uniform
 Distribution and Monochromatic. Now the print
 is looking very old and has the appearance of a
 mezzotint.

5. Clicking on the background color icon to open the
 Color Picker dialog box, I selected a reddish brown
 color for my border. Then I chose Image > Canvas
 Size and added one inch to the dimensions. After I
 clicked OK, the border appeared the color chosen
 in the background box.

6. Using Auto FX Photo/Graphic Edges, Volume IV, I
 chose #AF#42 for my edge. I then decided to select
 a texture to add to the edge. I chose #457 because it
 looked like the sea. Volume IV in the Photo/Graphic
 Edges software is unique in that it has lighting effects
 and colored textures as well as edges. It is a very
 useful tool for the artistic photographer.

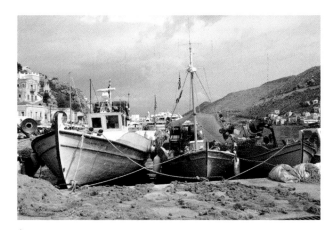

1

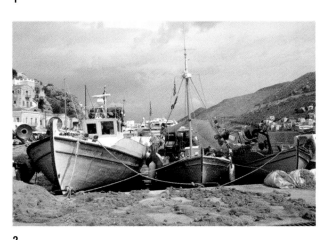

2

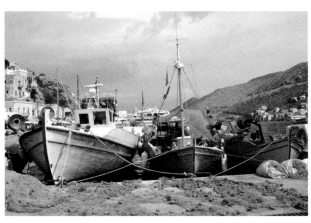

3

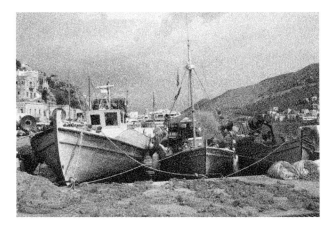

4

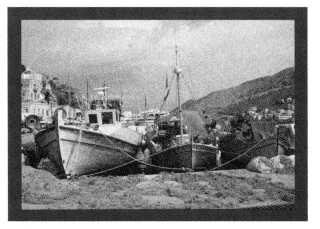

5

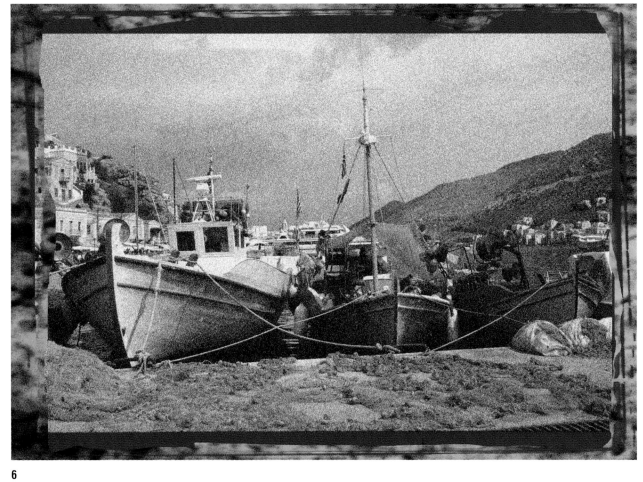

6

WATERCOLOR EFFECT

Photoshop's Watercolor filter is found under Filters > Artistic > Watercolor. If used correctly and moderately, it can impart a very painterly look to your images. If used incorrectly and heavily, it will make your images look too gimmicky.

The secret to the Watercolor filter is to make sure you don't overdo it and thereby obliterate details and wipe out important information. This filter can make an image look like a cheap reproduction of a good painting if you are not judicial in your approach.

GONDOLA, VENICE

SELECTION TOOL: magic wand
ADJUSTMENT TOOLS: Feather; Curves; Hue/Saturation; Color Balance; Color Picker; Canvas Size
FILTER: Watercolor
PLUG-IN SOFTWARE: Auto FX Photo/Graphic Edges

1. This is a manipulated Polaroid made with Time-Zero Film that was scanned on my U-Max 1200 Power Look flatbed scanner. The original size of the image was 3.25 × 4.25 inches.

2. First, to lighten up the shadow areas in the water, I selected those areas with the magic wand tool. Then I chose Select > Feather (you can also use Command-Option-D) and set the Feather Radius at 20 pixels. With feathering applied, the sharp edges around the selected areas blend more gradually. The next step was to open up the Curves dialog box (Command-M), keeping the same areas selected. By pulling down on the Curves graph from the center, I made the areas lighter.

3. Next I applied the Watercolor filter (Filter > Artistic > Watercolor). I set the Brush Detail at 10, Shadow Intensity at 0, and Texture at 2.

4. In the Hue/Saturation dialog box (Image > Adjust > Hue/Saturation), I took some of the color out of the image by setting Saturation at -10 and made it a bit lighter by setting Lightness at -5.

5. I then chose Image > Adjust > Color Balance, where I added some yellow and red to the image to give it the appearance of an evening scene rather than one taken on a bluish morning.

6. Then I added a blue border. The first step was to click on the background box in the tool box and select a color from the Color Picker). (You can also take the eyedropper into the image and select a color from there.) Then I chose Image > Canvas Size and added an inch to the dimensions. After I clicked OK, the border appeared around my image in the color selected for the background box.

7. Next, I went into Auto FX Photo/Graphic Edges and selected edge #306 from Volume I. I printed the 16 × 16-inch image onto Somerset Velvet paper, then enhanced it with Conté pastel pencils. I added a bit of red to the boat and a bit of gold to the windows and bridge. A little bit of gold was also added to the reflection on the water. These types of slight enhancements can really snap up an image!

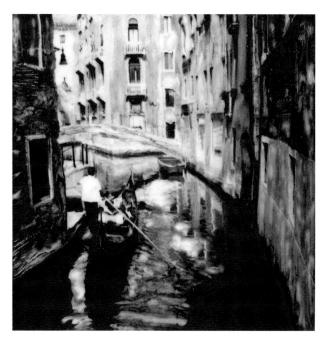

1

2

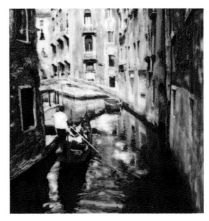

3

4

5

6

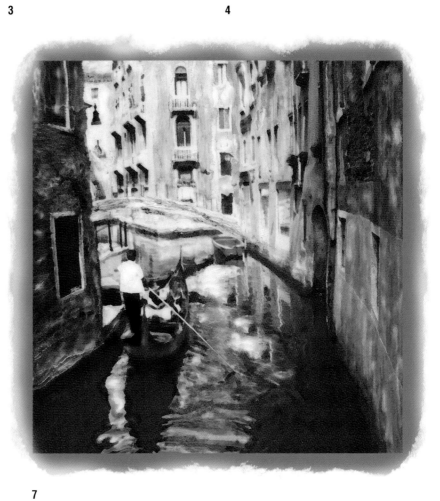

7

LINE DRAWING

The line-drawing effect is achieved by using the Find Edges filter (Filter > Stylize > Find Edges). It works best with architectural imagery or wherever there is an abundance of straight lines. As the colors get lighter when this filter is applied, working with a relatively dark-colored image helps you to arrive at a more colorful final image. I usually intensify my colors just before using this filter.

This effect gives the image a hand-drawn or pencil-sketch look. With lighter colors, it simulates a watercolor wash effect.

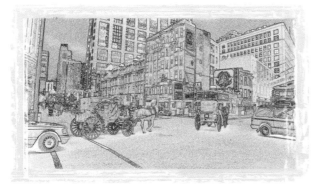

Horse and Buggy, Chicago
I shot this image with a Canon EOS IX APS camera. After scanning the negative, I made adjustments in Curves and used the Find Edges filter to achieve the line-drawing effect. Then I added the border.

BETH AT THE OCEAN

ADJUSTMENT TOOL: Color Balance
FILTER: Find Edges
PLUG-IN SOFTWARE: Auto FX Photo/Graphic Edges

1. This image was taken with black-and-white Kodak High Speed Infrared film at the beach on Molokai, Hawaii. The negative was scanned on a Nikon LS1000 transparency scanner at 2700 ppi.

2. The first thing I did was convert the file to RGB mode (Mode > RGB.)

3. Once that was done, I was able to add color by going to the Color Balance dialog box (Image > Adjust > Color Balance). I set red at +10 and yellow at -10 to give the print a rich sepia tone.

4. Then I used the Find Edges filter (Filters > Stylize > Find Edges) to achieve the line-drawing effect. It also reversed and lightened the colors somewhat. Finally, I went into Photo/Graphic Edges to find an edge that would enhance the power of the giant waves. Volume III, #85 seems to do the trick.

 The final image was printed on Hahnemühle William Turner, which has a softer finish than other inkjet papers—it's a bit like Lumijet Classic Velour.

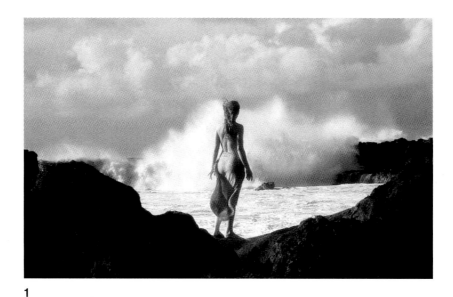

1

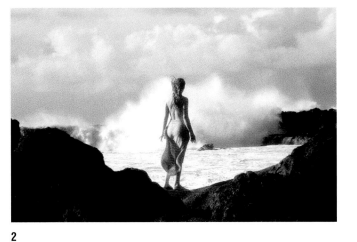

2

3

4

FORT ST. CATHERINE'S BEACH, BERMUDA

ADJUSTMENT TOOLS: Color Balance; Color Picker; Canvas Size
FILTERS: Find Edges; Add Noise
PLUG-IN SOFTWARE: Auto FX Photo/Graphic Edges

1. This image was taken with Fuji Astia color slide film. The slide was scanned on a Nikon LS1000 transparency scanner at 100 percent and at 2700 ppi.

2. My first step was to convert the RGB file into a grayscale file (Image > Mode > Grayscale). I did this because I needed a black-and-white image without a full tonal range in order to get a drawing effect with the filter I was planning to use.

3. Next, I applied the Find Edges filter (Filter > Stylize > Find Edges). This gave the image the sketch-like look I had in mind.

4. I applied the Add Noise filter (Filter > Noise > Add Noise), selecting 80 percent and Uniform Distribution. Then I converted the image back to the RGB mode (Mode > RGB). It still looked grayscale on the screen, but the title bar read RGB.

5. I chose Image > Adjust > Color Balance and added +44 red and -56 yellow. This gave the image a nice sepia or brown tone.

6. To add a border, I began by choosing the color. I double-clicked on the background color icon in the toolbox and the Color Picker dialog box appeared. Then I used the eyedropper to sample colors in the image. When I had the color I wanted, I clicked OK and the background color in the toolbox changed from white to the color I had chosen. Next, I chose Image > Canvas Size and added 1 inch all around the image, by changing the dimension box as shown. When I clicked on OK, the image appeared on the screen with a border in the color that I had chosen. Note that when you are adding borders, if the color you choose the first time doesn't look right, you can always choose Edit > Undo and try another shade. Darker borders usually work best.

7. If you have software that creates edges installed in your computer, you can use that to create a more painterly or artistic finish to the image. Creating a border around the image first prevents the edges program from cutting into the image. I used an edge from Auto FX Photo/Graphic Edges (Volume I, #39) to finish off my image.

1

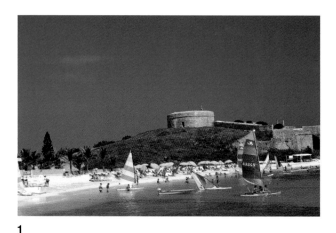

2

3

4

5

6

7

SPECIAL EFFECTS

There are so many kinds of special effects software available now that for a beginner it is hard to choose which one(s) to purchase. Eye Candy is a program made by Alien Skin Software that is relatively inexpensive and is fun to use. The newest version, Eye Candy 4000, costs $169. I used Eye Candy 3.01 to create an image I call *Santorini Steps,* which has a very van Goghesque look to it that was easily created with a filter called Swirl.

SANTORINI STEPS

ADJUSTMENT TOOLS: rubber stamp; Curves; Replace Color; Color Picker; Canvas Size

PLUG-IN SOFTWARE: Eye Candy; Auto FX Photo/Graphic Edges

1. I shot this image with Fuji Velvia and my Nikon F4 system. It was scanned at 100 percent at 2700 ppi.

2. Using the rubber stamp tool, I cloned out the pole and wires in the sky.

3. Playing with the curves graph (Image > Adjust > Curves), I got the look I wanted and clicked OK. This is the image after I made my adjustments.

4. The image needed to be darkened, so I went back into Curves and raised the graph line from the center.

5. I wanted more blue in the green sky, so I went to the Replace Color dialog box (Image > Adjust > Replace Color). I placed the eyedropper in the sky area to select it and then went to the Hue slider bar and found the color blue-purple to replace the green. Next, opening Eye Candy, I used the filter called Swirl.

6. I felt the image needed something more, so I added a blue border. To do this, I first double-clicked on the background box in the toolbox to open the Color Picker dialog box. Then I clicked on one of the colors in the image (Aegean blue) with the eyedropper to change the background to that color. Then I chose Image > Canvas Size and added one inch to both dimensions and clicked OK. The 1-inch border then appeared around the image.

 The last step was to choose an edge from Photo/Graphic Edges (which appears in the plug-in folder when installed). After applying #204 from Volume I, I felt that the print was finished.

1

2

3

4

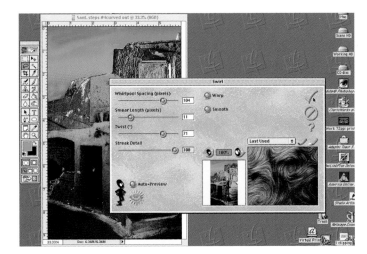

5

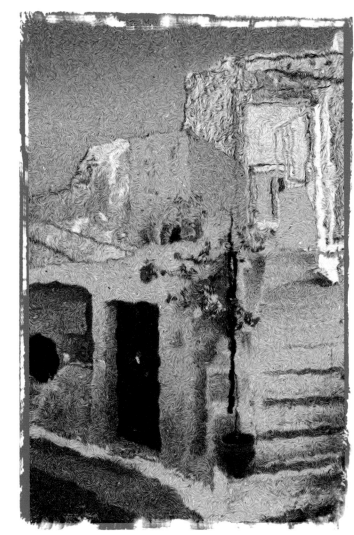

6

Studio Artist is a great plug-in software that can be used in conjunction with Photoshop. It is fast and easy to use the program's thousands of artistic effects, and Studio Artist is the only program that can actually draw and paint by itself. It will create a painting at a low resolution and then automatically render it at a high resolution (selected by the user) for the final print. This is accomplished through a complicated fractals program built into the software. You can also use the effects manually.

The Wacom graphics tablet is a wonderful tool to use with this software, allowing you to create an image as you would on a canvas or paper. The results are spectacular! If you are not good at painting or drawing but would like to express your creativity in a painterly way, this is definitely a program to look into.

PALACE OF FINE ARTS

ADJUSTMENT TOOL: Curves
PLUG-IN SOFTWARE: Studio Artist; Auto FX Photo/Graphic Edges

1. This is the original image scanned from a Fuji Astia slide.

2. Here is the image created in Studio Artist using the scan. The effect was created using Category > General and Patch > Wet Mixer. After I saved the image to my desktop, I opened it in Photoshop and used Curves to make it lighter. Then I applied a fog edge to the image using Auto FX Photo/Graphic Edges (Volume VII, #689). The image was printed on Hahnemühle William Turner paper.

1

2

LAYERS

In traditional photography, montaging and collaging elements together from different sources is a very tedious, time-consuming, and often frustrating task. With Photoshop, it is accomplished with ease and sophistication in a very short time.

Working with layers allows you to hide and reveal portions of your image so that you can work on it without permanently changing the pixel data. You can add adjustment layers so that you can apply color and tonal adjustments; apply effects to multiple layers; duplicate layers; add new imagery; and more. When you are finished making your adjustments, you simply flatten the image and your collage is beautifully interwoven. Using layers is fun and the results are very exciting.

MARION

ADJUSTMENT TOOLS: Color Balance; Invert; Curves; Color Picker; Canvas Size
FILTER: Plastic Wrap
PLUG-IN SOFTWARE: KPT 3; Auto FX Photo/Graphic Edges

1. The basic image was shot in a studio with Kodak black-and-white infrared film, using an ISO of 250 and a #25 red Hoya filter. The model was standing behind a translucent piece of fabric and the lights were also behind her in order to throw her shadow onto the cloth. I scanned the negative at 100 percent at 2700 ppi.

2. I changed the file's color mode from grayscale to RGB (Mode > RGB). The image is still black and white, but the title bar now says RGB. Then I added color in the Color Balance dialog box (Image > Adjust > Color Balance). I set red at +75 and yellow at -95 to give the image a sepia tone. I then inverted the colors (Image > Adjust > Invert or Command-I).

3. After inverting the image, I brought up the Curves dialog box (Image > Adjust > Curves or Command-M). I played with the brightness curve until I saw what I liked. This is the image and color that I finally ended up with.

4. Next, I went into Kai's Power Tools 3. (Kai's Power Tools 3, 5, and 6 are graphics programs with plug-in filters.) I chose Filters > KPT 3 > Texture Explorer. I chose a texture that I liked and applied it to the print with an opacity of 45 percent.

5. I went back to the Curves dialog box and darkened the print by pushing the brightness curve up slightly. Then I applied the Plastic Wrap filter (Filters > Artistic > Plastic Wrap) because I thought the image could use some texture and dimension.

6. To add a border, I began by double-clicking on the background color icon to open the Color Picker dialog box. I then took the eyedropper into the image and clicked on the color I wanted. Then I opened the Canvas Size dialog box (Image > Canvas Size) and added an inch to both the height and the width.

7. I felt that the image was still lacking in excitement, so I went into Auto FX Photo/Graphic Edges and chose #245 from Volume III.

8. While that border added another dimension to the print, I felt it looked too perfect, so I went back into the Edges program and applied #58 from Volume I. This gave the image what I had in mind—lots of movement and dimension!

1 2

3

4

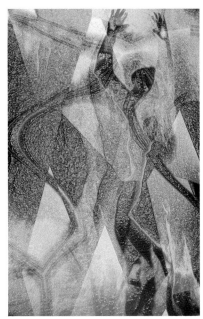

5

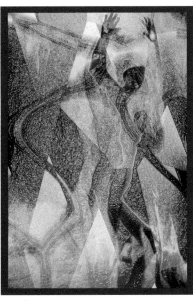

6

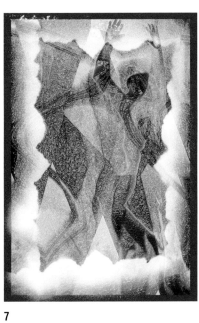

7

8

POSTCARD FROM DAD

ELEMENTS

- Postcard from Dad, c. 1943
- Skeleton leaf
- Painting of soldiers
- Picture of me at age three
- Photo of a soldier's homecoming

ADJUSTMENT TOOLS: Hue/Saturation; Opacity slider
PLUG-IN SOFTWARE: Auto FX Photo/Graphic Edges

1. This collage image was created using five different sources. All but two were combined using Photoshop's Layers feature; the leaf and the postcard were placed on the glass bed of the scanner and scanned together to create my background image. The postcard was sent to me in 1943 by my father, who was stationed in France during World War II. The war has been over for nearly 60 years and my father has passed away. The skeleton leaf is symbolic of both.

2. I scanned an old photograph of myself with a U-Max Power Look 1200 and sized it down to drag over onto the postcard image. Then, using the Layers palette, I made the image slightly transparent with the Opacity slider.

3. Next I scanned a painting of soldiers and made that another layer by dragging it over onto the background image (the postcard and leaf). I intensified the colors using the Hue/Saturation command (Image > Adjust > Hue/Saturation or Command-U) and then made them very transparent by using the Opacity slider in the Layers palette.

4. I scanned a photo of a soldier's homecoming from an old newspaper and placed it on the right side of the postcard by dragging it over the image. Again, I made it slightly transparent by means of the Opacity slider in Layers.

5. The card was finished, but it didn't have a finished look.

6. I opened up Auto FX Photo/Graphic Edges Vol. IV and applied edge #AF005. It still needed something, so I found a texture (#AF018 from Vol. IV) that looked like camouflage. That did it.

1

2

3

4

TIP
When dragging elements of pictures into another image, be sure that both images are initially the same resolution (same ppi) or your elements will be out of proportion.

5

TIP

If you drag a black-and-white image over a color one, the black-and-white element will remain black and white. However, if you drag a color element into a black-and-white image that is in the grayscale mode, the color element will lose its color. To keep the color of the element that you are bringing into a black-and-white image, change the black-and-white image's mode to RGB.

6

COSMIC DREAMS

ELEMENTS

- Slide of a nude in the stream
- Slide of an abstract from the side of an old car

SELECTION TOOL: lasso

ADJUSTMENT TOOLS: move tool; Layer mask; eraser; gradient; paintbrush; Dissolve; Color Picker; Canvas Size

PLUG-IN SOFTWARE: KPT 5; KPT 3; Auto FX Photo/Graphic Edges; AutoEye

1. I created *Cosmic Dreams* by combining two images. The nude was photographed with Fuji Astia and the abstract was a close-up of sanded paint on an old car photographed with Kodak Ektachrome. Both slides were scanned on the Nikon LS 2000 scanner at 2700 ppi. I decided to use the abstract as my background image. This image is 7 × 10 inches, 300 ppi.

2. Since the nude was going to be an element in the composition, I first made the image's resolution the same as that of my background image (300 ppi), then made the figure smaller to fit into the composition.

3. With both images on the screen, I selected around the nude with the lasso, then used the move tool (V) to drag the cutout on top of the background image (the abstract). I could also have selected the nude with the magic wand. Next, I opened the Layers palette (Window > Show Layers or F7). The nude became Layer 1 and the abstract shot became the background in the layers box.

4. I made a mask on Layer 1 (the nude) by clicking on the Layer mask icon at the bottom of the Layers palette (it looks like a screened square with a clear circle in the center). Another way to do this is to choose Layer > Add Layer Mask > Reveal All. Working on the mask layer allows you to paint information out or back in using the eraser tool, since you are not actually working on the image itself.

5. Next I went to Layer 1 and clicked on the mask icon next to the image of the nude. Once that mask was selected, I went to the toolbox and clicked on the eraser tool. There are several modes to choose from: paintbrush, pencil, airbrush, or block. You must also set the level of opacity. I chose the paintbrush because it is round and comes in any size; I chose 100 percent opacity because I wanted to completely remove all the extra information around the figure. I then erased the background on the nude image, allowing the abstract image to be seen. To make sure the background image was visible, I had to keep the foreground color white.

6. This is what the two images looked like when combined.

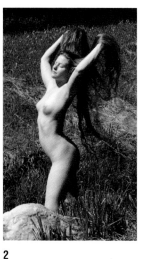 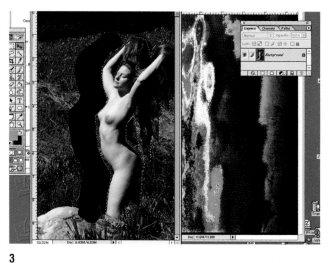

1 2 3

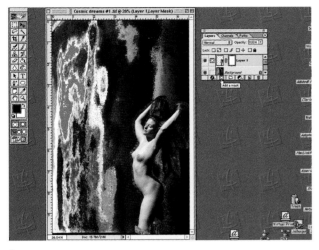

4

TIP

You can make the element (in this case the figure) you are dragging into another image less opaque in order to better see the background. This helps with placement. Then bring the element back up to 100 percent to work on it.

5

TIP

When working on a mask, if you keep the foreground color white, you can erase unwanted information and reveal your background image. If you change the foreground color to black, you can use the eraser tool to "paint" back lost information.

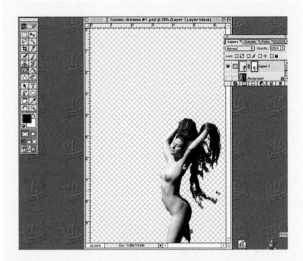

TIP

After erasing, you can check if you have failed to erase any of the information you wanted to remove by clicking on the eyeball icon to the left of the Background image in the Layers palette to hide the background layer.

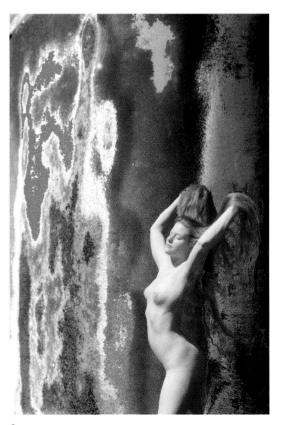

6

7. With the nude's layer mask selected (by clicking on the icon), I went to the toolbox and selected the gradient tool. This is a great tool that allows you to blend images together. I chose an opacity of 42 percent, which gave me a light gradual blending of the figure into the background. I then drew a diagonal line across the figure from the upper left to the lower right corner. The gradient made the body fade gradually into the abstract.

With the paintbrush in the toolbox selected, I clicked on the foreground box and used the eye-dropper to select a soft yellow color when the Color Picker dialog box popped up. First, I went to the Options bar and selected Normal in the Mode menu and an opacity of 29 percent. I went to the menu bar and selected a brush size of 100. Then I clicked on the background layer (in the Layers palette) and began to paint the soft yellow around the body, which created a glow around the body only because I was painting on the background layer. I decided that what I'd done was not enough, so I went back to the Mode menu on the Options bar and selected Dissolve. In this mode, I was able to paint star-like glitter around the body.

8. At this point, I flattened the image (Layer > Flatten Image) so that all the elements were on one plane or layer. But the image still did not have the look that I was seeking, so I applied a filter in KPT5. The filter is called Radwarp. I chose the Alpha channel and pulled the slider to the left of the center arrow until I got the distortion that I wanted. I wanted a feeling of floating into space.

7

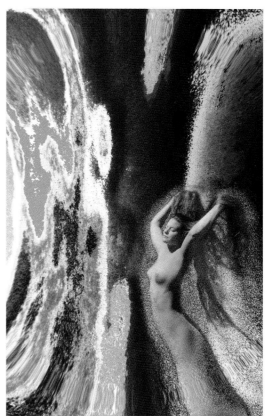

8

9. Next, I opened KPT 3 and used the Texture Explorer tool to find a texture that suited the image. I then created a border around the image. I clicked on the background color icon and brought up the Color Picker. Taking the cursor (which became an eye-dropper) over the image, I selected a reddish-brown color. Next I chose Image > Canvas Size and made the dimensions one inch larger than the image size. When I clicked OK, the border appeared around the print in the color I had selected for the background box.

10. It was almost there, but still I wanted to add some kind of a dimension that I felt it was still missing. So I went into Auto FX Photo/Graphic Edges for a suitable finishing edge (I chose Vol. III, #250). I liked the way this edge broke the planes of the image up. Finally, before printing, I applied AutoEye to give the image the snap and clarity that I wanted. Here is the final image, which I printed onto Lumijet Museum Parchment paper.

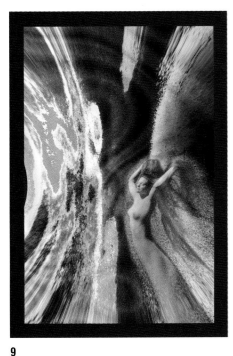

9

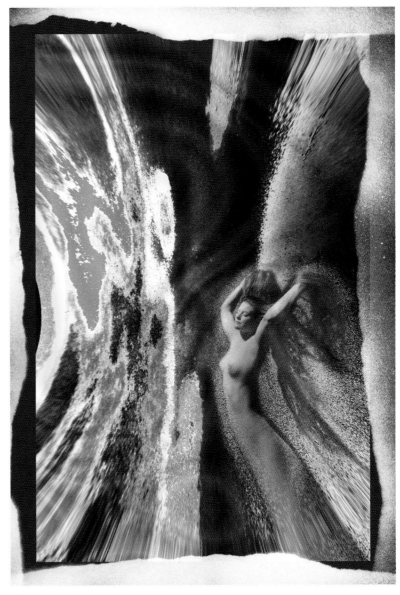

10

PAINTING WITH THE HISTORY BRUSH

This is a great tool to use when you are feeling creative and want to play. Some of my best images have come out of "playing." Here's how to begin: Open your History palette by choosing Window > Show History. Apply several filters to your image for different wild effects. Everything you do will be recorded separately in the History palette as a state. States are recorded from top to bottom, the bottom one being the most recent addition. By default you will have 20 states to work with; every time you do something to the image after 20 states are used, the oldest states are deleted to free up memory for the newer ones. Once you close the image you lose all the recorded data.

> **TIP**
>
> To change the number of history states (check first to see if you have enough RAM to support more) choose Edit > Preferences > General or Command-K. The preferences dialog box will appear and you will be able to change the number of history states to what you want.

Be sure to view your History Options command by clicking on the black triangle at the top side of the title bar. You want to be sure that Allow Non-Linear History is checked, so that the states that come after the one you have chosen to paint with aren't deleted. If you like the looks of an image, but still want to try another effect, take a "snapshot" of it by going to the bottom of the History palette and clicking on the icon in the middle (it looks like a piece of paper with the bottom left corner turned up). This will give you a duplicate of the present version of your image, so if you mess up later and that state has been deleted, you can go back and continue to work from that point.

When you have a nice selection of effects recorded, go back to the History palette and click on the original image. Then go over to the toolbox and click on the history brush. (It looks like a brush with a dotted line and arrow through it and is the fifth tool down on the right side of the toolbox.) Take the history brush back to the History palette and select an effect by clicking on

that state with the history brush in the empty box on that line. They will be listed by name such as Watercolor, Rubber Stamp, etc. You can now selectively paint that effect wherever you wish in the image. You can also go the menu and change the effect's mode and opacity. There are seemingly endless effects to be used!

LAS VEGAS DRAGONS

SELECTION TOOL: pen
ADJUSTMENT TOOLS: Curves; Color Balance; history brush; eraser
FILTERS: Plastic Wrap; Watercolor
PLUG-IN SOFTWARE: Auto FX Photo/Graphic Edges

1. This was originally a black-and-white Kodak infrared negative exposed at an ISO of 320 with a red Hoya filter. I scanned it at 100 percent on a Nikon LS 2000 transparency scanner at 2700 ppi.

2. I changed the image from grayscale to RGB mode (Image > Mode > RGB). It still looks black and white on the screen, but the title bar now reads RGB and the file size has increased. Next, I went to the Color Balance dialog box (Image > Adjust > Color Balance) and added red and yellow to give the image a sepia tone.

3. Next, I went to the Curves dialog box (Image > Adjust > Curves or Command-M) and played with the control bar until I got the colors and solarization that I liked.

4. I applied the plastic wrap filter (Filters > Artistic > Plastic Wrap) at Highlight Strength 15, Detail 9, and Smoothness 7, to give the image a watery feeling.

5. I then went back to the second version (the one that was in RGB mode). I opened the Color Balance dialog box (Image > Adjust > Color Balance) and added blue and magenta to get a nice purple tone.

6. Next, I went into the Curves dialog box again and solarized the purple print, obtaining some very different colors from those in the earlier solarized image.

1

2

3

4

5

6

7. I selected the history brush from the toolbox and the sepia-toned image in the History palette. Then I clicked my history brush in the square to the left of the solarized purple dragon effect, which was the last Curves effect that I had created. I chose to paint in the information from that image in the Dissolve mode (Shift-Option-I) along the neck and body of the dragon, then I switched to the Normal mode and painted in the rest of the dragons.

8. Once I had painted the dragons with the history brush using the Normal mode, I felt that the background needed something more. I went back to the History palette and placed my history brush on the Plastic Wrap state (step 4). I then painted in the background with Plastic Wrap using a large paintbrush.

9. I still was not satisfied with the results, so I used the pen tool to select the dragons. Then I opened the Paths palette (Window > Show Paths). After outlining the dragons with the pen tool, I clicked on the black triangle in the title bar of the Path palette and chose Make Selection. This turned the area outlined by the pen tool into a selection. After feathering with a radius of 2 pixels (Select > Feather) and inversing the selection (Select > Inverse), I was able to work on the background without affecting the dragons. I applied the watercolor filter (Filters > Artistic > Watercolor). I set Brush Detail at 5, Shadow Density at 2, and Texture at 1. I selected these settings through trial and error, trying different combinations until the image was visually pleasing to me.

I printed the image out and studied it for a while, but decided that it still was not right. What I didn't like was the color of the dragons—it was too magenta, too gaudy.

10. I decided to go back to the second print in sepia tones and open it up separately from the file I was working on. I used the sepia-toned print as my background and opened the Layers palette (F7). I selected the most recent version of the print with the rectangle marquee and dragged it over the sepia-toned print. In the Layers palette, I now had the sepia print as my background and the colored image as Layer 1.

11. I next gave the color image an opacity of 30 percent so that I could align the two images. After they were aligned, I raised the opacity of the colorful print to 60 percent. This toned the image down somewhat.

12. Next, I made a mask on Layer 1 and clicked on the eraser tool. I began to erase some of the information on the colorful print using an opacity of 75 percent to allow more of the sepia print to be seen. If I went too far, I would click on the arrows located between the foreground and background color boxes and reverse them. When the foreground color is white and you are working on the mask layer using the eraser tool, it will remove information and when you reverse them and the foreground is now black, it will paint the information back. I liked the print now, but couldn't resist making the dragons' eyes a bit more threatening. I clicked on the foreground box and selected a yellow from the Color Picker, then clicked on the paintbrush tool and painted in the eyes at an opacity of 60 percent.

13. I was ready to apply an edge. I chose Vol. IV, #005 from Auto FX Photo/Graphic Edges, then went into Textures and selected #320 to finish the image off.

Here is the final print. The edges and texture seem to give the print a magical sea-like look that I was searching for. I printed this image out on both Lumijet Museum Parchment paper and Flaxen Weave. It was a lot of work, but I do like the final result and I feel that all the struggle was well worth it. Who would guess that this color image came from a black-and-white negative! That is truly the magic of digital printmaking.

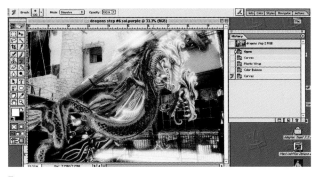

7

8

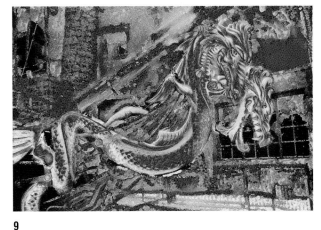

9

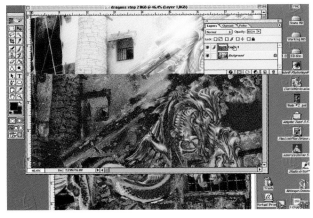

10

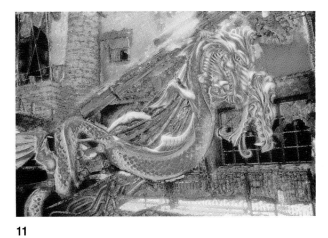

11

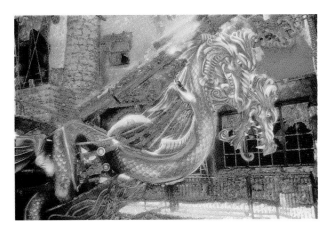

12

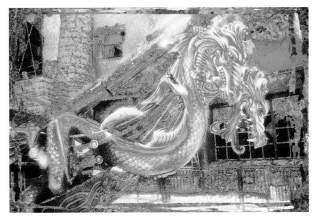

13

PART III
GALLERY

Lounging
Image by Robert Farber

CHARLES BOWERS

SANTORINI SHAPES

The original image is a Polaroid Time-Zero film print using a modified Polaroid 690 camera. The emulsion pack within the original print was manipulated with a stylist to achieve the look of the final image. The image was scanned using a Canon BJC-50 portable printer, which allows the usage of the Canon IS-12 Color Image Scanner Cartridge. The original Polaroid print was fed through the paper feed and the scanning software was set at 360 ppi. The final scan was transferred into Photoshop, where Bowers cropped the image but left a white border all around it. The resulting file size was about 4MB. In the Curves dialog box, Bowers selected the white point eyedropper. He touched it to the grayest portion of the white border, which set a temporary white point in the image. Next, he cropped the image again, eliminating the white border. The resulting file size was 3.5MB.

The image was then tuned in Photoshop using a technique that Bowers calls "tuning by the numbers." He decided where the white point and black point of the image would be by finding the most neutral white and black tones, then adjusted the red, green, and blue channels individually in Curves. Next he worked on the sky area, selecting it with the magic wand tool and despeckling it (Filters > Noise > Despeckle). He also used the rubber stamp tool to get rid of some scratches, spots, and specks. The next step was to invoke the magic of Extensis Intellihance Pro 4.0, which is a filter set with many different options—all user controlled—to help you enhance an image.

Bowers had one more step before he was ready to print—resizing the image file without resampling. The final size of the image was 7.5 inches square. The file size was still 3.5MB, but according to Photoshop, the resolution had dropped to 150 dpi. To print the image (on Arches Hot Press 90-lb. watercolor paper), he removed the scanner cartridge from the Canon BJC-50 and inserted the printing cartridge.

Charles Bowers is a practicing landscape architect specializing in residential gardens. He has a particular expertise in spatial design and relationships. The original motivating force in Bowers's choice of photography as an expression of his art was his desire to document and express the gardens that he designed and built. In the process, he discovered that photography itself was another way to express himself creatively. Bowers's photographs have been widely exhibited and have been published in many magazines, including *Southern Living* and *Better Homes and Gardens*.

DAN BURKHOLDER

ENCHANTED FOREST, IRELAND

Beautiful as the setting was in the autumn Irish woods, Dan Burkholder felt that the element of visual intrigue was missing. This bench was a perfect tableau just waiting for some complementary imagery that would add that missing visual intrigue and hopefully allow the viewer to experience the quiet sense of wonder that he felt that moody day in Ireland.

One of Burkholder's favorite filters is in the KPT5 set from the folks at Corel. What used to be called the Gaussian Glow filter (way back in the days of KPT 2.1) is now part of the KPT5 package (but not KPT6). This filter blurs highlights and midtones but protects the darkest shadow tones in the image. The result is a mossy richness in the darker tones of the image.

The filter effect wasn't quite right so Burkholder decided to use some Layer Options to change the Gaussian Glow layer's tonal effect on the image. To work on the bench as a separate entity, he had to select it first. The pen tool was perfect for this job. Burkholder saved this path (Path palette menu > Save Path or double-click the path name) and gave it a name. Whether or not to name paths and layers is a matter of personal preference; Burkholder does it because it supplies additional visual clues as to what each image component is doing.

With the bench selected, he created a new layer containing only the bench (Layer > New > Via Copy). Next he dragged this new layer to the top of the layer stack and named it Bench Icicles. The Wind filter (Filter > Stylize > Wind) makes terrific icicles. However, since it can only be applied from left to right (not vertically), Burkholder had to cheat in order to create these icicles. Making sure the bench-only layer was active, he rotated the entire image 90 degrees counterclockwise

(Image > Rotate Canvas > 90° CCW) and applied the Wind filter. He then fine-tuned the filter effect by using Photoshop's Fade Filter command (Edit > Fade Wind). He also reduced the Wind effect by dropping the amount to 85 percent. When the icicles looked just right, Burkholder rotated the image back to its normal position (Image > Rotate Canvas > 90º CW).

Since he thought the icicles hanging down onto the foliage from the legs looked bogus, Burkholder used a Layer Mask (Layer > Add Layer Mask > Reveal All) that blocked out the bench legs and arms on that Icicle layer.

The Czechoslovakian engraved eggs were photographed at the Texas Folklife Festival. Burkholder used the pen tool to make a path around the egg, then turned it into a selection (Path palette menu > Make Selection) and gave it its own layer. He then resized the egg (Edit > Transform > Scale) and moved it into position, then added shadows to the image. The image was complete. Call it a leprechaun egg or call it absurd—beauty and logic don't always run parallel in life!

Dan Burkholder's award-winning book, *Making Digital Negatives for Contact Printing,* (Bladed Iris Press) is in its completely revised Second Edition. Burkholder is one of photography's pioneers as he combines the beauty and permanence of the platinum process with the precision and control of digital imaging. His finely crafted platinum prints have been exhibited internationally and are represented by galleries across the United States. Burkholder uses a Photoshop-chomping Dual Processor G4 Mac that keeps a smile on his face and a buck in his pocket.

The original grayscale image as it was first scanned, with no manipulation.

Layer with the Gaussian Glow filter applied.

DANNY CONANT

DEAR MOTHER

This montage was created from a collage of two emulsion transfer pieces on watercolor paper: a photographed copy of an old family letter and a portrait of a young woman. The 8 × 10-inch emulsion transfer was scanned on a flatbed scanner. In Photoshop, Conant selected the letter and girl from the white background by using the magic wand to select the white and then choosing Image > Adjust > Invert. Then she darkened the image slightly using Curves.

The background was a slide of a pink wall taken in Greece. Conant scanned it, then cropped out the printing on top and resized the image to 15 × 13 inches at 300 dpi. In Layers, she dragged the girl and letter on top of the pink background. Then the image was sharpened using the Unsharp Mask filter with the following settings: Amount: 75%; Radius: 1.0 pixels; Threshold: 3 levels.

Finally, Conant flattened the image, then printed it on a very thin kozo-like paper from Nepal. To put this paper through her Epson 3000 inkjet printer, she used double-sided tape to attach the leading edge and sides to a piece of watercolor paper, which she fed in from the back of the printer. Conant uses Lyson archival inks in her printer. The printer settings were 1400 dpi, plain paper, and error diffusion. For color adjustment she used photo-realistic, and added some brightness +10, saturation +10, and magenta +8 in the print adjustment menu.

Danny Conant is a fine art photographer specializing in figure work and environmental portraits. She uses the alternative processes of Polaroid image transfers, Polaroid emulsion transfers, and platinum printing as well as creating traditional black-and-white images. Conant's most recent work has been computer-generated images on watercolor paper, handmade paper, and silk. Her emulsion transfer figures were featured in the April 1998 issue of Camera Arts magazine. Her work is in corporate and private collections and can be seen at Touchstone Gallery (Washington, D.C.), Factory Photoworks Gallery, (Alexandria, Virginia), and the Gallery at Studio 105 (Shepherdstown, West Virginia).

GEORGE DEWOLFE

WHITE FENCE AND FOG

As George DeWolfe drove his son Luc to school one day, he noticed the scene captured in this image from the corner of his eye. DeWolfe immediately stopped the car in the middle of the road and backed up. "Luc," he said, "You're going to be late for school this morning."

DeWolfe made two photographs using his 4×5 Wisner Pocket Expedition and a 180mm lens. He scanned the negative into an Epson Expression 1600 scanner and manipulated it in Photoshop 5.5 on a Macintosh G3 to correct overall contrast, sharpness, and local contrast with Curves, History Brush, and Airbrush. He then printed it out on an Epson 3000 printer using the Jon Cone Piezography quadtone ink set on Somerset Enhanced paper. With the Cone ink set and driver, the resolution changed from 720 dpi to 2100 dpi instantly.

George DeWolfe has been a photographer since the mid-1960s. He studied with Ansel Adams, extensively with Minor White in the 1970s, and with Dr. Richard Zakia. He holds an MFA in Photography and Graphic Art from the Rochester Institute of Technology.

DeWolfe taught Zone System and Perception at the New England School of Photography, the University of Idaho, and Colorado Mountain College. He initiated the Appalachian Mountain Club Photography Workshop and teaches numerous other workshops and seminars throughout the United States. He has also published three books—most notably *At Home in the Wild* (Appalachian Mountain Club/Friends of the Earth)— and contributed to dozens of others.Currently, he is an advisor for Epson and other digital and inkjet companies, a contributing editor to *ViewCamera* and *Camera Arts,* and Adjunct Faculty of Photography and Graphic Art at the College of the Atlantic.

BOB ELSDALE

ELEPHANT BALANCING ON A BEACH BALL

The elephant was an outtake from a *Cable & Wireless* shoot and was shot in a car studio in London. The seascape was shot at Saunton Sands, Devon, England. The images of the beach ball and the elephant's footprints were both originated in Elsdales' studio, the beach ball being compressed with a large weight to create the desired distortion. The elephant, ball, and footprints were shot on a Mamiya RB 6×7, and the seascape on a 4×5 Linhof. The images were scanned and output by his company on an ICG drum scanner and Kodak LVT film recorder. Elsdale assembled the image in Photoshop on a Daystar Genesis.

Bob Elsdale works as an advertising photographer, mainly in Europe and the United States. He was first introduced to digital imaging some 10 years ago, and is now a partner in RGB Ltd., an image manipulation company, which is located under his central London studio.

Elsdale works a lot with animals, but is happy to work on anything other than cars and beauty/fashion. His first children's picture book, *Mac Side Up,* was published in the fall of 2000 by Dutton Children's Books, a division of Penguin Putnam. Elsdale both wrote the text and created the computer images, "which were a walk in the park, compared with writing the copy." Mac the cat is the main character, with Dusty the ferret as a support act.

MARTIN EVENING

KALEIDOSCOPE SHOE IMAGE

The original idea for this image came while Martin Evening was collaborating with still-life photographer Davis Cairns on a photographic and design project for Red or Dead, a UK fashion company. After retouching over a hundred shoes and bags, Evening and Cairns thought it was time to have some fun with the pictures, so they played around, building variations like this one.

Using Photoshop 5.0, Evening began by creating a new document in the RGB mode. He added some guides, which intersected at the center, and then added a cutout of a Red or Dead shoe as a new layer.

Next, he duplicated the shoe layer and applied the first transformation. (The transformation commands that affect layers are located in the Edit menu; Free Transform is the most versatile to use.) To carry out a rotating transformation, Evening just had to drag anywhere outside of the bounding box. By holding down the Shift key, he constrained the rotation to 15-degree increments. Using the Info palette as his guide, Evening was able to measure precise angles—he ended up using 36 degrees—to create a kaleidoscope pattern. To complete this step, he dragged the layer with the copy of

the shoe image below the original in the Layers palette, then duplicated the shoe copy layer. By repeating this process another six or eight times, he was able to complete the kaleidoscope pattern. When the circle was complete, Evening linked all the layers into a single layer. He then clicked on the uppermost layer to make that active and added an invert adjustment layer.

Next, Evening experimented with gradient patterns. First, he Option-clicked the divide between the merged shoe layer and the adjustment layer to create a clipping group for the two layers. Then he activated the background layer, made black the background color, and chose a new foreground color by clicking on the foreground swatch. Since it is tempting to select a color that will fall outside the CMYK gamut, he switched on CMYK Gamut Warning in the View menu. This made the Color Picker overlay the out of gamut RGB colors with gray.

Evening started with the radial gradient and used the centering guides to click in the middle of the picture and drag outwards. Later, he experimented with different colors and gradient fills. The possible variations are endless.

Martin Evening is a professional photographer who has been working with digital images and Photoshop for many years. He works mainly in studio-based beauty photography for public relations and direct clients. The use of the computer has played a significant role in Evening's work, with nearly everything being retouched or manipulated in Photoshop.

Evening writes regularly about digital imaging for *MacUser* in the UK, contributes to *PEI* magazine, and is the author of *Adobe Photoshop 6.0 for Photographers* (Focal Press). He has presented seminars on Photoshop techniques in the United Kingdom and the United States and acts as a digital imaging consultant for design and photographic studios. Evening was a founding member of the Digital Imaging Group, London, and is co-listowner of the Prodig mailing list—a Photoshop discussion list on the Web. He lives and works in Islington, London.

LEWIS KEMPER

MOOSE IN HAYDEN VALLEY

When one of Lewis Kemper's stock agencies recently cleaned house, it returned a group of his slides that he hadn't seen in years. Kemper took the opportunity to go through his old images and see if he could learn anything from them. He found an image of a sunset that he thought was particularly nice, and at first he wondered why it had never sold. But the more he studied the picture, the more he began to understand; the light was wonderful and the reflection added to the image, but there really was no focal point, or center of interest. Although he couldn't have fixed the image back when he first took it, now, 10 years later, he had the ability to do just that!

The original image was made in Hayden Valley in Yellowstone National Park. Remembering how at other times he had seen moose and bison in the vicinity of this location, Kemper went through his files and found an image of a moose that he had taken not a quarter of a mile from the spot where he took the sunset. Through digital magic he transplanted the moose into the sunset scene.

First he scanned the 35mm image of the sunset on an Adara TwinStar 1000 scanner to create a 69MB file, since he wanted to get a 4×5 transparency as his final output. He then scanned the moose—also a 35mm original—in to create an approximately 15MB file, since it was going to be a smaller element in the image. Kemper was working in Adobe Photoshop 5.02. He picked the lasso tool to select the moose, feathering it with a radius value of 3 pixels to give it a soft edge.

Once he had outlined the moose and its reflection in the water, he copied and pasted the selection into the image of the sunset. Since this pasting automatically created a new layer, he now had the ability to move and size the moose exactly where he wanted it in the picture. He placed the moose in position, then Command-clicked on the moose layer in the Layers palette. (On a PC he would have used the Control key and clicked on the layer.) This selected the moose and the shadow. While the moose was selected, Kemper filled the selection with black to silhouette the moose. In the original moose image, the reflection is not complete, so he used the paintbrush to complete it by painting on a new layer.

Once he had completed the work, Kemper flattened the image and saved it as a TIFF file. He then had it output on a Cymbolic Sciences Light Jet 2080 film recorder at RES 80. He now had a very sharp new 4×5 transparency that was made from his 35mm originals.

For the final test, he sent the new 4×5 to his editor at Tony Stone Images. It was selected for inclusion in their Dupe Master Collection and in an upcoming catalog. The rejected image was now resurrected!

Lewis Kemper has been photographing the natural beauty of North America and its parklands for over 20 years. Before moving west, he received a BA in Fine Art Photography from The George Washington University in 1976. The grandeur of the West beckoned and Lewis moved to Yosemite National Park, where he lived for 11 years. From 1978 to 1980, Kemper worked at The Ansel Adams Gallery.

Kemper photographs in color using 35mm and 4×5 cameras. He is also working with digital imaging to create new work. The author of *The Yosemite Photographer's Handbook* and *The Yellowstone Photographer's Handbook*, Lewis's most recent book is *Ancient Ancestors of the Southwest* (Graphic Arts Center Publishing Company). Currently, he is a contributing editor to *Outdoor Photographer* and *PCPhoto*.

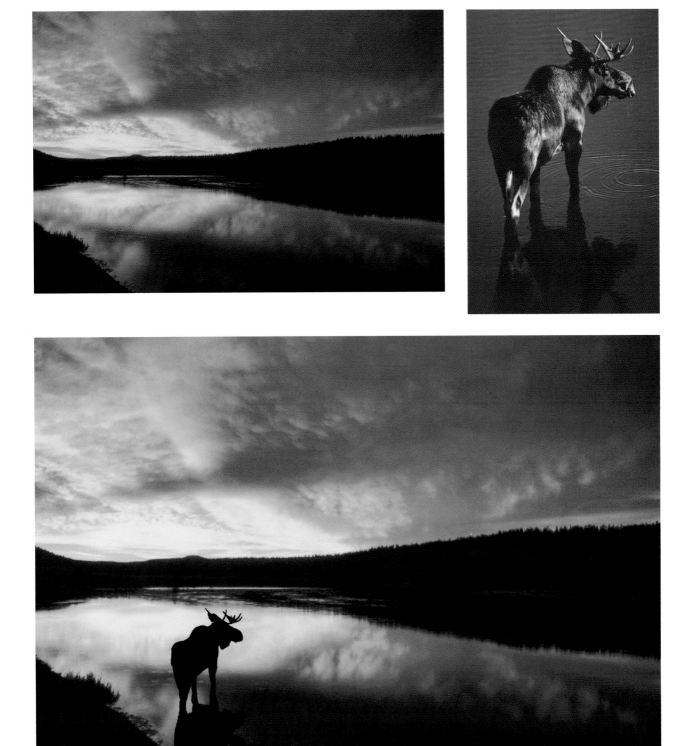

DOROTHY SIMPSON KRAUSE

URSULA

. . . The sky at night
is chunky salt and the bear unseen
swirls overhead—

Ursula is part of a series of images inspired by *Macomber House,* a collection of poems by Ray Amorosi. Ursula, after whom the poem was named, was one of the women who settled the Macombers' land in southeastern Massachusetts.

The image was composed in Photoshop using a celestial map from a PlanetArt copyright-free CD, a scan of a vintage photograph, bound to its frame by a fraying string, and a scan of a draft of the poem in the poet's handwriting.

First, Krause prepared a traditional fresco mixture by heating a mixture of water, calcium carbonate, and rabbit skin glue. She poured the mixture onto a masonite panel that had been taped around the edges to form a tray and left it overnight to dry.

The image was flipped horizontally and printed (in reverse) with the 50-inch Roland Hi Fi Jet on Rexam's clear film. Krause then spray-dampened the fresco panel and placed the print face down on top of it. A roller and bone-burnishing tool were used to transfer the image from the film onto the fresco surface.

Krause printed a second copy of the image on gold handmade Japanese paper. She cut the center oval from the paper and discarded it, then aligned the remaining outer portion of the paper to the transferred fresco image and adhered it with PVA glue. A heavy cord was used to wrap the final piece.

According to Krause, "Of all the media I use, the computer is the one most important to my work and the last I would part with. It is a mega tool, which I will never master and of which I will never tire."

Dorothy Simpson Krause is Professor Emeritus of Computer Graphics at the Massachusetts College of Art, a founding member of Unique Editions™ and a part of Digital Atelier™, a digital artists collaborative. She is a frequent speaker at conferences and symposia and a consultant for manufacturers and distributors of products that may be used by fine artists. Her work is exhibited regularly in galleries and museums and featured in more than three dozen current periodicals and books. In July 1997, Krause organized *Digital Atelier: A printmaking studio for the 21st century* at the National Museum of American Art of the Smithsonian Institution and was an artist-in-residence there for 21 days.

BONNY LHOTKA

THUNDER CLOUD

An old, faded umbrella with a pattern created by sun bleaching became the base for this image. It was photographed with a digital camera. Scanned paint chips from Lhotka's studio were composed on an Intergraph NT computer. The image was printed on film and transferred to wet etched glass. The glass image was then photographed to become the sun element.

A glass lithograph plate was made for the cloud and photographed for layering in Photoshop as well as for the second layer of printing as a planographic process in the etching press. Next, Lhotka printed the umbrella image on Encad QIS film and tested it for positioning over a print of the lithograph plate. Then the plate with the cloud image was inked while the paper soaked.

The glass plate of the cloud, inked with oil-based lithography ink, was printed over the digigraph umbrella image without affecting the water-based inks. The final print was peeled from the glass plate. The edition of 30 was printed on Rives BFK.

Bonny Lhotka is a founding member of Unique Editions and a part of Digital Atelier, a digital artists collaborative. Work from the Digital Atelier is displayed both nationally and internationally and is in more than 200 corporate and museum collections including the permanent collection of the National Museum of American Art. Lhotka gives presentations and workshops at venues as diverse as the College Art Association, MacWorld Expo, and the Smithsonian Institution.

PAUL LOVEN

RAVELLO

High atop the Amalfi coast lies the ancient city of Ravello. A place where dreams are made. The Mediterranean glimmers from the summer sun far below. Oh, to be free to climb the olive groves and lemon-covered slopes. . . .

This image was first photographed traditionally in 35mm with a Canon EOS-1N camera. The location was Ravello, Italy, on the Amalfi coast. Loven scanned the image and manipulated it using Adobe Photoshop 5.0 on his Macintosh G3. The result is an ethereal, dream-like rendition of the original image. The file was printed (using an Iris 3047 printer) onto watercolor paper in a signed, limited-edition series.

Award-winning photographer **Paul Loven** has owned and operated Paul Loven Photography in Phoenix, Arizona, for over 20 years. He specializes in commercial location photography, and has worldwide experience in shooting cruise lines, airlines, annual reports, and resorts. Loven's commercial images are sold by The Image Bank. His work has been widely published in such prestigious magazines as *Zoom, National Geographic* and *Photo District News,* who recognized his style with a "Digital Art" award in 1996.

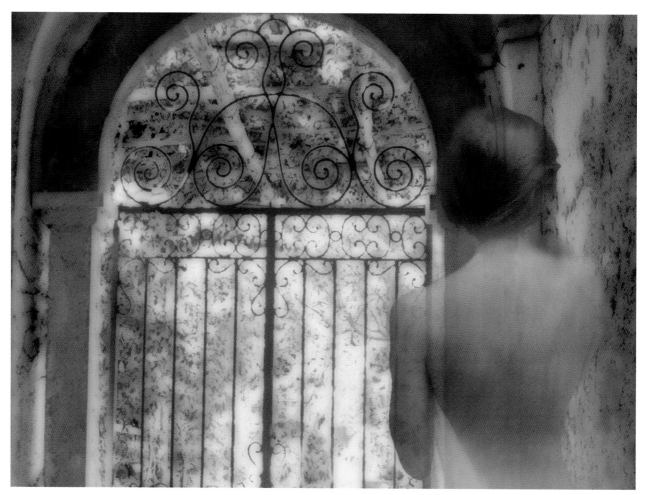

Detail.

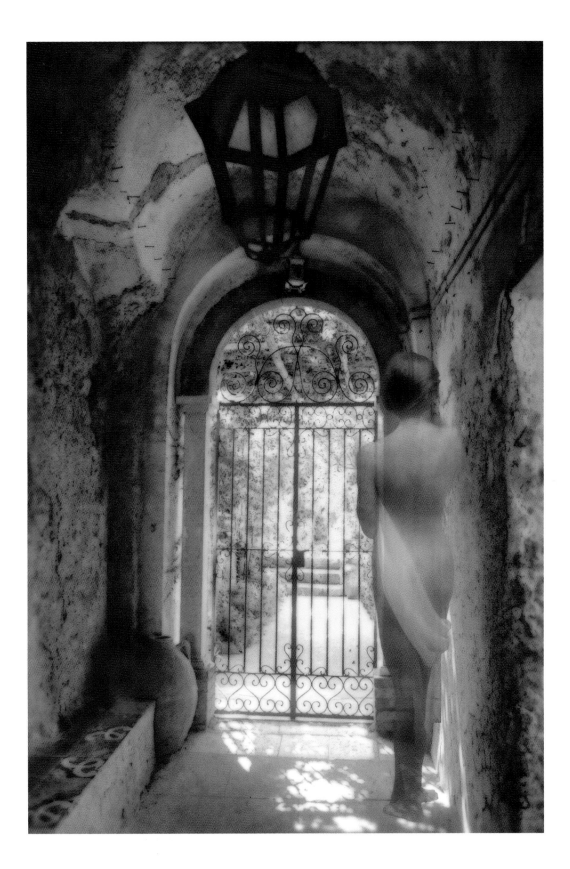

JOSEPH MEEHAN

CROWN OF WATER

This image was shot on Fujichrome 100 film with an early Widelux 120 (6 × 12cm) swing lens panoramic camera on the coast of Northern California in late spring, just as the sun was setting. Meehan had to guess at the exposure settings—his meter was not working—so the original exposure (*f*/16 at 1/15 sec.) was slightly under. While he was quite pleased with the setting and composition, he really wanted to change the color of the light with filters because of the gloomy atmosphere that day. Unfortunately, no appropriate filters were available for his camera at the time. In addition, headlights from cars on the highway on the right

had produced an unwanted glare. Thus, for many years, Meehan was unhappy with this image and rarely published or exhibited it. This changed once he set up a digital workstation and was able to make adjustments in the color, remove the headlight glare, adjust the exposure, and clean up minor imperfections in the sand. Now, it is his favorite panoramic image.

The original image was drum-scanned at 300 dpi for a 44-inch-wide output (panoramic photographers tend to think of image size in terms of width only because of the elongated format), producing an approximately 90MB file. It was archived on a CD as a

Joseph Meehan has been a commercial photographer, teacher, and writer for more than 30 years. He is presently the Senior Technical Editor of *Photo District News,* the premier magazine for commercial and advertising photographers in the United States, and a former editor of the *Photography Yearbook,* which has been published in England since 1935. Hundreds of his pictures have been published in editorial and advertising publications in the United States and Great Britain. His style has been described by *The New York Times* as "alive with color and sparkling with light!" Meehan has written over 500 articles on photography, which have appeared in such magazines as *Popular Photography, Photographic Magazine, Outdoor Photography,* and the *British Journal of Photography,* and has authored 15 books on photographic techniques, including the Amphoto publications *Panoramic Photography* and *The Photographer's Guide to Using Filters.*

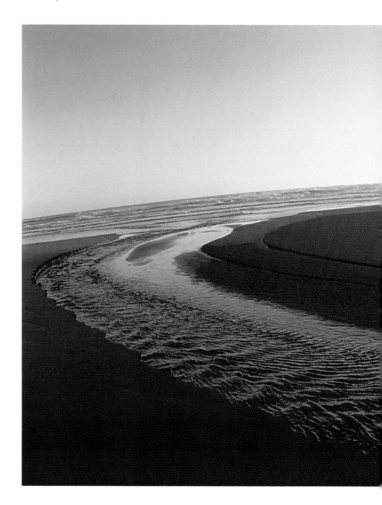

TIFF/RGB file. Meehan performed all corrections in Photoshop using a Mac G3 with 384MB of RAM. First, he added +15 magenta, +10 red, and +20 yellow to the middle tones, and +20 blue to the shadows. The image was also lightened by +10 and contrast was then increased by +10. He used the Unsharp Mask filter at 100 percent with a pixel radius of 2.0 and a level 1 Threshold. Meehan prints this image using pigmented inks and the Epson 2000P printer, which is capable of producing a print size of approximately 44 inches long for this format. For larger sizes, he uses a LightJet 5000 with both Fuji and Ilfochrome papers.

He says, "For me, the most interesting thing about working in the digital darkroom has not been the fact that it is possible to create a new image from combining parts of different images. My particular photographic vision is almost solely a consequence of the conditions encountered at the time the picture is taken; thus, the digital darkroom is, for me, a place where a picture is refined to achieve all that I perceived originally. In this case, the digital darkroom allowed me to do something in Photoshop that I saw in my mind's eye as part of that original scene but could not include at the time because the necessary filters were not available to me."

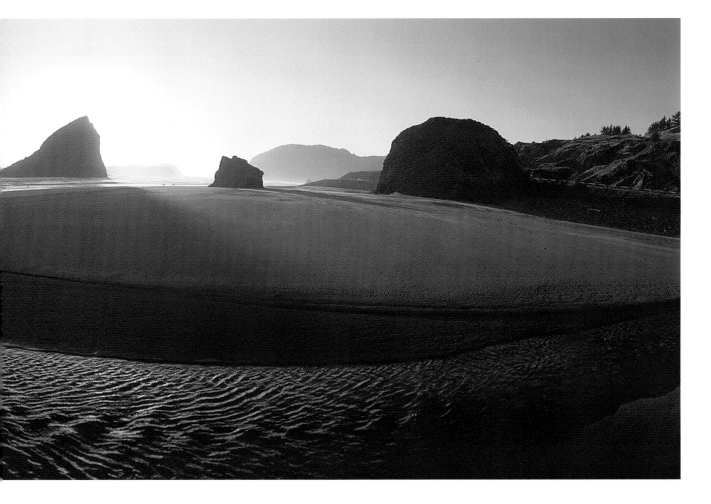

RANDY MORGAN

TRANSGRESSION: ACT II—LA CASA DE LOS INDAGACIONES

The source file for this Photoshop montage was a shot of a very dilapidated hotel that was at the end of Calle Yardley Place, where Morgan used to live in San Juan, Puerto Rico. It was captured with an old Nikon F on Kodak Tri-X film and scanned on a Leaf 45 film scanner. Morgan also used a few technical diagrams and pencil drawings that were scanned on an AGFA Arcus II flatbed. The rest of the photographic imagery was scanned on a Nikon Super CoolScan 2000 with Multi-Sampling set to 4x.

After looking at the scans, Morgan sketched the idea for the piece in pencil, then started to build it in Photoshop. He transformed the imagery layer upon layer, checking and changing the blending modes on the Layers palette, playing with the Opacity settings, and even sometimes duplicating an existing layer to blend with itself for a more pronounced effect. He also used layer masks on various layers to adjust the density of the imagery.

The three spheres in the upper right corner of the image started out as three elliptical selections filled with black. Morgan created a clipping group consisting of the black circles and three scans of a river. He then adjusted the color with Hue/Saturation and by using the Hard Light blending mode. This looked a bit harsh, so he applied the Motion Blur filter to the circles to soften them a little.

The image contained 80 layers during the working stages and measured up to 850 megabytes. In order to fit it on a 650MB CD-ROM, Morgan saved it in the native Photoshop format, which compresses a file without loss. The final print was 16 × 24 inches with a 0.25-inch bleed for the overmat to cover.

Randy Morgan is the proprietor of Studio IX, a creative atelier, and also an instructor at the Maryland Institute, College of Art, in Photoshop, Illustrator and QuarkXPress.

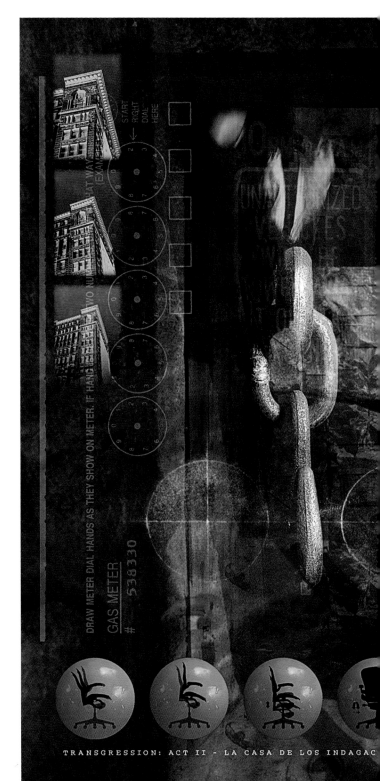

TRANSGRESSION: ACT II - LA CASA DE LOS INDAGAC

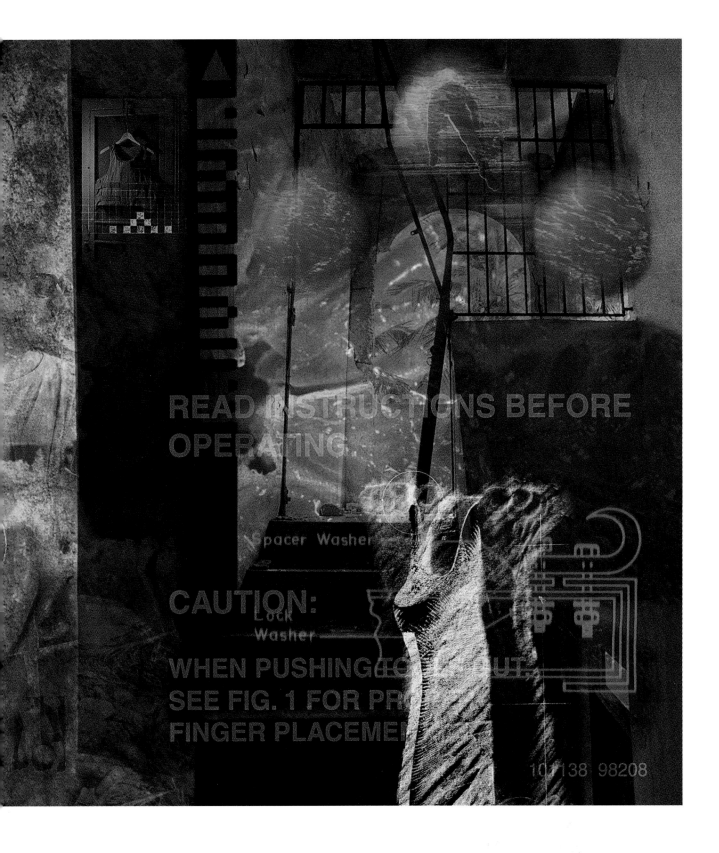

READ INSTRUCTIONS BEFORE
OPERATING

Spacer Washer

CAUTION:
Lock
Washer

WHEN PUSHING
SEE FIG. 1 FOR PR
FINGER PLACEMEN

101138 98208

WILLIAM NEILL

DAWN, LAKE LOUISE, BANFF NATIONAL PARK, CANADA, 1995

The beauty of nature . . . motivates and inspires my photography. When I stand before landscapes of silent rock, reflecting water, and parting cloud, I feel most connected to myself and to life itself. Seeing and feeling this beauty is more vital to me than any resulting imagery.
—*William Neill,* Landscapes of the Spirit

After shooting in Banff National Park in rainy conditions for two weeks, Neill rose very early one summer morning, hoping for a dramatic and brilliant sunrise on Lake Louise and the glaciers above. When the sun did rise, it did not live up to his expectations; persistent clouds continued to shroud the mountains. Neill made two exposures, but expected little and forgot about this session during the rest of his trip. When he saw the film after returning home, he was amazed. Unconsciously, but facilitated by his experience and instinct, the power and magic of that landscape, at that moment, had come through on film.

The Lake Louise photograph was made with Neill's 4 × 5 Wista metal view camera and a 150mm lens. The combination of the slow Fujichrome Velvia film he used, a small aperture, and the low lighting required an exposure time of about two minutes, which resulted in some blurring that added balance and mystery to the image. The transparency was scanned on a drum scanner at 2500 dpi, resulting in a file size of 300MB.

Neill considers himself a traditionalist in many ways, and does not alter his images digitally. However, he does use Photoshop to adjust contrast and color saturation the way he would in a regular wet darkroom. When he was satisfied with the appearance of this image, he used a LightJet 5000 laser printer to print it onto Fujicolor Crystal Archive paper. *Dawn, Lake Louise, Banff National Park, Canada, 1995* has been published many times in several countries, but Neill has only had to scan his original chrome once, greatly decreasing the risk of its loss or damage.

William Neill, a long-time resident of Yosemite National Park, is a landscape photographer concerned with conveying the deep, spiritual beauty he sees and feels in nature. Neill's award-winning photographs have been widely published in books, magazines, calendars, and posters. His limited-edition prints have been collected and exhibited in museums and galleries nationally, including the Museum of Fine Arts, Boston, and the Polaroid Collection. In 1995, Neill received the Sierra Club's Ansel Adams Award for conservation photography. A retrospective monograph of his landscape photography entitled *Landscapes of the Spirit* (Bulfinch Press/Little, Brown, 1997) relates his beliefs in the healing power of nature.

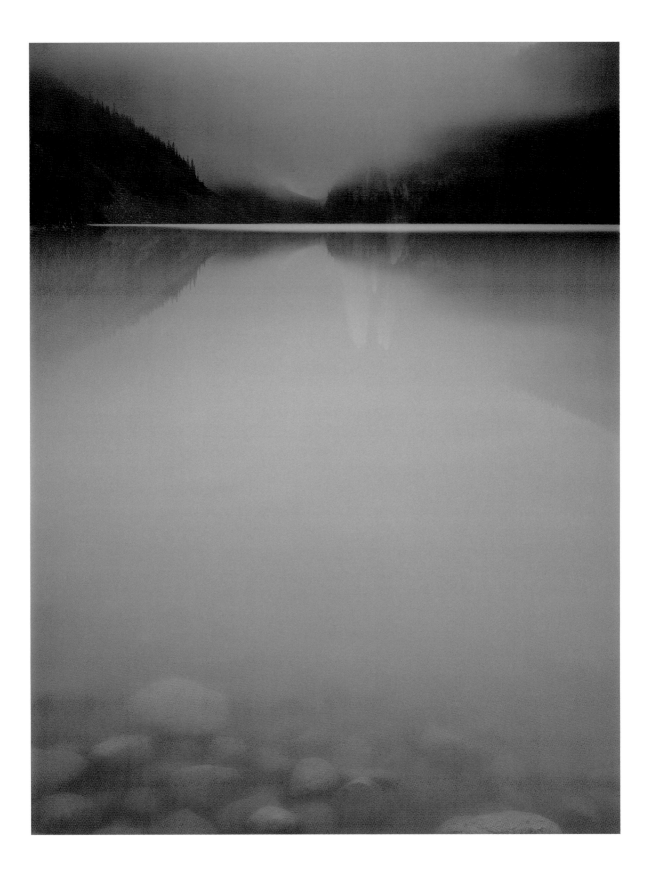

JOHN REUTER

CLOISTER WOMAN

This collage was created mostly from images taken at The Cloisters (a branch of the Metropolitan Museum of Art) in New York. To create the background, Reuter used an interior photograph of a view through a double window and a second image of a vine growing against a wall on the exterior of the museum. The images were blended using Layer Styles Blending, where he adjusted the highlight and shadow tones of each image to create a solarized look.

The central image is from a photo of a female bust from the museum's collection. The image has a warm, slightly blurry effect because Reuter was using daylight film in low light. He used Layer Styles Blending again to make the woman a more realistic part of the background. Sometimes image information is accidentally lost in the blending process, which removes information based on its position in the tonal range selected. To restore some information, Reuter used a layer mask. He duplicated the layer with the female bust and returned the Layer Styles Blending information to the default state. The new layer was placed behind the landscape (vine + window) image. Then a layer mask was attached to the landscape (which had been converted from a background image to a normal layer), which rendered imagery from the window image transparent, thereby revealing parts of the woman's image that had been lost. This process allowed Reuter to have the best of both worlds—the wonderful chance elements of blending with the control to restore those parts he deemed essential.

After looking at the blended image for a while, Reuter felt it wasn't quite right, so he decided to add the hair from a portrait of a friend to counter the tree branches behind the figure. First, he used Layer Styles Blending again to remove parts of the image, leaving only the hair. Then a layer mask was used to remove additional information in order to make the hair appear to be part of the Cloister Woman. To finish the image, Reuter adjusted each layer mask individually until he had the balance he sought in the various elements. The final step was to desaturate the face of the woman to better integrate her into the background.

John Reuter was born in Chicago, Illinois, in 1953. Raised in California until high school, he moved to New York and attended college at SUNY Geneseo. It was there that he began to study photography and art. He studied with photographer Michael Teres and painter and art historian Rosemary Teres. Together they inspired his early work, which took advantage of photographic process to transform the camera's reality into a more "mythic" reality. Reuter continued this work in graduate school at the University of Iowa in the late seventies, then began working for Polaroid Corporation, first as a research photographer and later as main photographer and director in the 20x24 Studio.

Throughout 20 years of working with other artists Reuter's work and vision have moved in a unique direction. His early SX-70 collages gave way to painted image transfers in formats ranging from 8 × 10 inches to 5 × 6 feet. Reuter has been working digitally since the early 1990s. Taking advantage of the image combination abilities of the computer, he creates elaborately layered images. His work has been published in *Aperture, Popular Photography, Marie Claire, Zoom* and *American Photo,* and, most recently, *View Camera.* Reuter has also exhibited extensively in America and Europe, and he teaches workshops at the International Center of Photography (New York), the Palm Beach Photographic Centre, the Santa Fe Workshops, and Toscana Photographic Workshops.

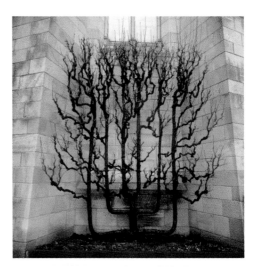

Tree Image, The Cloisters, New York

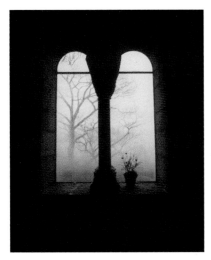

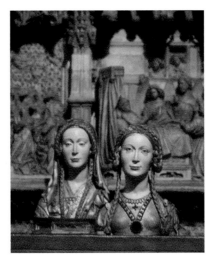

Portrait of Tricia Rosenkilde.

Window, The Cloisters, New York.

Female Bust, The Cloisters, New York.

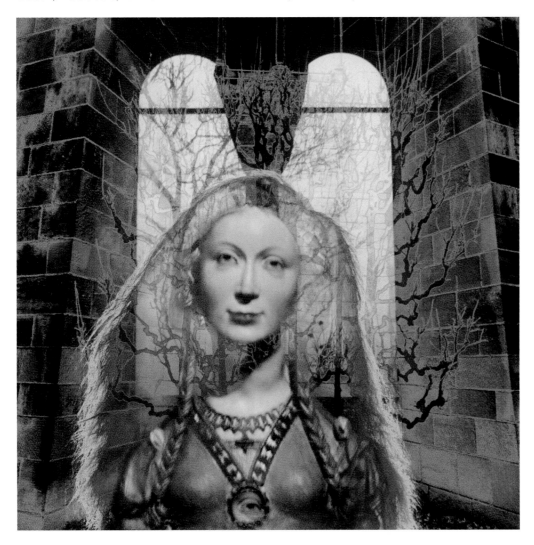

BOB SHELL

AUDRA

Bob Shell loves to manipulate his images in Photoshop and other photographic software applications, often taking the final image far from the photographic original. This image is from a session with one of his favorite models in which he had her recline and try a variety of poses on a cushion atop the radiator in his dining room. To make the lighting softer he taped large sheets of frosted Mylar from an art supply store over the outside of the window, effectively making the window into a giant softbox. The photo was taken with a Canon EOS-1N camera with the Canon EF 28-80mm f/2.8 L zoom lens at around 70mm. The film used was Ilford XP-1 chromogenic black and white, which Shell finds easier to scan than silver-based black-and-white films. The negative was scanned as a grayscale image using a Microtek 35Ti scanner. In Photoshop, Shell began by changing the image mode to RGB to enable him to add colors. Then he used the Find Edges command in the Filters menu to make the image more abstract. He added colors with a variety of Photoshop's options and adjusted sharpness and contrast until he had just the look he wanted in the final image. Prints were then made using a Kodak 8600 dye sublimation printer.

Bob Shell is probably best known for his 11 years as Editor of *Shutterbug* magazine, the world's third largest monthly photography magazine. He has recently semiretired and become Editor-at-Large for the magazine. In addition he is on the permanent technical staff of *Color Foto,* Germany's largest photo magazine, and writes for a number of other photography magazines worldwide. He has written more than a dozen books on photographic subjects, including *Canon Compendium,* the authorized history of the Canon Camera Company; *Pro-Guide: Mamiya Medium Format Systems*; *Pro-Guide: The Hasselblad System;* and many more. Shell's images are sold worldwide through agents and have appeared in many books, magazines, posters, CD and cassette covers, and even on jigsaw puzzles. He has received international design awards for his work in magazine design and industry awards for his articles. His workshops on photographing the nude are conducted in a wide variety of locations both in the United States and abroad.

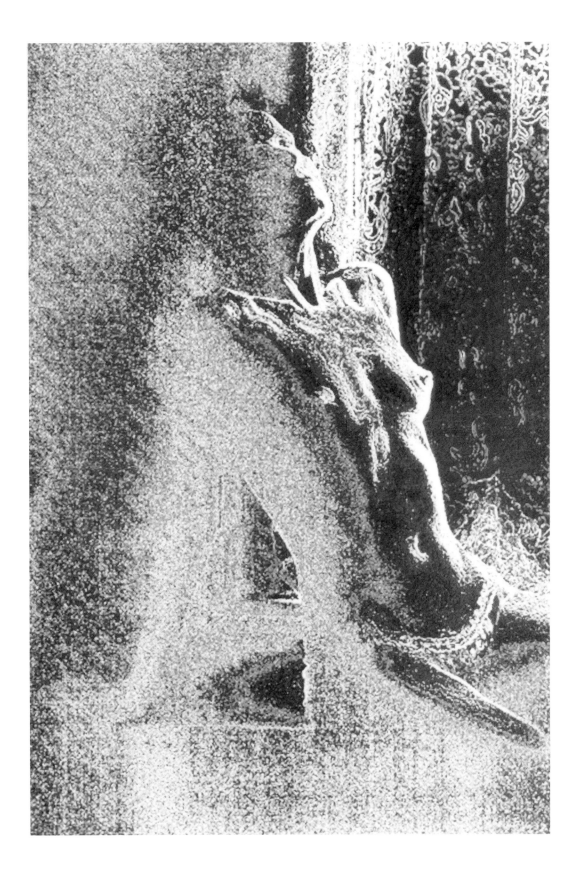

MEL STRAWN

LOST PARK CHRONICLES

Lost Park Chronicles is a simple juxtaposition of two images. The background is a digitized 35mm slide the artist made of a wall of torn posters in 1960s Italy. The other image is a digitized and then color-modified pencil drawing from Strawn's sketchbook that was made on a hiking trip to a remote Rocky Mountain canyon area. The blue side borders, suggestive of a fabric-mounted scroll, were added in Photoshop using simple flood-fill and airbrush tools.

Strawn's goal was to scale and place the drawing so as to let the wall's texture, color, and detail function in lieu of the naturalistic mountain/rock detail that was "abstracted" out in the pencil drawing. Very little electronic filtering or effect was used to help create the illusion that the wall and drawing were one surface. In fact, Strawn erased some of the bottom sections of the drawing that would have printed on top of the horizontal pipe (which was part of the wall image). This pushed the drawing "behind."

Strawn's tools include a digital camera (Olympus 600L), a scanner (Microteck ScanMaker IIHR, a three-pass scanner), and a Novajet Pro36 (ENCAD) inkjet printer. Since his objective is to create a rather large printed image—to be viewed as a wall-hung piece, similar to large prints or paintings—he finds the relatively low resolution of this set of tools acceptable.

About his work, he says, "Digital processing in the visual space provided by programs such as Adobe's Photoshop allows and encourages compositional ventures that result in new qualities of experience, related to but quite different, often more complex and interestingly ambiguous than is typical of my work in traditional drawing, painting, and photographic media. . . . My [digital] work, often using photographic elements, is not intended to be 'photographic' in the traditional sense—even though new digital imaging devices approach very high resolution photo quality."

Mel Strawn received his BFA and MFA degrees from the California College of Arts and Crafts. He taught art at the university level for many years and is Professor Emeritus at the University of Denver. Strawn has been painting and exhibiting his work since 1950, and began working digitally in 1981. His book *Transitions* deals with the transition of his own work from traditional, essentially abstract painting to digital imaging over an 18-year period. It also addresses the digital issue in basic technical terms, as well as some of the historical and professional contexts and issues that seem pertinent in the fine arts, including photography and design.

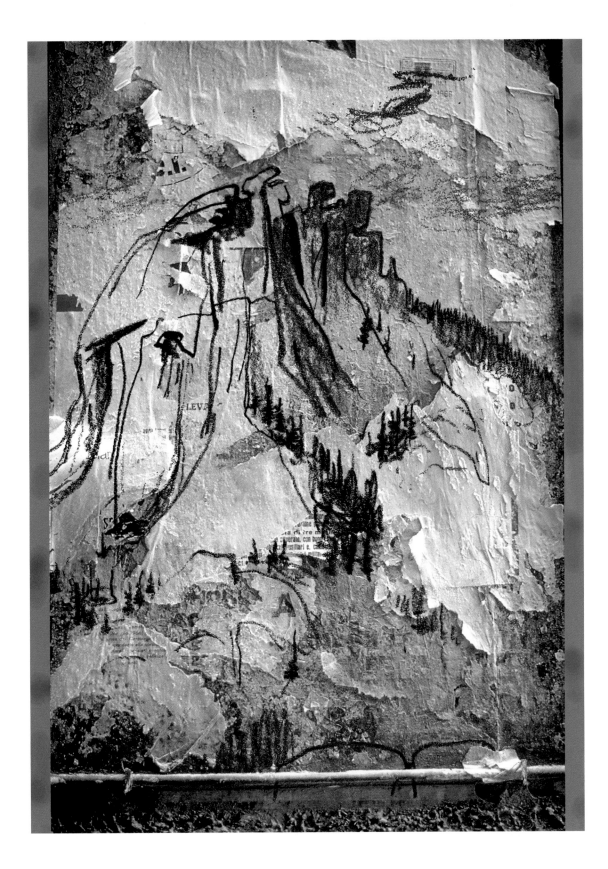

MAGGIE TAYLOR

POET'S HOUSE

This image is composed of a series of layers. Taylor began with a background simulating a sunset, which was made in Photoshop using the gradient fill tool and the paintbrush. Over this layer, she placed a pastel drawing that she had created and scanned on a flatbed scanner. The Normal blend mode was applied to this second layer and the Opacity was set to 50 percent to allow some of the sunset-colored background to show through.

The third layer, the landscape, was a portion of a black-and-white photograph that was also scanned on a flatbed scanner. The Hue blend mode was applied and the Opacity was set to only 20 percent. A duplicate layer of the landscape was set to 30 percent Opacity and the Color Burn blend mode was applied.

The next layer was an image of a two-inch toy house. The Overlay blend mode was applied, with the Opacity set to 100 percent. A shadow or reflection of the house was made by duplicating this layer, applying the Gaussian Blur filter and the Multiply blend mode, and reducing the Opacity to 50 percent. Finally, the images of floating pieces of paper were made one at a time by scanning old handwritten letters. Each of the letters was combined with a scan of a crumpled piece of plain white paper, which was in the Luminosity blend mode in order to create wrinkles and irregular edges. A layer mask was made for each handwritten note so that it would not extend beyond the irregular edges of the crumpled paper.

Once all of the layers were assembled, the Hue and Saturation were adjusted on each of the floating papers individually, and a small amount of Gaussian Blur was applied to the more distant pieces. Finally, a new layer with small dots of white was added for the stars.

Maggie Taylor was born in Cleveland, Ohio, in 1961, and graduated from Yale University in 1983 with a BA degree in philosophy. She received her MFA in photography from the University of Florida in 1987. Taylor's photographs and Iris prints have been shown in more than 40 solo exhibitions during the past twelve years, including shows at the Center for Photographic Art, Carmel, California; Blue Sky Gallery, Portland, Oregon; The Light Factory, Charlotte, North Carolina; the Society for Contemporary Photography, Kansas City, Missouri; and Vanderbilt University, Nashville, Tennessee. Her work has been included in more than 70 group exhibitions, and is represented in many permanent collections, including the Fogg Art Museum, Harvard University; the Center for Creative Photography, Tucson, Arizona; Princeton University Art Museum, Princeton, New Jersey; the Museum of Fine Arts, Houston, Texas; the Mobile Museum of Art, Mobile, Alabama; Musée de la Photographie, Charleroi, Belgium; and Museet for Fotokunst, Odense, Denmark.

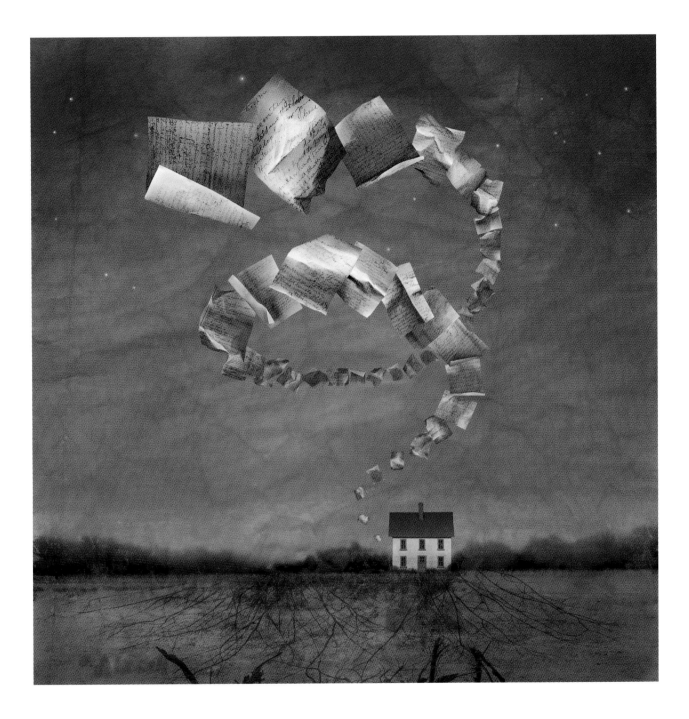

JENN WALTON

THERE'S NO PLACE LIKE HOME . . .

For this image, Walton used a Hasselblad camera with a 50mm lens to photograph the models—Felice (the adult) and Zinnia (the baby)—on a white paper background so that she could place them in a custom cartoon-style background. She shot them in black and white so that she could choose the image's final colors. Although she knew what she wanted to achieve and what kind of feeling would be evoked from the final image, she had to shoot about 20 different poses before she felt that she had the image that would work for her.

The next challenge was to develop an environment for the mother and child. Walton brought the image into Photoshop and made it into a TIFF file so that she could take it into the software program called Painter, by Fractal Design. In this software program she created a tracing paper for it and started to play with colors and brushes, discovering that the spray brush created exactly the effect she wanted for the dress. Next, she colored in the walls and floor. The image was almost complete, but the wall seemed bare and the image lopsided, so she added a picture frame with a cartoon portrait of a family. Still dissatisfied, she smeared the portrait and it became a mirror.

After saving the tracing paper, Walton brought it back into Photoshop in order to merge it with the black-and-white image of Felice and Zinnia. There she made final adjustments to the painted background and manipulated the Curves of the black-and-white photograph for output. She also colored the skin tones in Hue/Saturation to give them life. Finally, she duplicated the flattened image and darkened it overall. This layer was then erased away in certain areas to create the shaft of light shining down from above, which hits certain areas of the floor, the woman's dress, and the faces of both the woman and the baby. This light added some mood and depth to the image.

The image was basically complete. Walton applied the Unsharp Mask filter with the following settings: Amount: 150; Radius: 1.0 pixels; Threshold: 0. This sharpened the image just enough—not so much that the edges of the image were highlighted.

About *There's No Place Like Home . . .* , Walton says, "I think the reason this image was so successful is because it is a huge part of my chosen lifestyle and of many of today's parents. I think it hits home and make people realize they aren't alone in their frustration."

"The challenge of digital photography comes on the technical end of the medium as with any type of photography, the fun comes in when you discover how limitless the possibilities have become . . . it's a whole new world opened up."

Jenn Walton graduated in 1995 from the Langara College Professional Photography Program in Vancouver, British Columbia. She has won recognition for her work from the Canadian Association of Photographers and Illustrators, the Portrait Photographers of British Columbia, *Applied Arts* magazine and *PhotoMedia* magazine. Her work has also been displayed in a number of group exhibitions in Vancouver. She is co-owner of Hot Digital Dog Studios, a commercial digital photography studio located in Vancouver, British Columbia. The studio gives professional digital photography workshops year-round to beginning, intermediate, and advanced photographers and artists.

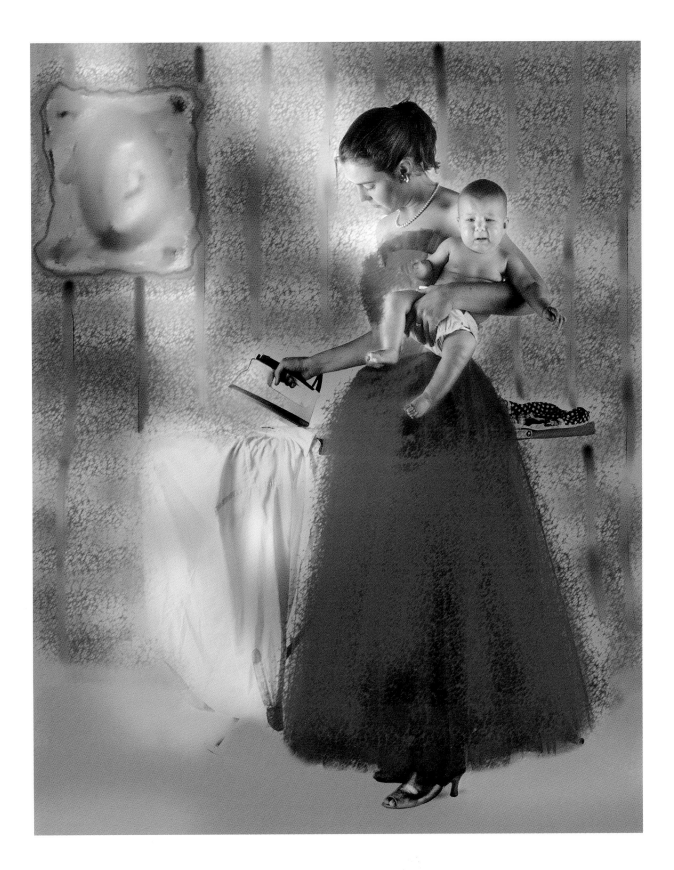

HUNTINGTON WITHERILL

CEMETERY #2, NEW ORLEANS, LA—1990

While there are many state-owned cemeteries in Louisiana that are of historical significance, *Cemetery #2, New Orleans, LA—1990* was made in a privately owned facility. Witherill was granted permission to photograph the cemetery with the condition that, out of respect for the privacy of the departed and their families, he did not allow any of the names that appeared on the gravestones to appear in his photographs. This would have been a tall order before the advent of Photoshop's cloning tool!

The original image was made with a 5 × 7-inch camera, using Ilford FP4 film. The resulting negative was then scanned into digital form as a grayscale file. In the upper-right portion of the image, there is a polished marble slab on which several names were chiseled. These names, along with a few cigarette butts and other ubiquitous trash items, were removed using the cloning tool. Fortunately, because the original negative was exposed and developed with extra care, very little dodging and burning was required to produce a finished standard enlargement and thus, extensive contrast control within the digital file was unnecessary.

The finished digital file was output to an imagesetter as a 16 × 20-inch half-tone film negative, at 2400 dpi. The negative was then contact-printed onto standard enlarging paper and processed to archival standards.

Huntington Witherill is a fine art photographer whose works have been exhibited in museums and galleries throughout the world in more than 100 individual and group exhibitions since 1975. His photographs represent a remarkably varied approach to the medium, including landscapes, studies of Pop art, botanical studies, nude studies, and digital imaging. Recently, an extensive series of his landscape photographs—spanning nearly 30 years of work—was published in an award-winning hardcover monograph entitled *Orchestrating Icons*, by LensWork Publishing, Anacotes, Washington. A resident of Monterey, California, Witherill teaches photography for a variety of institutions and workshop programs throughout the United States.

JIM ZUCKERMAN

AMANDA

This image consists of six photos: the model; a Jackson's chameleon; a mountain range in Alaska; the sun and clouds; and a Mardi Gras mask. All of the photographs were originally taken with a Mamiya RZ 67 and scanned with a Leaf 45 scanner to 38.5MB. The composite was created using Adobe Photoshop 6.0 on a Macintosh G4.

Zuckerman began by using Layer > Transform > Scale to squeeze and stretch the range of mountains. He then selected and filled the mountains with a gradient abstract using Kai's Power Tools. The sky is a combination of a sunset and another gradient design created using Kai's Power Tools. The reflection was made by selecting the mountains and sky, copying the selection to the clipboard, pasting it back into the image, and flipping it vertically. It was then moved into place with the move tool to simulate a mirror reflection, after which Zuckerman darkened it in Levels. He then applied the Wave filter to introduce the ripples.

The model was cut out of her background (using the pen tool) and pasted into the scene. Zuckerman used the clone tool to "cover" her feet with the reflected image in order to suggest that she was actually standing in water. The mask was then cut out and pasted over her face. (The glass eyes that can be seen had been originally photographed with the mask.)

Next, Zuckerman selected the upper portion of the chameleon and inserted it into the frame. The reflection of the model and the reptile were made using the same steps outlined above. Using the Photoshop plug-in filter Terrazzo, made by Xaos Tools, the image was mirrored in a very unique way. The final step was to alter the colors using Hue/Saturation.

Jim Zuckerman left his medical studies in 1970 to pursue his passion for photography. Unlike many photographers who specialize in one aspect of the business, Zuckerman shoots wildlife and nature, international travel destinations, and special effects. He has been a contributing editor to *PHOTOgraphic* magazine for over 25 years and is the author of seven books on photography, including *Fantasy Nudes* (Tiffen) and *Capturing Drama in Nature Photography* (Writer's Digest). His stock is represented by Corbis Images.

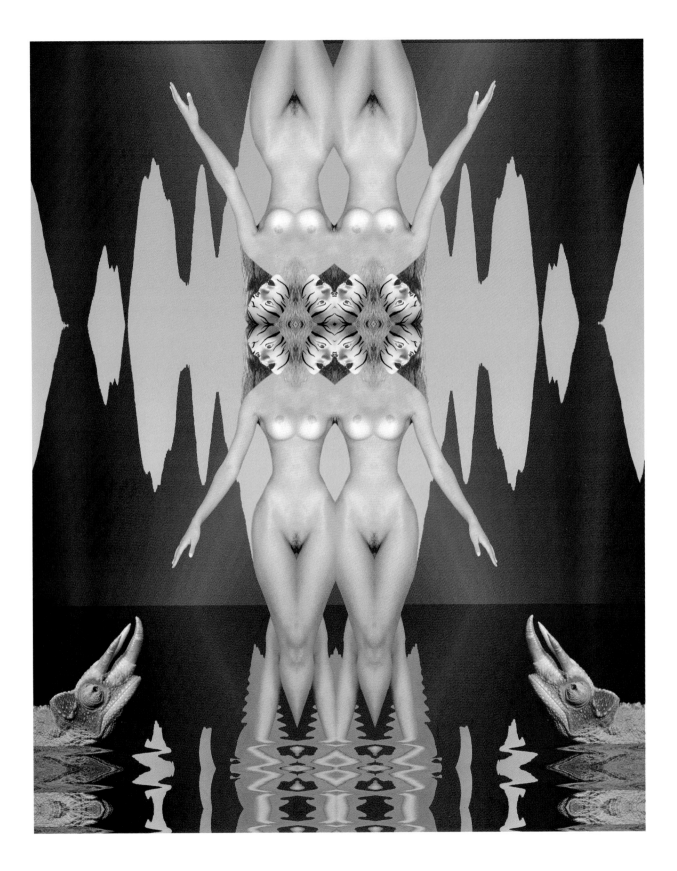

Appendix I: TROUBLESHOOTING: PRINTING WITH AN INKJET PRINTER

PROBLEM: *The ink beads up and will not dry. It can be easily wiped off.*

SOLUTION: You may have printed on the wrong side of the paper. Back coatings are formulated to counteract curling and are not usually formulated to retain inks. Another possibility is that you are using pigmented inks on an incompatible paper.

PROBLEM: *The colors in the print look flat and do not match the color of the image on the monitor.*

SOLUTION: Make sure that your monitor is calibrated and that you are using the correct color profile for the paper and ink (see Chapter 3). You may also have printed on the wrong side of the paper. The back side of some coated inkjet papers is yellowish; this is sometimes hard to distinguish in low light.

This can also happen if you use artist's papers that are sized on one side only (not tub-sized). If watercolor, pastel, or drawing papers are used, the inks may be absorbed too deeply into the paper's fibers.

Yet another possibility is that you may not be using a suitable paper-and-ink combination. Consider the base color of the paper—white, off-white, or yellowish. If the tone of the paper is yellowish, your blacks or dark colors will have a greenish cast, while your highlights will have a yellow cast.

Finally, you may have sent the file to the printer after converting it to CMYK. Most printers (for example, the Epson 3000) require an RGB file so that the printer engine can make the conversion to four or six colors.

PROBLEM: *The paper gets jammed or does not move through evenly, causing the inks to layer on top of each other.*

SOLUTION: The paper is too thick to make a U-turn through the rollers of your printer. If you are working on a printer such as the Epson Stylus Color 3000, these thick papers can be back-loaded so that they come straight through and do not have to make the U-turn.

You should also check your printer's paper thickness level setting. Some printers have a switch that lets you load thicker papers such as card stock. The normal setting is for thinner papers.

PROBLEM: *The printer will not accept the paper, or keeps running it though without printing.*

SOLUTION: One possible explanation is that you are feeding thin paper through and the printer is set up for receiving heavy paper. On the Epson 3000 there is a lever with the setting 0 to +. The 0 is for thin paper and the plus sign for extra-thick papers. There are also settings for papers that fall somewhere in between.

Sometimes the paper tray is a bit too low. This can happen when you move the printer around or travel with it, and they sometimes come from the manufacturer that way. If the paper is not exactly level with the paper feeder and is not pulled in at the exact right angle, the printer heads do not make contact and the paper is fed straight through.

To solve this problem, place a sheet of paper (the same thickness as the one you are printing on) on the bottom of the paper tray to be used as a guide and tape it down so that it does not feed into the printer. In many cases, this is all the extra height that is needed to allow the printer to pull the paper in at the right angle. If it continues to happen, abort the printing job, turn the printer off, and wait a few minutes before turning it back on.

Another option is to feed the paper in through the back of the printer manually, avoiding the tray altogether.

PROBLEM: *The paper comes out of the printer wrinkled.*

SOLUTION: Some types of paper—especially Oriental papers—are too thin and delicate to run through a printer smoothly. Cut a piece of thicker paper, such as watercolor paper, to the same size as the thin sheet and use it as a backing. First, use either removable or repositionable adhesive or removable tape to gently attach the corners and midsection of the thin paper to the thicker paper, making sure that the leading edges of the two papers are aligned and flat. Then run the paper sandwich through the printer, giving it a manual push to get it started if necessary. Once the paper sandwich is in the rollers, printing will proceed as normal. If you have used repositionable adhesive, slowly and gently pull the two sheets apart immediately after printing.

PROBLEM: *Thin vertical lines with no information appear in the print.*

SOLUTION: This phenomenon may be caused by color banding, which occurs when you print an image at a resolution that is too low. Study the print carefully; if the lines are most noticeable in the large areas of similar color (such as the sky), it could be just a matter of using a higher dpi. Try printing at 1440 dpi.

If this does not correct the problem, the printer heads may be dirty or out of alignment. In your printer dialog box, choose Utilities and run an alignment check and head cleaning if necessary.

If all else fails, check the paper. Some papers (such as those with laid surfaces) have a banding-like weave and the inks accentuate the structure of the paper's surface.

PROBLEM: *Ink seems to bleed or spread out on coated papers and sometimes has a bronzing effect in the blacks.*

SOLUTION: You are probably laying down too much ink on the paper. Before you print the image,

choose Image > Adjust > Curves (if you are not using Photoshop, you can use the curve controls in the printer driver) and reduce each color by 10 percent. Or you can open the Levels dialog box (Image > Adjust > Levels or Command-L) and change the settings in the Output Levels boxes. This will reduce the amount of ink being laid down in the dark areas of the print. In the dialog box, you will see a histogram of the tonal range of your print, which maps out the distribution of pixels, from the darkest to the lightest. You can use slider bars or option boxes to adjust the image's contrast. The first Output Levels box, which should say 0, controls the darkest tones in the print. By changing that number to 5 or 10, you lighten the dark areas, allowing more information to be read and less ink to be deposited during printing. If you reduce the number in the second box from 255 to 250 or 245, you darken the highlights in the print, thus revealing more detail in them. You do however have to be judicial in your numbers or you will make the print too flat.

This is the image with no adjustments to the Levels or Curves. The blacks are too dense and blocked up, causing bronzing in the dark areas of the print.

I changed the Output Levels settings to 5 and 250. The blacks are now more open. There is also good information in the highlights (the sidewalk area).

Now, the Levels adjustments have gone too far (from 0 to 10 and from 255 to 245), causing the image's contrast to flatten too much. The colors are also a bit washed out.

Appendix II: RECOMMENDED COMBINATIONS OF PAPERS AND MEDIUMS FOR HANDCOLORING

The following papers all have been used and tested by me and were printed with one or all of the following inksets: Lumijet Platinum, Silver, and Monochrome quadtone inks, MIS inks, Jon Cone's Quad inks, and Generations Pigment color ink.

The secret to using water or water-based paints on inkjet paper for the most part is using an archival ink.

There are only two papers that I have used that cannot tolerate water (it dissolves the coatings)—Lumijet's Tapestry X and Charcoal R.

If you attempt to use water-based paints on a coated inkjet paper that was printed with OEM (standard) inks, the inks will lift and mix with the colors being applied, leaving you with a very muddy, messy print.

COATED INKJET PAPERS

Paper Name	Paper Characteristics	Compatible Mediums
CONCORDE RAG	• white • slightly toothy	• Marshall's Photo Pencils • Conté pastel pencils • Faber-Castell watercolor pencils (blend with a moistened cotton swab or brush) • watercolors • gouache paints
HAHNEMÜHLE		
Arkona	• cold-pressed watercolor paper • good texture • can tolerate blending, rubbing, and use of an eraser	• Conté pastel pencils • watercolors • Jo Sonja's gouache paints • Faber-Castell watercolor pencils
Japan	• semi-transparent white Oriental-type paper with long random white threads throughout • print on either side • very strong surface for reworking color • use kneaded eraser for removing color • will take more water than other coated inkjet papers	• Faber-Castell watercolor pencils (can blend with water) • watercolors • Marshall's Photo Pencils (blend with cotton swab) • Conté pastel pencils (blend with cotton swab)
Structure	• very white, softly pebbled surface • cannot be used with water-based mediums	• Conté pastel pencils • Marshall's Photo Pencils (but these leave a shiny, waxy look)
William Turner	• lightly textured white surface with a lot of tooth • grabs pigment very well	• Conté pastel pencils • watercolors (use water sparingly) • gouache paints (use water sparingly) • Marshall's Photo Pencils

COATED INKJET PAPERS

Paper Name	Paper Characteristics	Compatible Mediums
LUMIJET		
Tapestry X	• pure white canvas-like texture • does not receive pigment inks (puddles) • susceptible to "pizza wheel" tracks • renders good detail • very archival (120+ years)	• Marshall's Photo Oils • Marshall's Photo Pencils (blend very easily) • oil paints • Conté pastel pencils • pastels • no water-based paints
Charcoal R	• pure white smooth surface • susceptible to "pizza wheel" tracks • does not receive pigment inks • shows great detail • very archival (120+ years)	• Marshall's Photo Oils • Marshall's Photo Pencils • oil paints • Conté pastel pencils (blend gently or they will rub off) • no water-based paints
Museum Parchment	• very beautiful parchment-like surface • imparts a classic, rich look to the image	• Conté pastel pencils (apply gently) • Faber-Castell watercolor pencils (can be applied dry or with water for a flow of color) • Jo Sonja's gouache paints • watercolors (use water sparingly)
Flaxen Weave	• very rough patterned surface; tough surface for coloring or erasing	• Conté pastel pencils • Jo Sonja's gouache paints • acrylics • Marshall's Photo Pencils (for added color, but they do not blend well) • Faber-Castell watercolor pencils (can be applied dry or wet for a wash of color) • watercolors
Classic Velour	• soft white surface is very delicate and will not tolerate blending or erasing	• Conté pastel pencils (applied delicately)
Soft Suede	• very white smooth matte surface • surface is very delicate and easily lifted; it will not tolerate blending or erasing	• wax-based pencils • Prismacolor pencils • Marshall's Photo Pencils • Faber-Castell watercolor pencils

APPENDIX II: HANDCOLORING MEDIUMS THAT WORK WELL WITH COATED INKJET PAPERS

COATED INKJET PAPERS

Paper Name	Paper Characteristics	Compatible Mediums
Somerset Photo Enhanced	• extremely white • soft • slightly toothy • apply all pencils gently to avoid making indentations	• Conté pastel pencils • Marshall's Photo Pencils • Faber-Castell watercolor pencils • watercolors (if water is kept to a minimum)

NON-COATED ARTIST'S PAPERS

Paper Name	Paper Characteristics	Compatible Mediums
ARCHES		
Arches Bright White Watercolor paper (hot-pressed)	• smooth white surface • more delicate than cold-pressed, which will take more abuse (blending & erasing)	• pastels • Conté pastel pencils • Faber-Castell watercolor pencils • watercolors • gouache paints • Marshall's Photo Pencils (apply lightly)
Arches Bright White Watercolor Paper (cold-pressed)	• rough-textured white surface • can take more abuse (rubbing, blending, and erasing) than hot-pressed	• pastels • Conté pastel pencils • Faber-Castell watercolor pencils • watercolors • gouache paints
BIENFANG		
Aquademic	• heavily textured • soft cream color • inks tend to "wick" so it does not give great color; however, prints can be used as sketches for paintings	• Conté pastel pencils • pastels
Inca	• smooth white paper with a bit of a tooth • lightweight (70 lbs.)	• Conté pastel pencils • Marshall's Photo Pencils
SOMERSET VELVET	• very white • soft velvety surface with good tooth	• Rembrandt soft pastels • Conté pastel pencils
SAUNDERS WATERFORD RADIANT DI (DIGITAL INKJET)	• bright white cold-pressed watercolor paper • heavily sized • medium-textured surface • works very well with pigmented inks	• Conté pastel pencils • Marshall's Photo Pencils (blend very well) • watercolors • Jo Sonja's gouache paints (use very little water) • Faber-Castell watercolor pencils (dry or with a moistened cotton swab or brush)

MY FAVORITE COLORING MEDIUMS

Pastel Pencils

I prefer Conté pastel pencils because they are neither too hard nor too soft and they can be used on both artist's papers and photographic papers. There are 48 beautiful saturated colors in the Master Set.

Soft Pastels

I like the Rembrandt soft pastels. They make a great Landscape set and a lovely Portrait set. These pastels are neither too soft nor too hard, with rich colors. They work well on large digital prints printed on artist's papers such as Arches CP and Somerset Velvet.

Watercolor Pencils

I like Faber-Castell watercolor pencils because they have such lovely colors and they are smoother than other brands. The smoothness of the pigment makes it easy to apply color to delicate surfaces, such as inkjet coated papers, especially if you are applying the color dry. If you want a wash of color, a moist cotton swab or brush pulls out a wonderful flow of color from the dry pigments.

TIP

If you like to paint with wet watercolor pencils, do not dip the pencil into the water—this dissolves too much of the pigment and flattens the pencil's point. Rather, make a puddle of water on your palette and roll your pencil around in that to work up a color wash and keep the point sharp. Your pencils will last longer.

Gouache Paints

I use Jo Sonja's gouache paints made by Chroma. Gouache paints dry opaque and flat and they also come in some exciting iridescent colors. Chroma also makes watercolor paints and a watercolor medium. If you add the watercolor medium to the Jo Sonja's gouache paints they produce a transparent gouache effect, which is very interesting—instead of flat and opaque, they are flat and transparent.

Oils

I use two oil paints: Marshall's Photo Oils for a transparent paint and Shiva's Signature Oils for an opaque paint. Both have great selection of colors and are lightfast.

Oil Pencils

Marshall's Photo Pencils are the best oil pencils on the market. They have enough oil in them to allow them to blend on most coated inkjet papers and well as on semi-matte or matte photographic papers. They come in 31 gorgeous colors. You can use them heavy with no blending for intense concentrated colors, or blend them with a tissue or a cotton swab for a more subtle, airbrushed effect.

If I could only buy two sets of coloring mediums, I would choose Conté pastel pencils and Marshall's Photo Pencils, because with these two sets you can color on inkjet coated papers as well as photographic papers and artist papers. They are clean and easy to use and give you fabulous colors.

GALLERY PARTICIPANTS

CHARLES BOWERS
3818 Spring Meadow Court
Ellicott City, Maryland 21043
Home: (410) 465.2696
Office: (301) 924.4131
E-mail: Charlie@gardengate.com

DAN BURKHOLDER
P.O. Box 111877
Carrollton, Texas 75011
Phone: (972) 242-9819
Fax: (972) 242-9651
E-mail: danphoto@aol.com
Web site: www.danburkholder.com

DANNY CONANT
3901 Woodbine St.
Chevy Chase, Maryland 20815
Phone: (301) 652-9102
Fax: (301) 652-4479
E-mail: danny@aol.com
Web site: www.dannyconant.com

GEORGE DEWOLFE
P.O. Box 1492
Southwest Harbor, Maine 04679
Phone: (207) 244-0966
E-mail: dewolfe@midmaine.com

BOB ELSDALE
10-11 Bishops Terrace
London SE11 4UE
England
E-mail: bob@bobelsdale.com
Web site: www.bobelsdale.com

MARTIN EVENING
14 Premier House
1 Waterloo Terrace
London N1 1TG
England
Web site: www.evening.demon.co.uk

ROBERT FARBER
530 Park Avenue
New York, New York 10021
Phone: (212) 486-9090
E-mail: robert@farber.com
Web sites: www.farber.com;
 www.photoworkshop.com
Robert Farber, professional photographer and author of seven books, has had his fine art photographs published in virtually every form.

He has won numerous awards, including Photographer of the Year in 1987 from the Photographic Manufacturers Association and the ASP International Award. His work has been exhibited in Japan, Europe, and the United States, and he has lectured extensively around the world. Farber's commercial work includes major campaigns for fashion, beauty, and advertising clients. His editorial and advertising work has appeared in most major magazines in the United States. His Web site, Photoworkshop.com, has become the most successful and unusual way to learn photography on the Internet.

LEWIS KEMPER
3251 Lassen Way
Sacramento, California 95821
Phone (916) 974-7200
E-mail: Lkemper@aol.com

DOROTHY KRAUSE
32 Nathaniel Way
P.O. Box 421
Marshfield Hills, Massachusetts 02051
E-mail: dotkrause@aol.com
Web site: www.dotkrause.com

BONNY LHOTKA
5658 Cascade Place
Boulder, Colorado 80303
E-mail: Bonny@lhotka.com
Web site: www.lhotka.com

PAUL LOVEN
1405 E. Marshall
Phoenix, Arizona 85014
Phone: (602) 253-0335
E-mail: lovenphotography@home.com

JOSEPH MEEHAN
360 Between the Lakes Road
Salisbury, Connecticut 06068
Phone: (860) 824-9848
E-mail: joseph.meehan@snet.net

RANDY MORGAN
619 West 36 Street
Baltimore, Maryland 21211
Phone: (410) 790-6735
E-mail: Studio9@mindspring.com
Web site: www.studioix.com

WILLIAM NEILL
40325 River View Court
Oakhurst, California 93644
Phone: (800) 575-4604
Web site: www.WilliamNeill.com

JOHN REUTER
48 Gautier Ave.
Jersey City, New Jersey 07306
Phone: (201) 333-0171
E-mail: JRphoto@pipeline.com
Web site: www.pipeline.com/~jrphoto

MEL STRAWN
8905 Highway 285
Salida, Colorado 81201
E-mail: mels@chaffee.net
Web site: www.911gallery.org

BOB SHELL
P.O. Box 808
Radford, Virginia 24141
E-mail: bob@bobshell.com

MAGGIE TAYLOR
5701 SW 17th Street
Gainesville, Florida 32608
Phone: (352) 372-1746
E-mail: jermag@ufl.edu
Web site: www.maggietaylor.com

JENNY WALTON
Hot Digital Dog Studios
203-950 Powell Street
Vancouver, B.C., Canada V6A 1H9
Phone: (604) 255-1130
E-mail: hdds@uniserve.com

HUNTINGTON WITHERILL
E-mail: hwphoto@mbay.net

JIM ZUCKERMAN
P.O. Box 8505
Northridge, California 91327
Phone: (818) 360-1198
E-mail: photos@jimzuckerman.com
Web site: www.jimzuckerman.com

GLOSSARY

ANTIALIASING Smoothing or softening of pixel edges. Gradual color merging from one color to another by mixing the percentages of color in the pixels.

BACK UP To save copies of computer files as a safeguard against lost or corrupted files.

BIT The smallest unit in binary code that a computer can work with; a kind of electronic pulse.
1 Bit = 2 values (black and white)
8 Bit = 256 Values (grayscale/Indexed)
16 Bit = 32,768 Values (RGB)
24 Bit = 16,777,216 Values (RGB)

BIT DEPTH A measure of the amount of color information stored in a single pixel.

BPC Bits per channel in a digital file, also called *bit depth*.

BLEED Spreading of ink into the fiber of the paper (or substrate), or running of the ink off of the substrate (receiving material).

BRIGHTNESS Term that describes paper's reflectiveness

BRUSH Photoshop tool for applying effects such as painting, color, erasing, blurring, and cloning. Brushes come in many different sizes, and you can also create your own size.

BYTE Unit of memory or storage on a computer
1 Byte = 8 Bits
1024 Bytes = 1 kilobyte (K)
1024 Kilobytes = 1 megabyte (MB)
1024 Megabytes = 1 gigabyte (GB)
1024 Gigabytes = 1 terabyte (TB)

CCD Charge-coupled device. A device used by scanners to capture information.

CD-ROM Compact Disc—Read-Only Memory. A storage device for digital files. Most CD-ROMs hold up to 700MB of information.

CD-RW CD-Rewritable. Unlike CD-Rs (CD-ROMs), they allow information to be altered or deleted.

CLIPBOARD Area of memory that is reserved for temporary storage. The commands Cut and Copy will put the selected data on the clipboard.

CLONING Duplication of pixels from gathered from other pixels in the image.

CMYK Cyan, Magenta, Yellow, and Black. These are the four inks used when outputting to a printing press.

COLOR BALANCE Photoshop command that allows you to add or subtract a color from the range of colors in a file.

COLOR GAMUT Range of color that can be seen. Monitors display the RGB color gamut which is based on light and the CMYK color gamut is based on ink colors and used in printing. The RGB color gamut is wider than the CMYK gamut. Each model of scanner or printer has a unique color gamut.

COLOR PICKER Photoshop tool that allows the user to select a particular color to be used in such applications as paint bucket, background/foreground colors, painting, etc.

COLOR MODE Defines the way a color image is stored or described. Common color modes include RGB, CMYK, and grayscale.

COMPRESSION Method of condensing a file to create a smaller file.

CONTRAST Relationship between dark and light areas in an image.

DIGITAL IMAGE Image that has been converted into numerical digits (a binary file) through a scanner or taken with a digital camera.

DOWNLOAD To copy information or data from a remote source into a local computer.

DPI Dots per inch. Term describes printer resolution. Output devices such as desktop printers, laser printers, image setters, all use tiny dots to represent line art and continuous tone art.

DUOTONE In traditional printmaking, it is the overlaying of two different ink color halftones each at a particular screen angle to increase the tones in a print. In Photoshop, it is a mode using two different colors, usually black for the dark values and another color for the midtones and highlights, in order to increase the tonal range of a black-and-white image.

EPS Encapsulated PostScript. A file format created by Adobe Systems to store graphics, photographs, page layouts, and image files.

FILE FORMAT The manner in which a software program codes information and stores data. Different formats, such as TIFF, EPS, and JPEG, use different means of compressing information.

FLATTEN To combine different layers of an image into one.

GAMMA A measure of the contrast that affects the middle grays.

GIF Graphic Interchange Format. A compression file format designed for use on the Internet.

HARD COPY Computer file printed out onto paper, film, or any other material of substance.

HIGH RESOLUTION An image with twice the resolution of the line screen at which it will be reproduced is considered a high-res image. Newspapers need 85 lpi (lines per inch) and high-quality book reproduction around 150 lpi. So an 8 × 10 image with 300 ppi printed at 150 lpi will be of high resolution or high quality.

HISTOGRAM A graph that displays the pixel distribution throughout the image's highlights, midtones, and shadows. It displays the pixel values based on their level of brightness, ranging from 0 (black) to 255 (white). On the graph, the high columns have the most pixels.

HTML Hyper Text Markup Language, which is used to create documents for the World Wide Web.

ICC PROFILE Developed by the International Color Consortium, ICC profiles are used to map the color gamuts of all devices that capture, display, or ouput color. They can be assigned or attached to a file in order to ensure that the file is output correctly.

IMAGE SIZE Physical measurement of a file in pixels, inches, or megabytes.

IMPORT Reading an image created in one application and translating or bringing it into another application.

GLOSSARY

INKJET PRINTING Process that projects tiny drops of ink onto a receiving substrate such as paper or canvas.

JAZ Removable storage device. Each disk holds 1GB to 2GB of data.

JPEG A file compression method developed by the Joint Photographic Expert Group.

LOAD To copy an application onto your computer.

LOSSLESS COMPRESSION Method of reducing the size of the file without losing data.

LOSSY COMPRESSION Method of reducing the size of a file by throwing away data.

LPI Lines per inch. Image resolution is measured in both lli and dpi. Lines per inch operate on the same principle as dots per inch, for example: 65 lines per inch means there are 65 lines of dots in one inch. The more lines that fit in the inch, the smaller the dots. The smaller the dots, the better the resolution or the sharper the image. Newspapers need 85 lines per inch; high-quality art books print at least 133 lines per inch. *See* dpi.

MAC Apple Macintosh computer

MARQUEE A Photoshop selection tool.

MASK A computer shield or device that protects selection areas of an image from the effects applied through filters, brushes, or commands.

MIDTONES The tonal values between the black and the white values.

MOIRÉ (mwah-RAY) A wave-like pattern caused by screen conflict or the misalignment of halftone screens.

MODEM Modulator-demodulator. Electronic device that allows a computer to use the telephone system to transmit data.

PICT Graphic file format used on the Mac system. It was designed for screen images.

PIXEL An acronym for "picture element." Pixels are the smallest picture element—the tiny dots that makes up an image. Think of them as analogous to square grains in film.

PIXELIZATION An effect caused by low resolution, where the shape of the pixels is readily seen.

PLUG-IN Secondary software that is used in conjunction with your main program.

POSTERIZE Technique that reduces the number of colors that make up the image.

POSTSCRIPT A page-description language developed by Adobe Systems.

PPI Pixels per inch. Used to describe image resolution.

PROCESS COLOR Cyan, Magenta, Yellow, and Black (CMYK). The four primary colors used in offset printing.

RESIZE A process of altering the number of pixels in an image.

RGB Red, Green, Blue. The three primary colors used to show color on a monitor.

RIP Raster Image Processor. Software that is dedicated to converting fonts and graphics into rasterized data.

SATURATION A color's intensity. The saturation of colors in a digital image can be altered using image editing software like Photoshop.

SCANNER Device that captures images by converting what it sees into a digital or binary format.

SCROLLING Moving to a different section of a file that is too large to be seen on the screen all at once.

SUBSTRATE The base or material onto which an image or file is printed.

STORAGE MEDIA Devices designed to store digital information or data, including CD-ROMs , DVDs, floppy disks, and Zip disks.

TIFF Tagged Image File Format. A file format for storing bitmapped images created by Aldus Corporation. It is the most commonly used raster image file format.

TINT Less than 100 percent of a color's opacity.

TONAL RANGE The number of tones between black and white in an image.

TRANSPARENCY ADAPTOR An accessory to a flatbed scanner that enables it to scan negatives and transparencies .

VIRUS A program design to enter a computer system and cause problems or destroy the system. PCs are more susceptible to them than Macs. A virus can enter your system through the Internet when you are downloading data. They are also spread via e-mail.

WATERMARK Elements embedded in a digital file to identify the copyright holder. The term also refers to a manufacturer's logo imprinted on artist's papers.

WYSIWYG What You See Is What You Get. Part of a computer interface that shows on the monitor an exact representation of what will be printed out.

WORM Virus that affects the Mac system.

WWW World Wide Web.

ZIP Removable storage device. Each disk holds 200MB to 250 MB of data.

RESOURCES

SUPPLIERS

ADOBE SYSTEMS INCORPORATED
345 Park Avenue
San Jose, California 95110
Phone: (800) 833-6687
Fax: (408) 537-6000
Web site: www.adobe.com
Technical help with all programs and software; updates; news; support with installation; new products.

ALIEN SKIN SOFTWARE
1111 Haynes Street, Suite 113,
Raleigh, North Carolina 27604
Phone: (888) 921-7546
Fax: (919) 832-4065
E-mail:support@alienskin.com
Web site: www.alienskin.com

ALTAMIRA
1827 West Verdugo Avenue
Burbank, California 91506
Phone: (800) 913-3391
Fax: (818) 556-3365
E-mail: info@altamira-group.com
Web site: http://206.63.152.155/default.asp
Genuine Fractals Photoshop plug-in.

ART-Z
P.O. Box 6568
Bozeman, Montana 59771
Phone: (800) 789-6503
Fax: (406) 586-8732
Web site: www.artzproducts.com
Fantastic albums for presenting work.

ASSOCIATED BAG
400 West Boden Street
Milwaukee, Wisconsin 53207
Phone: (800) 926-6100
Fax: (800) 926-4610
Web site: www.associatedbag.com
Packing materials including large mailer envelopes that can be used to ship large prints.

ATLANTIC PAPERS
1800 Mearns Rd., Suite P
Ivyland, Pennsylvania 18974
Phone: (800) 367-8547
Fax: (800) 367-1016
E-mail: atlpapers@aol.com
Web site: www.atlanticpapers.com
Hahnemühle digital papers, inks, and artist's papers.

AUTO FX SOFTWARE
31 Inverness Center Parkway, Suite 270
Birmingham, Alabama 35242
Phone: (205) 980-0056
Fax: (205) 980-1121
E-mail: custservice@autofx.com
Web site: www.autofx.com
Photo/Graphic Edges is a plug-in that provides creative and artistic edges; AutoEye greatly improves scans; Studio Bundle Pro 2.0 is an excellent design tools bundle for professionals. It includes edges, textures, layout designs, a universal rasterizer, and more.

BULLDOG PRODUCTS, INC.
8050 East Crystal Drive
Anaheim Hills, California 92807
Phone: (714) 279-2380
Fax: (714) 279-2381
Digital papers (BullDog, Epson, Hahnemuhle, Concorde), Tarajet and BullDog canvas, BullDog and Epson inks, BullDog ultra coating for digital prints and equipment.

CALUMET PHOTOGRAPHIC
890 Supreme Drive
Bensenville, Illinois 60106
Phone: (800) CALUMET [(800) 225-8638]
Fax: (800) 577-3686
E-mail: website@calumetphoto.com
Web site: www.calumetphoto.com
Photographic and digital supplies, books.

CANON U.S.A., INC.
One Canon Plaza
Lake Success, NY 11042
Phone: (800) OK-CANON
Fax: (516) 328-4809
E-Mail: estore@va.ccsi.canon.com
Web Site: http://consumer.usa.canon.com
 (Canon MacPassport)
Digital cameras, digital equipment and accessories (scanners and printers, inkjet papers).

CONE EDITIONS PRESS
See Inkjetmall.com

COREL CORPORATION
1600 Carling Ave.
Ottawa, Ontario, Canada
K1Z 8R7
Phone: (800) 772-6735
Fax: (716) 447-7366
Web site: www.corel.com
Plug-in software for different effects, compatible with Photoshop (KPT [Kai's Power Tools] 3,5, and 6; Painter; Bryce; Vector Effects).

DANIEL SMITH
4150 First Ave. South
Seattle, Washington 98124
Phone: (800) 426-6740
Fax: (800) 238-4065
Web site: www.danielsmith.com
Artist's papers (Arches Bright White, Somerset, Waterford DI); coated inkjet papers (Hahnemühle, Concorde, Liege); MIS Archival and Quad Tone Inksets.

DAYMEN PHOTO MARKETING
100 Spy Court, Markham
Ontario, L3R 5H6 Canada
Phone: (905) 944-9400
Fax: (905) 944-9401
E-mail: info@daymen.com
Web site: www.daymen.com
Canadian distributor of Lumijet coated inkjet papers and inks.

DICK BLICK ART MATERIALS
Att: Order Department
P.O. Box 1267
Galesburg, Illinois 61402
Phone: (800) 447-8192
Fax: (800) 621-8293
Web site: www.dickblick.com
Art supplies; artist's papers (Bienfang, Arches Bright White); digital papers (Strathmore, Frederick Inkjet Canvas).

FREESTYLE CAMERA
5124 Sunset Boulevard
Los Angeles, California 90027
Phone: (800) 292-6137
Fax: (800) 616-3686
E-mail: info@freestylesalesco.com
Web site: www.freestylesalesco.com
Inkjet coated papers (Arista, Ilford, Epson, HP, Konica, Kodak, Imation, Mitsubishi); fine art digital papers (Lumijet, Hahnemuhle); digital cameras and equipment; inks (Lumijet).

FUJI PHOTO FILM USA, INC.
P.O. Box 7828
Edison, New Jersey 08818
Phone: (800) 800-3854
Fax: (732) 857-3487
Web site: www.fujifilm.com
Fuji digital equipment; disks; printers; scanners; papers.

RESOURCES

GLOBAL IMAGING INC.
248 Centennial Parkway, Suite 160
Louisville, Colorado 80027
Phone: (800) 787-9801
Fax: (303) 673-9923
E-mail: color@globalimaginginc.com
Web site: www.globalimaginginc.com
Digital papers; Lyson inks and papers; artist's papers; digital cameras; digital equipment.

HAWK MOUNTAIN ART PAPERS
314 Ziegler Road
Leesport, Pennsylvania 19533
Phone: (610) 926-4561
Fax: (610) 926-4527
E-mail: sales@hawkmtnartpapers.com
Web site: www.hawkmtnartpapers.com
Inkjet coated papers (Osprey, Red Tail).

HUNT CORPORATION
One Commerce Square
2005 Market Street
Philadelphia, Pennsylvania 19103
Phone: (800) 955-4868
Fax: (215) 656-3700
Web site: www.hunt-corp.com
Distributors of Conté products (Conté pastel pencils); manufacturer of Bienfang Fine Art Papers.

IDEAMALL, INC.
2555 West 190th Street
Torrance, California 90504
MacMall Phone: (800) 328-2790
Web site: www.macmall.com
PCMall Phone: (800) 863-3282
Web site: www.pcmall.com
Digital equipment catalog.

I-LAB CORP. INC.
P.O. Box 1030
Atkinson, New Hampshire 03811
Phone: (603) 362-4190
Fax: (603) 362-4191
E-mail: lepovsky@tiac.net
Web site: www.ilabcorp.com
Information center for inks for Iris printers, print coatings, papers, links with other sites; sales of digital products, Lyson inks for Iris printers.

IMPROVED TECHNOLOGIES
P.O. Box 209
Tilton, New Hampshire 03276
Phone: (603) 286-3034
Fax: (603) 286-3103
E-mail: iris@itnh.com
Web site: www.itnh.com
Printers; inks; papers; Iris Print Seal; technical support.

INKJETART.COM
See The Stock Solution

INKJETMALL.COM
Cone Editions Press
P.O. Box 51
East Topsham, Vermont 05076
Phone: (888) 426-6323
Fax: (802) 439-6501
E-mail: sales@inkjetmall.com
Web site: www.inkjetmall.com
Archival quadtone inks, papers(Somerset Photo Enhanced), software for printers, color profiles, workshops on black-and-white fine art digital printmaking and managing color.

THE INTERNATIONAL ASSOCIATION OF FINE ART DIGITAL PRINTMAKERS
570 Higuera Street, Suite 120
San Luis Obispo, California 93401
Phone: (888) 239-9099
Fax: (805)593-0201
E-mail: office@iafadp.org
Web site: www.iafadp.org
Information on latest developments, materials, and techniques in the digital world; Web site gives technical support.

JERRY'S ARTARAMA
P.O. Box 58638J
Raleigh, North Carolina 27658
Phone: (800) U-ARTIST [(800) 827-8478]
Fax: (919) 873-9565
E-mail: info@jerryscatalog.com
Web site: www.jerryscatalog.com
Art supplies (Conté pencils).

KEVIN MARTINI-FULLER PORTFOLIOS
P.O. Box 2156
St. Louis, Missouri 63158
E-mail: kmf@mlc.net
Custom hand-crafted portfolios.

KRYLON PRODUCTS GROUP
Phone: (800) 4-KRYLON [(800) 457-9566]
Web site: www.krylon.com
Protective spray fixatives.

LEGION PAPER CORPORATION
Subsidiary of Gould Paper Corporation
11 Madison Avenue
New York, New York 10010
Phone: (800) 278-4478
Fax: (800) 275-3380
E-mail: info@legionpaper.com
Web site: www.legionpaper.com
Inkjet coated papers, artist papers, MIS Inks. Minimum order is $200.

LUMINOS PHOTO CORP.
25 Wolffe Street
P.O. Box 158
Yonkers, New York 10705
Phone: (800) LUMINOS [(800) 586-4667]
Fax: (914) 965-0367
E-mail: luminos@att.net
Web site: www.luminos.com
Lumijet papers, inks (color and quadtone), photographic chemistry and papers.

MACMALL CATALOG
See Ideamall, Inc.

MARSHALL'S PHOTO COLORING SYSTEM
Brandess-Kalt-Aetna Group (BKA)
701 Corporate Woods Parkway
Vernon Hills, Illinois 60061
Phone: (800) 621-5488
Fax: (847) 821-5410
E-mail: bkaservice@bkaphoto.com
Web site: www.bkaphoto.com
Full line of Marshall's products (including Marshall oils and oil pencils).

MEDIASTREET.COM
44 West Jefryn Blvd, Unit Y
Deer Park, NY 11729
Phone: (888) MEDIA-XL [(888) 633-4295]
Fax: (888) FAX-5991 [(888) 329-5991]
E-mail: support@MediaStreet.com
Web site: www.mediastreet.com
Digital papers (Somerset Photo Enhanced, Concorde Rag); artist's papers (Somerset Velvet, Arches, Hawk Mountain, Waterford DI); canvas; Generation inks; digital accessories.

MICRO WAREHOUSE INC.
1720 Oak Street
Lakewood, New Jersey 08701
Phone:(800) 397-8508
Web site: www.warehouse.com
Digital equipment.

MULTIPLE ZONES, INC. (MAC ZONE/PC ZONE)
707 South Grady Way
Renton, Washington 98055
Mac Sales Phone: (800) 454-3686
PC Sales Phone: (800) 408-9663
E-mail: sales.email@mzi.com
Web site: www.zones.com
Digital equipment; software.

NANCYSCANS
273 Highland Road
Chatham, New York 12037
Phone: (800) 604-1199
Fax: (800) 551-9116
E-mail: scaninfo@nancyscans.com
Web site: www.nancyscans.com
High resolution drum scans; custom ICC profiles; great prints on Fuji Crystal Archive paper. Very reasonable prices.

NEW YORK CENTRAL ART SUPPLY
62 Third Avenue
New York, New York 10003
Phone: (800) 950-6111
Fax: (212) 475-2513
E-mail: sales@nycentralart.com
Web site: www.nycentralart.com
Art supplies (including very reasonable brayers); artist papers (especially rare and exotic). Steve Steinberg very knowledgeable about papers.

PC AND MAC CONNECTION, INC.
Attn: Credit-Prepaids
Route 101A, 730 Milford Road
Merrimack, New Hampshire 03054
PC Phone: (888) 213-0260
Mac Phone: (800) 800 2222
PC Web site: www.pcconnection.com
Mac Web site: www.macconnection.com
Digital equipment for Macs and PCs.

PCMALL CATALOG
See IdeaMall, Inc.

PEARL PAINT
308 Canal Street
New York, New York 10013
(locations throughout the United States)
Phone: (800) 221-6845 x2297
Fax: (212) 431-5420
E-mail: Pearlsite@aol.com
Web site: www.pearlpaint.com
Art supplies and papers.

POLAROID CORPORATION
784 Memorial Drive
Cambridge, Massachusetts 02139
Phone: (800) 343-5000
Web site: www.PolaroidDigital.com
Digital equipment (cameras, scanners); papers.

STEPHEN KINSELLA INC.
P.O. Box 32420
St. Louis, Missouri 63132
Phone: (800) 445-8865
Fax: (314) 991-8090
E-mail: info@KinsellaArtPapers.com
Web site: www.kinsellaartpapers.com
Great selection of artist papers at good prices.

THE STOCK SOLUTION
307 West 200 South, #1003
Salt Lake City, Utah 84101
Phone: (801) 363-9700
Fax: (801) 363-9707
E-mail: mark@tssphoto.com
Web site: www.inkjetart.com
Anything for computer/printer needs; panoramic slide mounts; digital papers; inks (Lumijet, Lyson, MIS, Generations, Xtreme Gamut); Wilhelm Imaging Research test results.

SYNTHETIK SOFTWARE, INC.
880 Folsom Street
San Francisco, California 94107
Phone: (415) 864-6582
Fax: (415) 864-0433
E-mail: sales@synthetik.com
Web site: www.synthetik.com
Studio Artist software; Web site features technical support, free demos, and gallery.

TRUE BLUE ART SUPPLY
100 Charlotte St.
Asheville, North Carolina 28801
Phone: (828) 251-0028
Fax: (828) 251-0306
E-mail: info@artpaper.com
Web site: www.artpaper.com
Artist's and inkjet coated papers; very good newsletter about papers posted on Web site.

WACOM TECHNOLOGY CORPORATION
1311 Southeast Cardinal Court
Vancouver, Washington 98683
Phone: (800) 922-9348
Fax: (360) 896-9724
E-mail: sales@wacom.com
Web site: www.wacom.com
Intuos pen; airbrush; tablets.

SUGGESTED READING

BOOKS
Most Adobe Photoshop books are written with designers and artists in mind, but there are four that I own that are packed with information especially for the photographer:

Making Digital Negatives for Contact Printing: A Step-by-Step Guide to Affordable Enlarged Negatives for Platinum, Silver and Other Printing Processes, Dan Burkholder (Bladed Iris Press, 1999) bladediris@aol.com
A very clear and precise book that gives lots of helpful tips on making large negatives for contact printing.

Adobe PhotoShop 6.0 for Photographers : A Professional Image Editor's Guide to the Creative Use of PhotoShop for the MacIntosh and PC, Martin Evening (Butterworth-Heinemann, 2000)

Real World PhotoShop 6, David Blatner and Bruce Fraser (Peachpit Press, 2000)
Both of these books are full of information on how to scan, color correct, and choose platforms, as well as on pre-press tips and considerations.

Sams Teach yourself Adobe Photoshop 6 in 24 Hours, Carla Rose (Sams, 2000)
This book consists of 24 one-hour lessons with clear step-by-step instructions. I highly recommend it for photographers who are just getting started with Photoshop.

Here are some other good books:

The Digital Imaging Dictionary, Joe Farace (Allworth Press, 1996)

Professional Photoshop 6: The Classic Guide to Color Correction, Dan Margulis (John Wiley & Sons, 2000)

Adobe Photoshop 6.0 Classroom in a Book, Adobe Creative Team (Peachpit Press, 2000)

MAGAZINES

CameraArts Magazine
P.O. Box 2328
Corrales, New Mexico 87048
Phone: (505) 899-8054
E-mail: camartsmag@aol.com
Web site: www.cameraarts.com

Digital Fine Art Magazine
P.O. Box 420
Manalapan, NJ 07726
Phone: (800) 969-7176
Fax: (732) 446-5488
E-Mail: dfasubscription@hobbypub.com
Web site: www.digitalfineart.com

Digital Photo Art
Creative Monochrome Ltd.
Courtney House
62 Jarvis Road
South Croydon,
Surrey CR2 6HU
England
Phone: (020) 8686 3282
Fax: (020) 8681 0662
E-mail: roger@cremono.demon.co.uk

RESOURCES

PCPhoto Magazine
P.O. Box 56381
Boulder, Colorado 80322
Phone: (800) 537-4619
Fax: (303) 604-7644
Web site: www.pcphotomag.com

Photoshop User Magazine
National Association of Photoshop
 Professionals (NAPP)
1042 Main Street, Suite 20l
Dunedin, Florida 34698
Phone: (800) 738-8513
Fax: (727) 733-1370
E-mail: info@photoshopuser.com
Web site: www.photoshopuser.com

Shutterbug
Published by Primedia
5211 S. Washington Ave.
Titusville, FL 32780
Phone: (800) 829-3340
Fax: 321-267-1894
Web site: www.shutterbug.net

USEFUL WEB SITES

For updated information on digital products
(equipment, papers, inks, etc.) as well as
ordering supplies.

DIGITAL EQUIPMENT: COMPUTERS, SCANNERS, PRINTERS, CAMERAS, TOOLS

Apple Computer: www.apple.com
Calumet Photographic:
 www.calumetphoto.com
Canon Computer Systems:
www.ccsi.canon.com
Cymbolic Sciences (LightJet printers):
www.cymbolic.com
Encad: www.encad.com
Epson: www.epson.com
Freestyle Sales: www.frestylesalesco.com
Fuji: www.fujifilm.com
Global Imaging: www.globalimaginginc.com
Hewlett-Packard: www.hp.com
Imation: www.imation.com
Ilford: www.ilford.com
Improved Technologies: www.itnh.com
Iris Graphics: www.irisgraphics.com
Konica Photo Imaging: www.konica.com
Mac Connection: macconnection.com
Mac Mall: macmall.com
Mac Warehouse: www.warehouse.com
Mac Zone: maczones.com

Mitsubishi Imaging:
 www.mitsubishiimaging.com
Nikon: www.nikonusa.com
Polaroid: www.polaroid.com
Roland DGA Corporation:
 www.rolanddga.com
Sony Corporation of America: www.sony.com
Wacom: www.wacom.com

DIGITAL SUPPLIES: PAPERS, INKS, DIGITAL ACCESSORIES

Agfa Digital: www.agfahome.com
American Inkjet Corporation: www.amjet.com
BullDog Products: www.bulldogproducts.com
Calumet Photographic:
 www.calumetphoto.com
Canon USA: www.usa.canon.com
Cone Editions Press: www.cone-editions.com
Daniel Smith: www.danielsmith.com
Dick Blick: www.dickblick.com
Digital Art Supplies:
 www.digitalartsupplies.com
Fuji: www.fujifilm.com
Global Imaging: www.globalimaginginc.com
Hawk Mountain Art Papers:
 www.hawkmtnartpapers.com
Hewlett-Packard: www.hp.com
i-Lab Corporation: www.ilabcorp.com
Ilford: www.ilford.com
Improved Technologies: www.itnh.com
Iomega: www.iomega.com
Inkjetart.com: *see* The Stock Solution
Inkjetmall.com: www.inkjetmall.com
Iris Graphics: www.irisgraphics.com
Konica Photo Imaging: www.konica.com
Legion Paper: www.legionpaper.com
Lumijet: www.lumijet.com
Lyson Ltd.: www.lysonusa.com
Mac Connection: macconnection.com
Mac Mall: macmall.com
Mac Warehouse: www.warehouse.comMac
Zone: maczones.com
MediaStreet.com: www.mediastreet.com
MIS Associates: www.inksupply.com
Mitsubishi Imaging:
 www.mitsubishiimaging.com
Polaroid: www.polaroid.com
The Stock Solution: www.tssphoto.com/sp/dg
UltraStable Color Systems:
 www.ultrastable.com
Wacom: www.wacom.com
Weber-Valentine: www.weber-valentine.com
Worldwide Imaging Supplies:
 www.weink.com

SOFTWARE: PLUG-INS, COLOR PROFILES, DRAWING PROGRAMS, PAINTING PROGRAMS, FILTERS AND EFFECTS PROGRAMS

Adobe Systems Incorporated: www.adobe.com
Auto FX Software: www.autofx.com
Cone Editions Press: www.cone-editions.com
Corel Corporation: www.corel.com
Mac Connection: macconnection.com
Mac Mall: macmall.com
Macromedia: www.macromedia.com
Mac Warehouse: www.warehouse.com
Mac Zone: maczones.com
MetaCreations: www.metacreations.com
Synthetik Software: www.synthetik.com
Xaos Tools: www.xaostools.com

ARTIST SUPPLIES: ARTIST'S PAPERS, COLORING MEDIUMS, SPRAYS, ALBUMS, PRESENTATION PORTFOLIOS, SHIPPING ENVELOPES, EQUIPMENT BAGS

Art Z Products: www.artzproducts.com
Cheap Joe's Art Stuff: www.CheapJoes.com
Daniel Smith: www.danielsmith.com
Dick Blick: www.dickblick.com
Digital Art Supplies: www.digitalartsupplies.com
Freestyle Camera: www.frestylesalesco.com
Hawk Mountain Art Papers:
 www.hawkmtnartpapers.com
Improved Technologies: www.itnh.com
Krylon Products Group: www.krylon.com
Lowepro Camera Bags and Accessories:
 www.lowepro.com

DIGITAL MAGAZINES

Camera Arts: www.cameraarts.com
Digital Fine Art: www.digitalfineart.com
PCPhoto Magazine: www.pcphotomag.com
Photo District News: www.pdn-pix.com
Photoshop User Magazine:
 www.photoshopuser.com
Shutterbug: www.shutterbug.net

UPDATES, DEMOS, TEST RESULTS, PRODUCT INFORMATION

Adobe Systems Incorporated: www.adobe.com
Best Buys: www.bestbuys.com
BullDog Products: www.bulldogproducts.com
Digital Art Supplies: www.digitalartsupplies.com
The Robert Farber Interactive Photography
 Workshop: www.photoworkshop.com
Handcolor.com: www.handcolor.com
Legion Paper: www.legionpaper.com
The Stock Solution: www.tssphoto.com/sp/dg
Wilhelm Imaging Research:
 www.wilhelm-research.com

INDEX

INDEX